Praise

These young thinkers us —intelligence,
resourcefulness and an eye for the everyday—to produce
readings at a pace that the academy cannot mirror. At its best this
collection sets a precedent for a new generation of critical
engagement with popular culture. EDA is fighting to carve a new
space for the intellectual in popular media. Its battle is just
beginning.
Matt Foley, *Irish Times*

Written in clear opposition to a growing academic practice where
knowledge control, gate-keeping and intellectual property have
become key assets, *Why Are Animals Funny?* is a serious book
that deserves close consideration by those interested in the
possible futures of political, social and cultural criticism.
Andreja Zevnik, *OpenDemocracy*

The EDA Collective's mission is simply stated in the introduction
to the book. They want to make us think, and constantly re-think
our reality, a reality that is full of impossible complexities. I think
these renegades attack this challenge in the best possible way,
and that is from the multi-vantage point that only a collective can
offer, a panoramic view of different voices, that see different
signs, objects, and symbols, and amalgamate them together in a
creative register, that makes for a delightful and engaging read.
Zachary Siegel, *Critical-Theory.com*

The EDA collective comes across as young, intelligent,
thoughtful and energetic at a time when the university has
become exhausted by the reactionary defence of its own suspi-
cious ideals. Together, the authors have captured the joy of
performance, the energy of protest and embedded this spirit

within a theoretical framework that is admirably deliberative. It is not often that theory is this fun to read, and less often still that satire is so well versed in the language of its assailants.

Jamie Mackay, *Review 31*

Like a literary two-way street, this book acts as an accessible inlet for outsiders of the ivory tower that is academia, and a much-needed outlet for those trapped inside (both students and accomplished instructors alike). In brief, it serves to ponder all aspects of cultural minutiae through pickings and choosings of theoretical heavy-hitters like Lacan and Marx, without removing the joy of the sheer insanity and absurdity of it all.

Allison Norris, *The Manchester Review*

All too many reviewers have said about a book that it will change the way you look at the world and now the phrase is tired and meaningless. In this case, however, the book's critical eye affects your real one and does (in a very literal sense) *change the way you look at the world*.

Ruari Paton, *Voix*

Twerking to Turking

Everyday Analysis:
Volume 2

Twerking
to Turking

Everyday Analysis:
Volume 2

Created and Edited by

Alfie Bown & Daniel Bristow

Winchester, UK
Washington, USA

First published by Zero Books, 2015
Zero Books is an imprint of John Hunt Publishing Ltd., Laurel House, Station Approach,
Alresford, Hants, SO24 9JH, UK
office1@jhpbooks.net
www.johnhuntpublishing.com
www.zero-books.net

For distributor details and how to order please visit the 'Ordering' section on our website.

Text copyright: Alfie Bown and Daniel Bristow 2014
Illustrations editor: James Smith
Cover illustrations: Joseph P. Kelly

ISBN: 978 1 78279 752 4
Library of Congress Control Number: 2014948081

A CIP catalogue record for this book is available from the British Library.

Design: Stuart Davies

Printed and bound by CPI Group (UK) Ltd, Croydon, CR0 4YY, UK

We operate a distinctive and ethical publishing philosophy in all
areas of our business, from our global network of authors to
production and worldwide distribution.

CONTENTS

0. Introduction

The political landscape, in the so-called West, remains as unarable today as it has been since the hegemony of the supposed 'centre' in parliamentary politics—that is, the hymnsheet all the mainstream parties sing from—laid the fields of political possibility, if not to waste, as it may have believed, then fallow, the returning crop of which has been the ravaging lurch to the right (exampled in the election of UKIP in the European elections in the UK). This pestilent weed is one especially adapted to growing in such an arid season. In such times as these we can only pray that analyses of, and investigations into, this situation's cultural catalysts and everyday originations can do some work and provide some hope, which is our intention with our second book. In this—our second volume of *Everyday Analysis* articles—we are covering everything from the dance craze of twerking (a movement in which the *glutæus maximus* is shaken mesmerisingly, popularised on the internet by Miley Cyrus' controversial deployment of it in a performance with Robin Thicke) to 'Turking' (the form of work in which an employee is paid a one-off rate for the completion of a task posted online; that is, paid directly their *use-value*, as opposed to an hourly or minimum wage). We order these articles by theme alphabetically, for ease of navigation, beginning with 'Advertising' and ending with 'Work and Play', and we are very proud to be able to punctuate them with great illustrations and artwork.

Since the publication of our first book, *Why are Animals Funny? Everyday Analysis: Volume 1*, we have grown in number of contributors, and thus diversity of theoretical engagement; we have contributed articles to other publications, such as the *Guardian*; and we have found resonance with audiences ranging from casual surfers online to those of the University (students

and teachers alike, and interdisciplinarily), from those established already by publishing outlets (our own followers on our social media and blog, to those of our publisher, the eminent Zer0 Books) to those curious enough to pick a new book up off the shelves which claims to decode the humour of our grumpy feline friends—the everyday reaches us all, and its analysis, it seems, has sparked the interest of people everywhere.

In the introduction to our first volume we defended vigorously, and we hope rigorously, analysis and critical theory as not only important tools with which to approach and decode our everyday situation (and the operations of ideology, propaganda, and even revolutionary radicality silently, subtly, and often unconsciously at work within it), but also as something intrinsic *to* our everyday; that is, that life—however simple it might feel or unexamined it may remain—always inherently involves processes of interpretation and decipherment, in all of its day-to-day going-about-its-business. In this opening to our new book we will concentrate more on *modes of analysis*, and try to define what our presiding ones have been, and how they might also move or shift in future realisations.

Write on What You Enjoy! (or, EVERYDAY aNALYSIS)

Probably the most significant criticism that *Everyday Analysis* has come under in the course of its first year (from January 2013 to 2014), is that it has been too lenient on the problematic in the popular culture that it has tackled (one instance of which concerned our take on Robin Thicke and sexism, from which we received tweets asking why we only focused on the issue of feminism, as opposed to 'the misogynistic pro-rape structures of society', for example), or even that it has defended such problematic elements of culture, instead of attacking them (such as the attempt to discover a radicalism in controversial rapper A$AP Rocky's music and particularly his voice).[1] These criticisms may have a political point to make about where emphasis is

placed, and herein we will try to negotiate them.

What we want to avoid at all costs is something that is common inside both academic and journalistic discourse; that is, criticising the popular from an imaginary privileged position of knowledge, and even setting up this imaginary position in the process, making it seem as though we can speak from somewhere *outside* of these discourses. This procedure attempts to make philosophy/theory into something pure, and allows it to appear to be a 'key' to reading the outside world, which is something we took particular issue with in our previous book.

What we follow instead is something found in, but by no means limited to, Lacanian psychoanalysis, which we can identify with quick reference to some of Jacques Lacan's 'mathemes' (more of which we discuss in our analysis of the children's film *Epic* in this volume). The below instance describes 'the discourse of the analyst':

$$\frac{a}{S_2} \rightarrow \frac{\$}{S_1}$$

The first position in the matheme is the 'driving seat', here filled by the symbol a. The a (as in the '*objet petit a*') here refers to what Lacan calls '*jouissance*', which for now we might settle on this definition of: an enjoyment which has no apparent purpose. This can be anything from biting our nails to enjoying rap music: it is that enjoyment that we cannot see, imagine, or measure the value of. The first position in the matheme operates on (and creates) the second position, here occupied by the symbol $\$$. This represents the (barred) Subject, or the individual, as s/he exists, subjected to his/her historical and political conditions. So, although there are many implications of this, we can say that what is reversed here is a traditional idea of 'cultivated taste': we do not control what we like, what we like controls us. As such there is a criticism here of some of those academic and journal-

istic tones referred to earlier; whilst they see themselves as culti-
vated, as 'above' problematic forms of enjoyment (imagine the
voice that says, 'oh, I only like arthouse cinema, etc.'), we ought
not to congratulate ourselves on our taste, because to an extent
we did not choose this enjoyment, it chose us.

And yet these enjoyments themselves are not entirely privi-
leged or privilegable either. In the matheme, below the first bar,
is the S_2. This represents 'knowledge', but we might better think
of it as ideology, or as the total amount of knowledge that a
particular time and place has. Being below the bar in the
matheme means it is the support, so that here it is knowledge, or
even ideology, which supports these enjoyments, which in turn
create us as subjects. So our enjoyment, the bit of it that we
cannot explain, the bit that does not fit the model epitomised by
a colleague who recently remarked 'oh, I love the opera
because it really questions the logic of Fascism', the bit we
'love' but cannot understand why, even the bit that it seems we
should specifically *not* love (biting my nails, controversial rap
music, etc.), is the bit which reveals to us how we are constructed
by the knowledge of our moment. The question of what supports
and constructs this *a* has always been the focus of *Everyday
Analysis*. We're not so much interested in criticising what we
enjoy, but rather we're interested in thinking about what allows
us to enjoy it. So we are by no means letting Robin Thicke off the
hook...

Thus, what we have tried to do in this project at times is write
on what we enjoy in the everyday, and even especially what we
enjoy but perhaps *should not* be enjoying or *cannot
explain* enjoying, according to our existing systems of knowledge,
because it is here that we can find out something about the way
our enjoyment is structured that was *previously unknown to us*. We
hope to avoid the journalistic and academic tendencies to write
positively about what we like and negatively about what we
don't, which simply re-affirms our position as the subject writing.

Instead, it is hoped that this approach questions that which constructs us as subjects. This means admitting that we have enjoyments we may not want, or feel uncomfortable about, and even placing these in the centre, in the 'driving seat' of the matheme, in order to take them apart. In this volume (and in the coming years of the project), it is our aim to further this, and to show more convincingly how in these terms the popular is *always* also the political...

In his book for Penguin's 'Philosophy in Transit' series, *Event*, Slavoj Žižek analyses the Korean pop sensation Psy's 'Gangnam Style' in a similar vein to that outlined above, concentrating not only on its type of ideology, but also on *how* its enjoyment works, in us and on us:

> 'Gangnam Style' is not ideology in spite of ironic distance, it is ideology because of it: [...] the self-mocking irony of 'Gangnam Style' makes palpable the stupid enjoyment of the rave music. Many listeners find the song disgustingly attractive, i.e., they 'love to hate it', or, rather, they enjoy the very fact of finding it disgusting so they repeatedly play it to prolong their disgust. Such an ecstatic surrender to obscene *jouissance* in all its stupidity entangles the subject into what Lacan, following Freud, calls 'drive'; perhaps its paradigmatic expressions are the repulsive private rituals (sniffing one's own sweat, sticking one's finger into one's nose, etc.) that bring intense satisfaction without our being aware of it – or, insofar as we are aware of it, without our being able to do anything to prevent it.[2]

In an earlier talk, from which this passage was derived, Žižek describes this process of enjoyment involved in 'Gangnam Style' as 'what Lacan calls "*sinthome*", not "symptom", but *synthesis*, [a] kind of condensation of stupid enjoyment.'[3] Whilst Lacan does designate a certain mode of *jouissance* as 'idiotic' — that is, specif-

ically, male masturbatory *jouissance*—what we should perhaps see here in Žižek's use of the concept of 'stupidity' is also its extension to encompassing the 'nonsensical'. We can see this perhaps in the phenomenon of twerking; whilst the movements involved in it are certainly *suggestive*, it is difficult to pinpoint exactly of what; and whilst this suggestiveness (and *suggestiveness* in general) is no doubt sexual, in the act of sex it would again be difficult to correlatively place this manoeuvre (too fast to be a sensual 'grind', too erratic to be a portrayal of copulation): as an ecstatic movement, it seems to derive enjoyment in those doing it from the 'motor' drive (of bodily movement) and in those watching from the 'scopic' drive (of the—most often male—gaze). The condensation that this *'sinthomic'* process enacts cuts out the bit of the phenomenon that 'makes sense', to leave us with access to 'a little bit of the Real' of uninhibited enjoyment itself. The putting to use of this process in manifestations of art and culture is something we discuss in relation to quantised structures in music in our article 'The *Sinthomic* Blank in Future Bass and Dubstep', below.

Culture and Contemporaneity

In terms of that which does make sense to us, however—that is, the realm of symbols, signs and symptoms, in culture, current affairs, media, and politics—Lacan also discusses the position of the analyst as one of

> symbolizing symbols. The analyst is the one who must do that. It's not a problem for him as he himself is already a symbol. It is preferable that he do it thoroughly, with culture and intelligence. This is why it is preferable and even necessary that he have as complete a background as possible in cultural matters. The more he knows about them the better.[4]

Echoing Freud—who, in his interpretative practice, showed such

a wealth of cultural knowledge and reference—Lacan is suggesting here that for the analyst knowledge of culture is essential for making interpretative connections, not for judging evaluatively (that is, passing judgement on those—the analysands—who might not have that same knowledge, or enjoy the same things), or for elevating to the level at which one becomes the setter of trends in 'cultivated taste', as an art critic, or even philosopher, might use this knowledge for (this is not to say that we only deploy the psychoanalytic method in our collective analyses, as they draw on critical and philosophical modes too). Further, in these terms of 'cultivated taste', there is the risk of neglecting, to the detriment of historiography, the popular—genre fiction in literature, pop in music, etc.—which gives us so many indications of the sociology and epistemology of the times we live in (and of those we can go back to and study). As Franco Moretti puts it:

But – it might be objected – the average production of a given genre is unreadable and boring now. I do not doubt it. But it is precisely this unbearable 'uncontemporaneity' that the historian must seek out. (We might reflect in passing that if everyone behaved like literary critics who only study what they 'like', doctors might restrict themselves to studying only healthy bodies and economists the standard of living of the well-off.) And then, are we so sure that we know those 'other' ghost stories, the 'conventional' ones? Have these conventions really been studied, or do we not rather confine ourselves to evoking them hurriedly for the sole purpose of adding lustre to their 'destroyer'? If one wants to keep the couple convention-innovation and give the latter term the full historical and formal weight it deserves, it is all the more important to realize that the first term of the pair has not yet become an 'object of knowledge' in a true sense for literary criticism.[5]

How better to make it 'an object of knowledge' than to analyse the culture of the here-and-now, rather than wait to see whether it becomes canonised or discarded down the line? However, we must also see the risk in this kind of assertion, as certain such studies of popular and conventional culture — that were denigrated by the literary establishment of the time — concerned what is now considered classic; Pierre Macherey's analysis of Jules Verne in *A Theory of Literary Production*, or even Moretti's own of *Dracula* and *Frankenstein* in the above work, for example (the question remains, when these have been canonised, of what it is that we haven't deigned to read, and what of its importance...?). It is these sorts of considerations we have tried to address, from a *structural* position, in our article 'Reading Between the Lines of What Stays Within Them: *Genre Fiction, Normality, and Analysis of Structure*' within these pages.

We follow Moretti, however, in his precisely pointing out that 'it is obvious that one can easily find a lot of Hegel in Goethe and a lot of Goethe in Hegel: how could it be otherwise? But the great intellectual construction is not the one which always surfaces *only* in the masterpieces of other great intellectuals. It is that which seizes, channels and modifies the 'spirit of the age' over the *entire* scale of its manifestations, from the highest to the most negligible.'[6] This channelling and modifying of the *zeitgeist* is something we try to locate in our various analyses; whilst there are artistic and cultural manifestations that seemingly always remain contemporary (Ezra Pound asserted that in essence 'literature is news that STAYS news'), there are also those that remain completely of their time, and those that move it on from one formation to the next, and then disappear (as a 'vanishing mediator'), a case in point being that of comedy.[7]

What we find funny is an interesting psychological question, one that rests on culturo-historical and subjective situationing in so many respects. It is, in the main, *relative*. However, a lot of what gets popularly described by the press as 'cutting-edge'

comedy today is perhaps described so as it is at the edge of a formation that is on the brink of being overturned. We see historically so much racism, sexism, and other forms of discrimination being staples of the stand-up routine, and we still see similar on TV now, in comedy based on the chastisement of social groups, such as that of the 'chav' (Lee Nelson), for example, or the caricaturing of minorities (*Citizen Kahn*), and so on, in all of which the element of *satire* (which, say, in early Harry Enfield, Steve Coogan and Chris Morris shows is exemplified) seems completely missing. *South Park*, however, is a transatlantic example of comedy that doesn't fall at the satirical hurdle, and one that questions itself the very temporality of comedy (the *Urban Dictionary* defines '22.3 years' as 'the amount of time it takes something tragic to become funny again', as according to the show, for example).

With the combination of these reflections in mind, the manoeuvre we intend to avoid is one exemplified in the shamelessly academic book *Taking* South Park *Seriously*, for example, in the introduction of which its editor takes to task the several dismissive comments its call for entries received online in various places. This procedure utilises techniques such as mocking these comments' spelling—'english' with a small 'E' is singled out by the editor—assessing their articulation and meaning with all the erudition that would be applied to meticulously crafted, proofread and copyedited published texts, and suggesting that these '*South Park* fans [have] derided any serious consideration of the program.'[8] To disqualify a mode of consideration, be it enjoyment, identification-with, reference-to, etc., from the possibility of being a *serious* endeavour—as compared to the author's (and, so he suggests, *academia*'s) own—is precisely the kind of value judgement we aim to steer well clear of with this volume, which we hope will open onto more interesting, inclusive and exciting modes of analysis than those of 'cultivated taste' and academic disdain, and open up these modes of

analysis themselves.

In Alain Badiou's taxonomy there are four types of *event*: 'politics, love, art and science'; it is these topics which form a formidable chunk of this second volume, a volume the event of which we hope will make some mark in the field it opens out into.

Advertising

11

1. The Pure Advert: *Analysing Perfume*

Much television advertising shows us images of commodities in ways calculated to make them desirable: cars driving on impossibly empty roads, soft drinks that are too good to be true, phones that will organise and improve your life. Some products, like cosmetics, cannot be shown directly and have to be represented through their effects. For this reason we have shampoo adverts that show hair becoming shiny and skincare adverts that show the effect healthy skin has on the opposite sex (and it is always, so far, the *opposite* sex). All these adverts are—in one way or another—forms of wish-fulfilment. This tells us that we are in the world of dreams, since Freud has shown us that, in all cases, 'a dream is the fulfilment of a wish'. It is a world Walter Benjamin associates with the growth of commodity fetishism in modern life, a phenomenon of which advertising is an organic outgrowth.

One product is so ephemeral, though, that neither it nor its effects can be adequately represented. This product is perfume. Perfume is nothing but a scent, a trace, and therefore utterly resistant to visual presentation. Even shampoo and spot-cream can be illustrated through the material effect they produce on the body, but the only thing perfume alters is our smell, our aura. How then, is perfume to be advertised? The answer is through the language of dreams themselves. If all advertising is a kind of dream, the perfume advert takes that logic and extends it so that there is *no product at all* at its centre. All that remains is image and sensation. Adverts like those for Chanel No. 5 with Audrey Tautou or Dolce and Gabbana with Keira Knightley offer up a confusion of identity, space and meaning that matches what we encounter in dreams. Such adverts often show people in bed, as in the case of Audrey Tautou, who appears to fall asleep in the Chanel advert. While any bed is sexual, here the bed gestures more specifically towards a *dream* of sexuality. Watching this

advert, we are invited to ask: is the man real, or is he a figment of her (or our) imagination? This is a question that might equally be asked of perfume, which is already almost nothing.

If all dreams and all adverts are circulations of desire and fulfilments of wishes, we might be tempted to say that the fulfilment offered here is sexual. Yet this is not the case, at least not in the way it first appears. Keira Knightley only tempts her man with a dab of perfume to the neck before she walks away, leaving him behind. Audrey Tautou may end the advert being kissed by the man she has been searching for, but there is no sense that this is any more real than the rest of the dream-like sequence: the man is no more solid now than when he appears as an image on her camera a little earlier. Instead, to understand the wish that is being fulfilled we have to return to Freud, who proposes several forms that might be taken by wish-fulfilment in dream, one of which is the *'wish to sleep'*. This is a powerful force in all dreams, but especially sexual ones: 'The operation of the wish to continue sleeping is most easily to be seen in arousal dreams, which modify external stimuli in such a way as to make them compatible with a continuance of sleep'.[9] It is this that we see in the perfume advert; the wish being fulfilled is not that desire is satisfied, but that it is *extended* so we can continue to sleep. This makes the perfume advert the purest of all adverts, since it reveals something fundamental about the way all advertising works. Advertising constantly works against something Freud pointed out over a hundred years ago: *'throughout our whole sleeping state we know just as certainly that we are dreaming as we know that we are sleeping'*.[10] All advertising is at once the revelation and the repression of this fact, but nowhere does either operate more powerfully than in the perfume advert.

2. No Surprises: *Kinder Eggs and Blue and Pink Economy*

'We do not advocate or promote our products as gender specific.' This was how the Kinder Surprise brand addressed complaints about their new range, where the usual chocolate eggshell containing a plastic toy comes with a new pink or blue-tinted wrapper. So, this Easter, children can look forward to 'limited edition' superheroes, cars, etc. in the blue eggs, and princesses, dolls and ponies in the pink ones. Of course, no gendering intended: as the company's statement goes on to explain, the new coloured eggs are merely to 'help parents navigate the toy ranges on offer and make purchasing decisions based on what is most relevant for their child.' Why does a popular product aimed at young children move its marketing strategy away from unisex and towards crass gender stereotypes via a multi-million pound campaign, whilst having to publicly deny that this is the case to save face?

Children's culture is becoming increasingly gendered. Where, up to the late nineteenth century, young children wore the same sack-like dresses, and up to at least the mid-1980s, girls and boys were assembling towers out of primary coloured blocks in the same dungarees, today even newborn babies within reach of globalised consumer culture tend to come in colour-coded nappies. There is an increasingly conspicuous discrepancy now between the triumphalist embrace of a discourse of equality between the sexes in the urban West, and the gender ideals on sale. Pink and blue for children conjure the traditional gendered binaries; active/passive, essential/supplementary, pragmatic/decorative; and Kinder Surprise's adverts sum up a whole market when they pitch 'cars to fuel the imagination' vs. a 'range of ponies, accessories, locks, bracelets, and dolls for creative play'.

But why do we say one thing and buy another? Brands are quick to excuse themselves via their customers' desires: 'this is what the research says people want', and via narratives of choice: 'we're not the ones who decide whether a child gets a pink or a blue egg—you, the parents, do. We are simply helping you navigate your purchasing decisions'. If the Pink and Blue Kinder chocolate eggs stand out, it's only because of the amusing inconsistencies of its promises: it's supposed to be a surprise—except one that now requires awkward gender-based pre-sorting. Surprise is the point but apparently no longer what we 'want'.

Even before pink and blue, there has been something paradigmatic about Kinder Surprise. Cultural theorist Slavoj Žižek, with reference to psychoanalyst Jacques Lacan, points out how the chocolate eggs demonstrate our desire for something beyond the thing we want: the hollow chocolate shell is discarded for another shell, with a toy inside, thus revealing the mechanism by which we replace one object of desire with another without ever arriving at the thing itself: the ultimate fulfilment of desire.[11] In this way, a basic structure of desire is harnessed by the commodity: Kinder Surprise offers the 'something more' (toy) beyond the initial object purchased but neglected for it (chocolate); but it is an addition for its own sake: mostly, the experience ends up dominated by the structural void between the two. So, Žižek claims, Kinder Surprise makes money on desire itself, without selling much of an object, and comes dangerously close to displaying 'too openly the inherent structure of a commodity itself'.[12] Pure consumerism then, without any claim to use-value beyond a temporary excitation of desire.

The important point is that Žižek renders the eggs not as paradigmatic of some atemporal, eternal desire, but desire under post-industrial capitalism. Perhaps the Pink and Blue eggs draw attention to themselves because they display another structural arrangement too openly: that the void in the egg is also the void to be filled with some narrative. Our desires aren't our own, and

this couldn't be more evident in the case of the three+-year-old consumers of Kinder Surprise, who so obviously did not know they were to want either pink ponies or blue cars (rather than everything in the world, in all its polymorphous perversity) until they were told. But there is no ideology here in the traditional sense, no overarching system of ideals as the basis of a political and economic system. And this is already beginning to be true in the early twentieth century, when big American department stores decided to promote pink for girls and blue for boys in order to increase their profits: if the average family has a boy and a girl, convincing parents to buy gender-specific clothing will mean fewer hand-me-downs, and more clothes sold. One explanation, then, is that pink and blue dominates today not because we believe in biological differences more than the Victorians, but because the most dominant narratives are decided by profit imperatives, not by conspiracies of sexists. Gender-specific paraphernalia means more stuff gets bought, and now the pink and blue culture is so pervasive even a tiny unisex surprise toy has become unattractive. This is not enough to explain this strange and growing culture of pink and blue—but it raises the distinct and uncomfortable idea that children's ideas of themselves as boys or girls are largely dictated by profit motives. Somehow the old devil patriarchy made for a better enemy. Kinder Surprise makers aren't patriarchs, they are players in post-industrial capitalism. But they are part of a culture, and a market, that sells crude, binary gender ideals that will have effects on the shape of our desires.

Art by Isabela Fawn.

3. Three Cold Sore Treatments

There are currently three main remedies for outbreaks of the *herpes simplex virus,* or cold sore, available over the counter: the lotion, the protective patch, and the 'invisible light treatment machine'. Whatever their relative merits as palliative treatments, what allows three so different products to simultaneously claim to achieve the same thing is the radically different rhetorical— and, we can say, *ideological*—strategies they employ. As Roland Barthes puts it in his classic 1957 discussion of different brands of washing powder: 'the relations between the evil and the cure, between dirt and a given product, are very different in each case'.[13]

The rhetorical claim of the lotion, first, is that it assimilates the troubling difference of the cold sore's arrival into the body's ordinary running. We use lotions every day, and are used to thinking that different parts of our bodies—hands, face, lips, eyes, hair, feet—require different kinds of lotion to keep them at their best: why shouldn't the same easygoing relativism be extended to this, the body's newest arrival? 'From a tingle to a blister' is the advertising slogan of the market-standard producer of cold sore lotion, which goes so far as to attribute to the cold sore its own narrative, independent of the body it has taken as its host. Ideologically, then, the lotion is 'a multiculturalist liberal', happy to play down tensions between the body's communities, and to acknowledge that the 'other' may have a story of its own to tell. But also in keeping with that ideology, the cold sore 'other' can only be integrated in this way if it abandons its most charac-teristic cultural properties. The lotion's habitual language of 'cooling' and 'reducing redness' demonstrates its double gesture: the cost to the cold sore of being blithely welcomed into the body's daily beauty routine is the demand that it be subsumed into the homogeneity of that body.

The protective patch seems to employ the opposite gesture. Far from integrating the cold sore into daily life, sealing it with a transparent sticker suggests a compulsion to cover it over, pretend it never existed, to slowly suffocate it. In this treatment, contagion is the main factor, and the attempt at sealing it off works to delimit its spreading to other part's of one's body and to those of others. But the heavy-handed literalness of this rhetorical cure only barely disguises its logical contradiction. For the dangerous 'other' being contained is being contained *inside one's own body*. The protective patch's knee-jerk 'nationalist' impulse to close all borders and 'send them back' comes with the resigned acknowledgement that pure national belonging is always only a fantasy, and that there are shards of the alienated immigrant within all of us.

If these two conventional cold sore remedies portray the relationship between the supposed interloper and the body proper in ways roughly analogous to the two mainstream positions on immigration in the West, then where do we situate the innovative third available treatment: the 'invisible light treatment machine'? The machine works by sending a concentrated beam of invisible light into the affected area, supposedly stimulating the body's immune system, and so destroying the cold sore. We should not ignore the apparently ludicrous analogy of the conclusion of the first *Star Wars* film, where the malignant globular Death Star explodes after a single laser is fired into its core. (The sci-fi loopiness of the product is inscribed in its clunky B-Movie name). Nor indeed the political capital Ronald Reagan — the figure most often evoked by today's neoconservative hawks — took from the franchise in his own escalation of America's military scope under its name.[14] For the 'invisible light treatment machine' actively plays out the hawkish fantasy only nervously implied by the other two: that of the complete and technologised obliteration of the other, and an abrasive indifference to the possibility that the other is part of oneself.

4. Can the Advert Say: 'You're Not You When You're Interpellated'?

There is a trend prevalent online of taking a source material and divesting it of its original intention to re-present it as an insightful or inspirational soundbite. It falls in the category of those snippets of new-age pep appearing in front of psychedelic backgrounds in Facebook feeds, which suggest that feeling good about your life will save the planet, etc., and the moving-image manifestation of this is the excerpted motivational business video, the 'real-life' sob story, or, commonly, the re-presented advert.

One of the latest that begs close reading is the re-presentation of the Australian 'You're not you when you're hungry' Snickers advert, which has appeared in various places across the net under headlines like 'Aussie Builders Surprise Women With Loud Empowering Statements', and so on.[15] As an advert it does what most do; derives its humour from playing around with a stereotype. The intention of the ad's re-presentation is, however, to suggest that there's something to this play, and that — imagining for a moment the ad isn't just ironic, or sarcastic — the world could learn something from it.

The stereotype it plays with is that of construction site workers shouting sexist remarks at passing women; instead of 'nice tits/arse, etc.', the builders shout complimentary comments about these women's dress and hair, and end up collectively calling for an end to misogyny. This is billed by the re-presentation as women receiving empowering encouragement from these builders.

The ideology of the advert in general, however, is such that, whilst playing with stereotypy, it nonetheless reinforces it; that is, the advert tends not to actually subvert stereotypy in and of itself. Through re-presentations such as these this ideological

manoeuvre is shown precisely in its actual mode of functioning. In other words, the mechanism by which it works is perceivable in this re-presentation, as it is here that we can see it working *on* those who spread it virally.

To the re-presentation of this advert as a feminist message can be raised many objections (as has been happening).[16] To list a few in no particular order:

- Initially, the stereotype of builders prevails in that they are all men, which discounts any moves in gender equality already made in this sector of work.
- The message appears that the builders' statements are 'empowering', but what of women's ability to empower themselves?
- In terms of class presentation, the builders are clearly visually defined as working class (albeit ironically not as working *crass*), and the women tend to be smartly dressed to perhaps suggest they are businesspeople. If this implies their success, the question again arises as to why they can only yet be validated by men.
- The gender specificity has only ostensibly disappeared in the redirecting of comments away from body-parts to clothing, for example; why don't the builders compliment passing men similarly on their colour choices?
- Even theatrically, the blocking of the scene perpetuates bias; the men launch their statements at the women from lofty heights *above* them.

From these few brief reflections we can clearly see that we are left with an advert that employs anti-feminism to render its humour that has been taken up by its viewers and repackaged in the guise of a feminist manifesto. Thus, in divesting the ad of its intended product we are resold anti-feminism *as* feminism. As unconscious as this process by viewers may be, it is symptomatic

of our late-capitalist state of affairs.

The German Idealist philosopher G. W. F. Hegel introduced the concept of *Aufhebung* (sublation) into philosophy; that is, a process by which a certain manifestation is cancelled and yet preserved at once; what is kept of the old order is that which was radical in it, and that allowed the new to come about. What we see in these manoeuvres of re-presentation is in effect an *anti-Aufhebung* (something which is key to the perpetuation of capitalism, in that capitalism subsumes all of its problems and disturbances—to deal with them 'internally'—so as not to be overturned by that which is outside it; it appropriates and incorporates its outside, and keeps it stifled within, without allowing it to bring about a new dimension). This notion of anti-*Aufhebung* represents, then, the maintenance of a manifestation (societal, cultural, economic, etc.) stripped of its revolutionary or radical potential.

In this anti-*Aufhebung* re-presentation of the Australian Snickers advert we see the issue of feminism depoliticised, deradicalised, demilitantised; erased are its fights, even some of its victories; reinscribed is the *empowering* (i.e. *powerful*) position of the man; perpetuated are gender and class stereotypes. We are left with a vision of the world in fact as it is, with the question over it: 'what if it could be this way?' And by this we are meant to feel inspired, enlightened and motivated, so many stand-ins for this operation's underlying insistence on complacency; complacency with the current manifestation in which we are thus fully interpellated. In the Althusserian concept of interpellation, as Robert Pfaller explains, the subject becomes 'a heteronomous servant ("subject to ..."), while experiencing itself imaginarily as a master ("subject of ...")'.[17] The question that thus remains is: can the advert say, 'you're not you when you're interpellated'?

Animals

5. One Foot in the Grave and One in the Distant Past: *Jonathan the Ancient Tortoise*[18]

The BBC News Magazine's most-read article on 13 March 2014 focused on Jonathan the 182-year-old tortoise.[19] With the internet as famous for its fixation on animals as it is for anything else nowadays, we ask, what is it about this particular article that has garnered such huge interest? In the article we named our first book after, 'Why Are Animals Funny?', we argued that the popularity of the funny animal is based on the animal seeming 'human'.[20] Contrary to the notion that it is the 'superiority' of the human to the animal that makes us chuckle, the rise of the animal-acting-human memes of grumpy cats, nonplussed dogs and cuter-than-thou sloths taking shade under umbrellas suggests that it is in fact the uncanniness of the animal that tickles our funny bones and pulls at our heartstrings. With Jonathan the ancient tortoise, there may be something similar at work.

In her article, Sally Kettle's gasping question, 'is it true that a living tortoise could have started its life in the first half of the 19th Century?', shows us that we are putting this creature into a very *human* context. We are told that there is a photograph of Jonathan taken in 1882 in which he is full-size, dating him to half a century, and then we are shown another, circa 1900, in which he is pictured with a Boer War prisoner and guard. This humanises the tortoise, to whom the name Jonathan is given to make him more human still. Indeed, as historian of consciousness Donna Haraway has noted, compared to ten years ago, pets are also now almost universally given human names, as relationships with animals have become increasingly 'substitutional' for those with humans.[21]

This substitutional logic is something that philosopher Jacques Derrida charmingly deconstructs in his 2002 lecture *The Animal That Therefore I Am*. Here Derrida analyses the bizarre

feeling of shame and nakedness he feels when he comes out of the shower and is confronted by his cat. In this instance both human and animal are naked, but Derrida's point is that they are *not naked in the same way*. Contrary to the human, the animal 'neither feels nor sees itself naked, and therefore it isn't naked'.[22] In other words, one can only feel *nude* after having been clothed. This is why the human feels shame and the animal does not; nakedness for the human is something altogether different. This demonstrates the way we graft a certain 'nature' onto the animal; when we think of animals as 'naked', 'pure' or 'innocent', these are only attributes that make sense in human language, they do not exist in the animal kingdom *a priori*, that is, before their deployment as human concepts. We *humanise* the animal.

So we return to our original question: what of old Jonathan? How is he different to this now-normal love of animals that we find all over the internet and our TV screens?

Might it be that Jonathan's remarkable appeal lies in the opposite: not in the way that he is like a human but in the way that he is somehow '*beyond*-human'? Compared to a human, Jonathan has managed to live beyond the caesuras or changing times of history—what the great 'archaeologist of knowledge' Michel Foucault calls 'epistemological shifts'—changes in history that make the past inaccessible. Jonathan has been able to live beyond what we know as 'living memory'. He has seen the other side of a time which is for us accessed only through historians' representations, TV programmes and cultural generalisations. Jonathan seems to us to have *transcended* the limits of the human.

Yet as the BBC article shows, the limits of the human are not so easily escaped by pretending to identify with an aging tortoise and imagining what he might have seen. With his obituary and 'shell preservation' arrangements already in place, the article ends: 'when he goes, Jonathan will be mourned by friends and admirers on St Helena and around the world.' Although he is

still alive, Jonathan thus appears as a kind of relic or document of a dead past; though fascinated by this ancient living creature, it is as if unconsciously we see him as a museum object from the past. We like Jonathan because he is old and has seen so many things that our lives would have to at least double to be able to see. But really we see him as if he is already dead, and therefore treat him like a fetishised relic of a past that is as unreachable for us as it is incommunicable for Jonathan.

6. Cat vs. Rabbit: *The Object of Desire*

An *Everyday Analysis* contributor owns a rabbit who is currently in a standoff with a cat, through a window, as seen here:

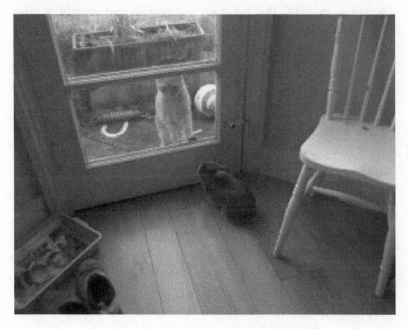

This 'standoff' tells us something fundamental about the structure of our desires, and explains a major tenet of psychoanalysis. This is that we do not truly want, nor could we handle, the realization of our deepest and most passionate desires. The cat gazes at the rabbit, occasionally attempting to pass through the window. It is completely obsessed with the rabbit, not taking its eyes off it at any point. If one tries to distract it, it doesn't work; the cat is in monomania. The rabbit, as the object of desire, is enjoying his position as desirable object. Far from being scared, he safely enjoys the feeling of being desired in the most ultimate way by the Other through the safety of the glass screen which is preventing the traumatic realization of this desire,

which would, if realized, lead to consumption and certain death for the rabbit-as-object.

Psychologically, the cat thinks that its every desire tends towards the rabbit; it is completely obsessional. If only it could get the rabbit, the cat would be happy. But another potential trauma is in play. The cat does not realize that should it pass through the glass and realize its desire for the object, the *Everyday Analysis* contributor mentioned above would be ready to bludgeon the cat to a brutal death with a nearby rolling-pin. There is a traumatic outside to the frame of the image above, which would destroy the structure of desire within it.

The point here is that the window is not the blocker of desire or the thing preventing its realization at all, but the very thing which creates and frames the fantasies of both parties; the thing which desire relies upon. Psychoanalysis insists upon this; that we do not want what we truly desire, but rather, that we want to hold the object of desire at a distance in order to dream and fantasize about it. The rabbit and the cat need the screen to be in place, in order for the rabbit to feel it is truly desired, and for the cat to feel that it truly desires, giving both a role and purpose. Further, they need the window to protect themselves from the reality of their purer desire, which would lead to the traumatic destruction of both. Žižek comments:

> Sharpening the paradox to its utmost—to tautology—we could say that *desire itself is a defence against desire*: the desire structured through fantasy is a defence against the desire of the Other, against this 'pure', trans-phantasmic desire (i.e. the 'death drive' in its pure form).[23]

The cat vs. rabbit standoff is in no way unique. Rather, it shows us that we cannot handle the true realization of desire, so we produce a framed fantasy of desire which we hold at a distance, to keep ourselves from this desire to be destroyed: as the United

States Declaration of Independence tells us, we do not want happiness, we only want the pursuit of it.

Photograph by Alfie Bown.

Art

7. The Assassination of J. D. Salinger by the Coward Richard Prince

Richard Prince's *The Catcher in the Rye* 'sculpture book' is a facsimile of the first edition of J. D. Salinger's *The Catcher in the Rye*, except it has Prince's name in place of Salinger's. It is a work of 'appropriation art' and thus billed a 'sculpture book'. The appropriateness of such appropriation is uncontested if the bill can be footed for any legal infringement protestation, of course. Is this what Barthes had in mind when he foresaw 'the death of the author', or what Foucault envisaged the disappearance of the 'author function' to look like, at the end of his essay 'What is an Author?'

The very opposite. Roland Barthes' manifestoed summative statement in 'The Death of the Author' is: 'the birth of the reader must be at the cost of the death of the Author'.[24] The author of *The Catcher in the Rye* may well be dead, but the notion of authoriality Prince sees it appropriate to force to remain obscenely and tortuously alive, and this at the cost of an abortion of the reader. This 'sculpture book'—which, incidentally, was ironically promoted by James Frey, a master of *appropriation ex nihilo*—may as well be as unread by Prince (and its $40 purchasers) as the author-function is made undead by him. There's something 'fascististic'—to coin a word—about the 'work': its implications of a moneyed *lack of work* (*'l'absence d'œuvre'*); its *murder of the author*, and subsequent disavowist, fraudulent identity-theft of the authored material. To say nothing of his other work, this fails as art precisely due to its disallowance of dialecticality; it represents a 'self-alienation [that] has reached the point where it can experience its own'—and not only its own, but the enforcement of others'—'annihilation as a supreme aesthetic pleasure', to put it in the words Benjamin uses at the end of 'The Work of Art in the Age of its Technological Reproducibility'.[25] And this failure

occurs in Prince's piece in precisely the way it doesn't in Banksy's 'Stolen Picasso Quote' (this work being an engraving in stone of Picasso's statement: 'The bad artists imitate, the great artists steal', with Picasso's name visibly scratched out, and 'BANSKY' etched underneath it).

8. If You Haven't Got Anything Nice to Say, Don't Say Anything

It is probably fair to say that, at some point in their lives, most people will have been told that if they have nothing nice to say then they shouldn't say anything at all. The recipients of this mantra are usually children being spoken to by an authoritative figure such as one of their parents or a teacher, for example. This reasoning suggests a preference for passive resistance to and silent sufferance of things that are displeasing or offensive rather than more vocal expressions that can be disruptive to the status quo. Children are conditioned into accepting and praising the social and economic conditions of their existence if they wish to satisfy their desire to communicate with their peers and integrate themselves within their community, otherwise they are to be silent and reduce their impact upon others, enabling the perpetuation of the system about which they have nothing nice to say.

The distinction between displeasure and indifference resultantly becomes blurred by the ambiguity that is inherent within an individual's silence. With the assistance of body language and gesticulations, silence can signify both shock and boredom, it can confirm or deny a proposition; silence is the voice of those who are dead and those who are in their infancy (derived from the Latin *in fant* which literally means 'not speaking' or 'one who is unable to speak'). Thus, a silent individual can signify perfect contentment and indifference or they can signify one whose opinions and observations are not deemed 'nice'.

Artist Marina Abramovic is to open 'her most ambitious artistic endeavour [...] since 2010' in London's Serpentine Gallery in June 2014. Her performance is to consist of 'nothing': just her and the public staring at one another for eight hours, six days a week. She told the *Huffington Post* that this performance will be 'the most radical, the most pure I can do'. Her intention, she said,

is 'to prove that you can make art with nothing'.[26]

Abramovic is not breaking new ground here. There have been a number of aesthetic uses of total silence or nothingness across various media: John Cage's '4'33"' on piano; Kazimir Malevich's painting 'White on White'; Don Paterson's poem 'On Going to Meet a Zen Master in the Kyushu Mountains and Not Finding Him', to name only a few. This minimalist mode of art attempts to passively resist interpretation by *saying without saying*. The art satisfies the desire to express and communicate oneself when the intended meaning must be censored in accordance with the (quasi-)parental authority that stipulates that they should not say anything at all. Displeasure therefore has to be inferred from the expressive act in much the same way that we infer an imminent visitor when the dog starts barking at the window. The bark itself is not suggestive *of anything*; yet, upon hearing it, we infer that it must be suggestive of *something*. It is upon this principle that artistic communication without language or signifiers is based.

The problem, however, can be read through Walter Benjamin: '[i]n every case the storyteller is a man who has counsel for his readers. [...] we have no counsel either for ourselves or for others. After all, counsel is less an answer to a question than a proposal concerning the continuation of a story which is just unfolding'.[27]

Works of art are not only inviting of criticism but are critical acts in themselves. Counsel, which Benjamin later goes on to call 'wisdom' and 'truth', is completely absent from these silent works of art. Consequently, art's obedience to a censoring authority imbues passive traits within its readers, viewers, and listeners. Where there is no story, there is also no counsel: that is, where the art does not contain any proposals regarding the human experience or the politics of civilisation, the art misses its purpose of inspiring criticism of dominant ideologies and cultural hegemony.

It is a shame, then, that when given an opportunity to freely articulate or express oneself or challenge some element of the status quo, make clear that which is obscure, alienate those who are content or indifferent, some artists choose to be silent. When given a space to utilise a voice which millions throughout history and across the world today have been denied, is it not at best a waste, or at worst, an insult not to speak for those who cannot speak for themselves? Some may say that this misses the point of modern art and that silence is sometimes far more radical than speaking out; however, in times when one has nothing nice to say it is that person's responsibility to say something, anything at all.

9. On Art and Disobedience; Or, What is an Intervention? *The Knight's Move from* Guernica *to Social Space*

'It is more than a painting, it is a manifesto in art' Alan Woods says of Pablo Picasso's *Guernica,* a stark commemoration of those who fell victim to the bombing of that Spanish town by the Nazis in April 1937.[28] As Theodor Adorno had before him, Slavoj Žižek—in his book *Violence*—recounts a 'well-known anecdote [about] a German officer [who] visited Picasso in his Paris studio during the Second World War. There he saw *Guernica* and, shocked at the modernist 'chaos' of the painting, asked Picasso: 'Did you do this?' Picasso calmly replied: 'No, *you* did this!''[29] Here the notion of intervention will be explored as a form of 'artistic manifesto', by theorising Picasso's response in the above anecdote in relation to the centrality of the knight's move, in chess, to the thought of the Russian art critic, Viktor Shklovsky.

The knight 'moves in an L-shaped manner', Shklovsky explains, going on to claim that 'there are many reasons for the strangeness of the knight's move, the main one being the conventionality of art, [...] The second reason lies in the fact that the knight is not free—it moves in an L-shaped manner because it is forbidden to take the straight road.'[30] It is, then, the 'conventionality' of art to circumvent, to circumvent in the manner of this chess piece's determined and determinate manoeuvre. By extension, art's disobedience *is* its very conventionality.

According to Shklovsky, art's conventional—that is, *only*—move is the L-shaped one. Thus, by responding to the German officer as Picasso is said to have, he made this very move, circumventing the disgust of the officer at the painting by alter-reflexively demonstrating where that disgust comes from: the ravages of war and its perpetrators, and the *real* of the destruction wrought by them. Indeed, it might briefly be worth

locating the mechanisms of this reply in the schema of the three orders as set out by Lacan; those of the Real, the Symbolic, and the Imaginary. Picasso's symbolic response to the *real* of the devastation of the Guernica bombing demonstrates its very effectiveness through the officer's reaction to it, which, to an extent, enacts the procedure of the imaginary; that is, of a connection and disconnection *at once*: the formation of an 'armor of an alienating identity' as it's labelled in Lacan's presentation on 'The Mirror Stage'.[31] The registration of disgust at the painting's 'chaos' by the officer is here a twofold one, betraying not just a revulsion at the painting's *depiction* (in a passive sense), but at *what* it depicts, to which, for that soldier, there would always already be an ineludible connection, a situation of himself 'in the picture as stain' in Lacan's words of Seminar XI.[32] Picasso's confirmation of this in his rejoinder to the officer is what forces their discourse surrounding *Guernica* to take the knight's path, by setting it in motion, around the real, via the symbolic, to arrive at a recognition of the imaginary element that ostensibly separated that chaos from its purveyor (although it was in fact linked all along; a fact, however, which was able to go unacknowledged until the staging of this L-shaped intervention).

What art's disobedient conventionality—Shklovsky's knight's move—seems to bring about, then, is the beginning of a 'creation, through destruction, of a positive social void, the refusal of the dominant organization of social space', as Kristen Ross describes it in her book on Arthur Rimbaud and the Paris Commune.[33] As Shklovsky himself puts it: 'all the great architects were destroyers.'[34] It is thus the determined procedure of the knight's move to also stage that which it travels around; a certain *objet petit a*, the square on the chessboard in front of it which it cannot move to, but must skirt: it creates, then, through the destruction of the straight line, this strange yet provocative—*necessitous*—path.

As in the case of Picasso's *Guernica* discussed here, art not only

takes the knight's move itself, but forces others to, around it: such is the logic of intervention. The tents of the Occupy campaigns in central squares of major cities around the world ensured a demonstration of this very logic by intervening in the dominant straight lines of social space and forcing note to be taken by passers-by by forcing the knight's move itself to be taken by them; both through simply having to walk around the space, and even, if moved to, through joining it: the straight lines are circumvented. There is, in this knight's move of intervention, both a resistance and a compulsion: a compulsion *to* resist; to resist pre-set, ideologically complacent straight lines, an injunction to realise our pre-critical state, through a defamiliarisation of the *straightened* territory (revealing of its *straitened* underpinnings), and 'to travel beyond its own bounds' in an act of deterritorialisation. Terry Eagleton, in his foreword to Ross's *The Emergence of Social Space*, describes this deterritorialisation as an operation inherent to language itself, and locates the intervening place of art as that around which revolution revolves, in a motion peculiarly analogous to the staging of the *objet a* in the knight's move:

> Like language, every revolution tends to travel beyond its own bounds. It is hard to dismantle particular social institutions without dreaming for a moment of what it might be like to be liberated from institutionality altogether. At its finest, the anarchist tradition has always signified the "revolution within the revolution," marking out what remains to be done, what fantasies and desires still go hungry, when certain urgently necessary political changes have been installed. It has been left, on the whole, to the poets of revolutions to remind the politicians that the only finally adequate transformation would be one of the flesh itself.[35]

It is here that the poet must always remind the politician that

there is still (and will always be) work to be done. In the location of the artistic manifesto in this point of intervention we see it setting in motion the discourses that must move around it: the *objet d'art* becomes the *objet a*; an object-cause which launches and ensures the continuation of centrifugal oscillation around it, opening up those spaces, social and discursive, around which L-shaped and oscillative movements occur and recur. It is perhaps due to this knight's move, constitutive and exemplary of the movement of intervention, that Michel Foucault gains the pertinent insight into what writing, art, the staging of discourse, of theory, history, of an enunciative practice in the wake of a certain concept of the author function, might be; that is, the 'prepar[ation] – with a rather shaky hand – [of] a labyrinth into which I can venture, in which I can move my discourse, opening up underground passages, forcing it to go far from itself, finding overhangs that reduce and deform its itinerary, in which I can lose myself and appear at last to eyes that I will never have to meet again'; the move which allowed him to demand, in a voice in which art and politics are one: 'do not ask who I am and do not ask me to remain the same: leave it to our bureaucrats and our police to see that our papers are in order. At least spare us their morality when we write.'[36] This risk, of 'submit[ting one]self to the criticisms of an obtuse middle class which entrust[s] its morality to policemen and its fine arts to impresarios', is that which James Joyce had noted in 1914.[37] It is the intervention, however, at once artistic, social, and political, that will circumvent these straight, regulative lines—so instituted and formalised—into which can and have slipped forms of domination that have calcified into regularities, banalities and institutions of oppression, decadence and evil, complacency and ideological saturation. Long may the logic of intervention never cease to do its work.

Books, Literature, and Reading

10. A Note on Feeling an Affinity with What You're Reading

We like to feel a connection with what we read. But can it be dangerous to be made to feel that you share something with the voice you're listening to? Of course, when we're addressed in the second person, we know we're being asked to agree. It's something even *Everyday Analysis* has been guilty of, but in fact it can be when this type of analysis is at its best; when it asks you to think again about something you've often felt.

But what about telling you how you've often felt? Or, if you really have felt the same way as the writer; what has already happened (to both reader and writer) in order for this to be so?

A language of 'we feel this way, and so…', no matter how radical the 'and so…' may be, commits a kind of reactionary crime. In assuming a feeling is sufficient ground from which to start a discussion we not only exclude and/or pass judgement on those who haven't felt that way, making what follows only relevant to a few, but we also participate in creating a sense of a 'human condition'—an assumption of shared feeling—which perhaps shows only our desire to naturalise the responses and instincts of our class and culture.

11. Ian McEwan and Intentional Fallacy

In their 1946 essay, 'The Intentional Fallacy', W. K. Wimsatt Jr. and M. C. Beardsley argue that a 'poem is not the critic's own and not the author's (it is detached from the author at birth and goes about the world beyond his power to intend about it or control it). The poem belongs to the public. It is embodied in language, the peculiar possession of the public, and it is about the human being, an object of public knowledge.'[38] Their sentiments can too count for any work of art beyond the poem—in literature, music, film, photography, painting, etc.—any cultural artefact in fact; even for *characters*, who are the creations not only of writers and artists, but of myths and traditions in storytelling and popular imaginations.

Like so many re-imaginings and re-presentations of the tales of Robin Hood or Odysseus, an author's charactorial creation must remain open to interpretation, otherwise it will become enchained in, and enslaved to, the non-dialectically restrictive *intentionality* of the author, so Wimsatt and Beardsley argue; an ensnarement and enslavement in rather bad faith, as—if taken to its extreme—it can become an attempt to close off the process of *reading* itself, precisely as an *interactive* process. To Wimsatt and Beardsley—whilst of course conceding the necessary zero-level ground to authorial intention (a work is after all composed by a *one* and not an *other*)—it mustn't matter what an author's *sole intention* behind specifics in the text is; as they eloquently put it: 'critical inquiries are not settled by consulting the oracle.'[39] This has of course been realised too by so many writers; James Joyce, for example, said of his own work: 'though people may read more into *Ulysses* than I ever intended, who's to say that they are wrong: do any of us know what we are creating?'[40]

So, what might be the consequences of an authorial reassertion of intentionality? Ian McEwan has talked of the

seemingly surreal experience of helping his son Greg with an A-level essay centred on his own novel *Enduring Love*, which was his son's class's set text.[41] The essay was apparently returned with 'a very low mark' after McEwan had given his son some 'key points' to assist with it (though Greg himself has said he received a by no means failing 'low B').[42] Whilst this makes for an amusing anecdote, which could nonetheless serve to highlight issues with the marking systems and criteria used in the assessment of Key Stages 4 and 5, which are based, as McEwan says, on 'the presentation of ideas, not the ideas themselves'—i.e. 'assessment objectives', etc., which can serve as so many tick-boxes to pass or fail young thinkers by—it is into McEwan's following statement that a further inquiry might be merited: 'I think one of his tutors thought that the stalker in *Enduring Love* carried the authorial moral centre of the novel, whereas I thought he was a complete madman.'[43]

Here McEwan makes an assertion on the character of Jed Parry that condemns him simply to 'madness', seemingly without allowing any other interpretations. Whilst McEwan does implicitly critique the notion of authorial intention itself (the A-level tutor is made out to assert that their opinion on what is the 'moral centre of the novel' is the correct one), and offers his own intention/interpretation with a hesitating, and therefore only suggestive, 'whereas I thought...', we are nonetheless met with a certain prescription here that disallows to an extent not only the act of literary criticism itself, but of its opening-out into so many other areas of cultural study and psychological penetration.

From personal A-level experience of interacting with *Enduring Love* (in being the same age as McEwan's son), much is made in lessons of Jed Parry's relation to erotomania, or de Clerambault's syndrome (as elucidated in McEwan's phoney appendix to the book), which at least brings some perspective on madness, and mental health issues, into relief (in part, of course, on the part of the author himself).[44] What the danger of such a dismissal of

Parry as 'complete madman' risks, however, is crossing the line of the 'fine shade between [...] romantic [i.e., literary] expressions and a kind of earnest advice that authors often give', as Wimsatt and Beardsley put it; that is, of entering into a type of moralism that has the potential to shut down the process of reading itself—the book through the world, and the world through its books.[45]

12. Morrissey and Canonicity

Morrissey's first book, his own *Autobiography*, came straight out as a Penguin Classic at the end of 2013, 'a move', says *Telegraph* reviewer Neil McCormick, 'that has offended purists – something that, [h]e suspects, was always part of [Mozza']s intention.'[46] On the book's back cover there is not the normal standout quotation from its inside in orange type, but instead this statement at the end of the blurb: 'it has been said '*most pop stars have to be dead before they reach the iconic status that Morrissey has reached in his lifetime.*'' Indeed, the death of the author is one of the prerequisites that the literary canon has been criticised for; its containing a majority of 'dead white men' or 'DWEM' (dead white European males) becoming a recognised bone of contention popularly paraded as a staple in the right-on academic lecture and essay.

The canon (not only literary, but that encompassing all art; musical, performing and expressive, plastic, etc.) is a cultural compendium built on conceptions of *taste*, on *judgement*, and on *anthologisation*; one with an incredible and chequered history of debate and contention, from Immanuel Kant's philosophical accounting for aesthetics in the *Critique of Judgement* to T. S. Eliot's argument in the essay 'Tradition and the Individual Talent' that 'no poet, no artist of any art, has his complete meaning alone. His significance, his appreciation is the appreciation of his relation to the dead poets and artists. You cannot value him alone; you must set him, for contrast and comparison, among the dead.'[47]

One argument for canonicity—a *socio-historical* argument— appears in Maurice Merleau-Ponty's assertion that 'human life confronts itself from one side of the globe to the other and speaks to itself in its entirety through books and culture'.[48] In Kant there is to be found this statement's philosophical underpinning: 'only in society', he claims, 'is it *interesting* to have taste'; that is, taste is not interesting in and of itself—i.e. *a priori*—but becomes a

foundation of *society*.[49] This is thus a statement which can just as well apply to the high society and *haut couture* of the connoisseur as it can to the analytical and activist fields of the commentator or sociologist. Indeed, as Kant argues in the *Critique*, 'fine art [...] is a mode of representation which is intrinsically purposive, and which, although devoid of an end, has the effect of advancing the culture of the mental powers in the interests of social communication.'[50] In itself 'purposive without purpose' (as Alenka Zupančič describes Kant's formulation), art's cathexis hooks onto the world—as utilisable in shaping and critiquing it—through its aesthetico-cultural import.[51]

But when it comes to *canonising* this art it is *judgement* (that is, most often, the hierarchical privileging of *a certain* judgement over any other) that determines things; and in his *Autobiography* it is judgement and jurisprudence that Morrissey exerts his most virulent polemical energy on. In commenting on the trial of Oscar Wilde, he asks:

> How does British society identify wayward judges? It doesn't, because it isn't allowed to. Identification can only be made by yet another judge, who is unlikely to point the finger at a colleague lest suspicion is returned from whence it came. When is a judge ever asked to account for his own words? Never. Barbarity might mount upon barbarity, but the British public has no legal right to question a judge on the grounds of bias – not even in a democratic society. But what if a judge *could* be proven to have been biased? One would need to convince another judge of this first, and no judge would ever be prepared to blow that particular whistle. If one fell, they'd all fall.[52]

This precedes and foreshadows the somewhat laborious forty or so pages concentrated on the court case brought against Morrissey by former Smith Mike Joyce, presided over by the not

so right-on-erable judge John Weeks, and Morrissey's long-held resentment over it all. However, these reflections of Morrissey's show that whilst the *Autobiography* may present an alternative to the identikit, ghost-written autobiographies of 'the pap of pop' (in Mozza's words)—which highlights the *classic*'s modern status as the *alternative*; that is, to the best-selling, eminently pulpable mainstream—what also becomes apparent as at stake in this book instantly published as a Classic, and which contains such an internal critique of judgement, is the process of canonisation's immanent subversion.[53] In other words, through not allowing the public even to have the chance to deem the book classic or not Morrissey and Penguin may seem to be acting as an *Eliot-the-Great-Editor* guarding the door to Faber and Faber and admitting only the *crème de la crème*, but mightn't the movement rather be one of re-emphasising the public's role in deeming classical status; of challenging our conceptions of canonicity, who may be admitted, and when; of raising publicly and critically the very question of judgement (inviting 'the pointed fingers'); and renewing the importance of the canon, and its critique, in a time when it has stagnated, not only through the Classic losing its public popularity, but also *under the purist's gaze*?

13. Reading Childishly: *A Case Study*

The Octonauts is a BBC children's television program in which a group of anthropomorphised animals undertake adventures as deep-sea explorers. In one episode, Peso the Penguin is required to investigate an area of ocean known to be the habitat of a 'vampire squid'. Hearing the frightening name of the creature, Peso initially fantasises about a terrifying Dracula-like monster, but this fear is put to rest when what Peso actually encounters is a cute and unthreatening little animal, who is far more nervous of the explorers than they are of him. The lesson, we suppose, is that our fearful anticipations are often unwarranted, those we

think are out to get us have anxieties of their own, and names, language, and reputations are not always to be taken 'literally'.

But at the heart of the experience of children's shows like *The Octonauts* is a disjunction between the secure and well-meaning life lessons they are intended to impart, and the more unpredictable ways in which they tend to be experienced by their target audience. Like the mathematician imagined by David Hume who reads *The Aeneid* only for its tracing of the geography of the Mediterranean, or the neurologist Oliver Sacks' brain-damaged patient who could recount the plot of *Anna Karenina* without having any recollection of its characters, children are apt to put emphasis in surprising places in their reading. A minor character, an incident in flashback or a misunderstood figure of speech can be far more stimulating to a child than the advance of plot or the protagonists who solicit their identification. But why should this be?

Take the example of one particular five-year-old watching the 'Vampire Squid' episode of *The Octonauts*. During Peso's horrible fantasy of what the vampire squid might be like, the child is blithely indifferent to what he sees on the screen. As Peso begins his undersea journey and the anticipation of the squid's actual appearance builds, the child starts to become agitated. Finally, in what is intended to be the bathetic moment when the unremarkable little squid is revealed, the child in fact becomes truly frightened. This child's investment, then, is a precise reversal of the intended rhythm of the episode. Instead of focusing on the reassuring movement from 'scary' to 'harmless', the child foregrounds the movement from 'not there' to 'there'. The scene that is supposed to be frightening is treated with indifference because Peso is 'just imagining' it, while the intended reassuring surprise that the actual squid is rather cute is far less important to the child than the fact that the anticipated object of horror has arrived at all.

When an adult in the room tries to reassure the child that the

squid has turned out to be 'just a silly octopus', he vehemently denies this, crying 'No! It's the vampire squid!'. It is as if the fear inscribed in the name is more important than what is seen on the screen. While the child has little idea what the word 'vampire' means, it has become specially invested in as an object of fear in its own right. The theme of the object that does not live up to the seriousness of the name is a relatively common one in comedy. Peter Cook's grave priest in *The Princess Bride* who opens his mouth to reveal an absurdly squeaky voice, or the former lover Diane Keaton builds up as a kind of Casanova figure but who turns out to be a squat, balding geek in Woody Allen's *Manhattan*, are two cases in point. But it would be patronising to say that in our case the five-year-old has simply failed to 'get' the joke.

In fact what is dramatised in this scene of childish reading is what we might call the Oedipal relation to the signifier. According to Lacan, what Freud had called 'the dissolution of the Oedipus complex' has less to do with the old psychoanalytic idea of a literal waning of the child's aggressive fear of punishment for his or her incestuous fantasies, than with an unconscious acceptance of the metaphorical 'name-of-the-father': the anchoring signifier at the centre of a person's relationship to language. For Lacan, the outcome of failing to undertake this anchorage in adulthood may be paranoia, which means anxiously attaching too much significance to every little thing that gets said; or schizophrenia, which means being incapable of distinguishing between figures of speech, irony and multiple meanings of words. Accepting the fixing power of language is what allows most adults to adopt an easy-going distance towards it, whereas these psychotics in whom the anchoring signifier has failed are doomed to indiscriminately assume meaning to be everywhere.

The same is true for a young child in whom the socialising strictures of language have not yet been fully instilled. This is

why such children will often veer from taking transgressive pleasure in nonsense songs, to insisting that a favourite story be retold with no single detail out of place, or that completely peripheral parts of their daily routine must be followed to the letter. Like adult psychotics, they are unsure where the emphasis of meaning is to be placed. It is also what has happened for our child who is insisting on the frightfulness of the vampire squid simply on account of its name. While shows like *The Octonauts* work hard to introduce sound lessons for young audiences, they can never quite predict what unexpected part of their discourse the Oedipal child is liable to 'take literally' in this way.

Art by Joseph P. Kelly.

14. Is God Dead in *Harry Potter*?

There is no good and evil; there is only power and those too weak to seek it.

The average philosophy student could be forgiven for attributing these words to the incendiary philosopher and author of *Beyond Good and Evil*, Friedrich Wilhelm Nietzsche. They may not guess the quotation's true orator: a hammed-up CGI sorcerer from a children's fantasy series.

'God is dead' is Nietzsche's most famous assertion, yet his work makes greater claims than announcing the death of a specifically modern God; Nietzsche claims there are no universal moral facts, only interpretations. Armed with, yet burdened by this new understanding, humanity must fight the absurdity and nihilism that results from loss of moral and religious 'truths'. Instead, we must strive towards a new life of courage, free thought and power. Needless to say, the firebrand who heralded the end of morality and described the Church as a filthy, parasitic institution was not welcomed by the Christian majority of his day. Nietzsche's madman is laughed out of the marketplace and the philosopher resigned himself to the notion that 'some are born posthumously.'

Contemporary Christian reactions to the *Harry Potter* series have been varied, but while many find strong examples of compassion, pity and self-sacrifice, it is clear that others feel threatened by the very notion of witchcraft and wizardry for children. This anxiety was caricatured through *The Simpsons'* Ned Flanders, who reads to his son that, 'Harry Potter and all his wizard friends went straight to hell for practicing witchcraft!' before tossing the book into the fireplace. In addition to very real fears about the corrupting influence of supernatural powers (or rather non-Christian supernatural powers) many simply ask

where is God (generally the Christian God) in these stories? Applying this kind of literalist question to a series of fantasy novels is similar to asking whether it's *really* possible to reanimate a corpse or if pigs could *really* manage a successful agricultural enterprise. Behind this simplistic questioning of God's 'absence' in the *Harry Potter* series, there is a more fundamental, less widely discussed issue. It relates to the sickly wanderer burdened by terrifying moral freedom, quoted above; that is, Lord Voldemort.

In the final confrontation of *Harry Potter and the Philosopher's Stone*, Voldemort offers to take Harry beyond good and evil. What makes his suggestion terrifying is not that it is spoken by a contorting face on the back of another's head, but that it suggests both to Harry and audiences that our morality is not universally true, but contingent and constructed. Interestingly, Harry does not interrupt Voldemort during his monologue on morality or attempt to escape with the stone. Instead, he removes the object so keenly sought by the Dark Lord, and brings it into full view. Harry's consideration of Voldemort's thrilling notion wavers, however. He retreats to the traditional codes of right and wrong, and, somewhat petulantly, tells Voldemort he is 'a liar' — although interestingly not that he is wrong.

When Nietzsche announced that God was dead he didn't mean that the old man upstairs had shuffled off and could be simply replaced with another set of transcendent values. Instead, humanity must face a new ethical existence without foundational concepts like good and evil. In this sense, it is clear that 'God' is alive and well in Harry Potter. Like Nietzsche's madman, Voldemort has come 'too early'.

When the dark wizard tries to take the stone by force, the mere touch of Harry's fingers causes him to disintegrate. In this way, the film condones Harry's return to the fold; the existence and essential opposition of good and evil is proven with potent physicality. Harry's powerful touch can be read, not only as a

convenient narrative device, but as projection. The need to so explicitly demonstrate the reality of evil and good betrays a fear that the process of contamination might actually work the opposite way. Perhaps the foundations of conventional morality also make it brittle and, if exposed to such dis-locating, deranging notions, such a morality might crumble away like so many flakes of wizard.

15. Reading Between the Lines of What Stays Within Them: *Genre Fiction, Normality, and Analysis of Structure*

Oscar Wilde said that 'nature imitates art', as opposed to the other way round. It is through such a statement that we might be able to investigate the phenomenon of *genre fiction*—in so many areas of culture—and its consequences. Broaching the subject invites fire from two camps, that bivouac on either side of such popular cultural manifestations: those whose very orientation comes from fidelity to such a genre (from those involved in the fantasy worlds of *Twilight, World of Warcraft* and *Warhammer,* certain types of metal in music, to romantics besotted with Mills and Boon novels, 'trekkies', *X Files* conspiracy theorists, *Game of Thrones* cosplayers, etc.), and those who are fascinated by these cultural instances, and read, watch, or interact with them in the name of a certain—supposedly disinterested—*analysis*; 'isn't it something to wonder at why Harry Potter is so popular; what is it about him, his story, that strikes people at a certain level?' 'Why is it that these *memes* do so well?'

A *structural* analysis, however, must exempt itself from the second attitude in order to show that its operation is in fact the same as the first, just at an ostensible remove. It is the mode of inquiry in the second stance that in fact produces its concept of a *mythos*. 'What is it that *speaks* to us in these stories?' and 'what is the *common cultural trait* that these fictions tap into?': these questions presuppose *that which speaks*, and its *common cultural traits*, imposing them on the cultural manifestation, as *a natural fact*, rather than reading them against a *structure* (e.g. our socio-historic *situation*). In other words, the stance both takes popularity as secondary, rather than primary—then tries to locate its cause in some shared primary 'common ground' (a popular *trait* common to all manifestations of popular culture, and thus

the same in all of them)—and it sees this popularity as completely autonomous and self-sufficient: *it must have sprang up all of its own accord; Because the* Harry Potter *series was written it became so famous and popular.* Other factors—of promotion, syndication, affiliation i.e. *ideology*—are left out. To put it in *X Files*-speak—despite adhering to structuralism, this contributor nevertheless *is* an *X-phile*—this mode of inquiry *wants to believe.*

To critique this attitude on these terms, however, is in no way to denigrate cultural studies, nor is it to dismiss such cultural products as unworthy of study. What is important to look out for *structurally*, however, is what *discourses* arise and are maintained in particular cultural trends. To take the mass appeal of Robin Thicke and of *Breaking Bad*, say, as two representatives merely *of popularity*—that is, of both containing something that is in itself intrinsically *popular*—is to miss what cultural themes and values are in fact being propounded, and propagated, by each (to say nothing of these themselves).

To an extent, this represents the respective difference in the psychoanalytic theories of Sigmund Freud and Carl Jung. In Freudian analysis, a subject's discourse is matched against their given history (their socio-historic situation) in order to provide insight into their unconscious (as constituted by the structure of their life). In Jungian theory, the unconscious accords to a series of archetypes, which are always pre-existing and, therefore, imbued with all the (pseudo-)significance of religious ikons. This latter method leads, in regard to genre fiction, to a postulation of an *absolute normality*: the *absolutely generic* (a concept that art proper resists); that is, to Jung's idea of the 'collective unconscious/consciousness', from which everything feeds. But as Adorno warns, in terms of its relation to the class struggle:

The notion of collective consciousness was invented only to divert attention from true objectivity and its correlate, alienated subjectivity. It is up to us to polarize and dissolve

this 'consciousness' dialectically between society and singularities, and not to galvanize it as an imagistic correlate of the commodity character. It should be clear and sufficient warning that in a dreaming collective no differences remain between classes.[54]

In terms of the hierarchy of *normality*, and its relation to art, then; against the Jungian method should be erected the argument that, while of course there are things that are normal, they should nonetheless not be taken as so for that reason alone. In other words, in *normality* there is a keen tendency towards tautology; that is, posing that things are normal *because* they are normal. Normality, *genre fiction*, accord, then, to a *structure* (Mills and Boon are [mythically] purported to send out writing templates to their prospective writers, according to the testimony of one of their writers, for example)—a structure that will struggle to maintain itself at all costs, and that must be examined to determine to what (ideology) it is in the service. But their development, or even overcoming, can only be envisioned by recognising that they are not in fact Platonic forms, but are rather changeable manifestations determined by our own modes of interaction with them.

To extend Wilde, our nature must not rest on imitating art, but create new art (which nature will no doubt imitate). In our analyses—as the warnings in the work of Roland Barthes and Louis Althusser attest—we must always be wary of any *common opinion*, any '*common sense*', any postulation of *the natural*; in a word, any *genericism*, that comes *at the expense of thought*.

Dating, Relationships, Sex, and Love

16. *Soft Focus*: How Dating Websites Subvert the Romantic Ideal

An advert appears on the television at 1a.m. for a website called onelastfling.com. Soft focus, monochrome images of couples entwined, dance around the screen; the narrator dribbles something about 'discreet relationships' with 'like-minded people'. No mention of commitment, or marriage, of finding 'The One'. This shifting ideal, of non-commitment, of transience, is an interesting aspect of postmodern society. It has come to promote an (anti-)ideology in which we are encouraged to explore our own desires in contrast to any moralistic mores we may have previously upheld.

In 2013 we have seen figures of childless women at their highest since 1920, the year of the post-war population dip; simultaneously, more people than ever are using dating websites such as 'Plenty of Fish' and 'Ok Cupid', the latter of which openly markets itself as 'The Google of online dating'. What does this imply? *Alea iacta est:* just as we use Google to both educate and pleasure ourselves, we are now using it to make our major lifestyle choices.

If you are of a certain age, and happen to bring up dating websites in a social situation, you will usually find one other person has had first-hand experience, or at least knows a friend who has used a dating website. Friends speak of the dates they have been on; one speaks of a guy who she was seriously dating for a couple of months, though at a fair distance. One day he flat-out stopped responding to her communications, and she hasn't bothered to enquire further. She simply assumed he had found someone new. This isn't a slight on men; male friends have spoken about women who will happily swap kinky messages (or as they have come to be known, 'sexts') but will scarper at the opportunity to date IRL; it seems they would rather experience

the 'other' from the safety of their home.

There are aspects of internet dating which directly, and tragically, oppose one another. The first is this problematic ideal of there being one person in existence who is meant to be with you: 'The One'. From a female perspective, it is a phrase oft-quoted in the media, from the moment we start reading books, right through to soppy romantic comedies. It is a (frankly ridiculous) fictional ideal that has grown beyond proportion. It is surely scientifically impossible that out of the billions of people in this world, two people are inextricably destined to be together. Nina Power eloquently references this problem in her *One-Dimensional Woman*:

> What does this obsession with 'the one' mean? [...] The 'one' as the transcendent culmination of an entire romantic destiny demonstrates a curious mélange of the sentimental ('we were always meant to be together!') and the cynical (if there's a 'one' then the 'non-ones' don't count[).] This strange mix of sentimentality and pragmatism – ideology, if ever there was a definition – reproduces itself seemingly spontaneously, in culture and conversation.[55]

The other aspect is choice. Reams and reams of choice. Thousands, perhaps millions, of attractive men and women linger in this online realm, who are just perhaps a click away, and could feature in your life somehow; perhaps for the long term, though more likely for the short term. Although dating websites suggest they are designed to promote the romantic ideal of partnership, of commitment, in fact all of them actively promote the opposite. The option is there to re-instate your profile at any time, browse anonymously, send a quick IM. Some even send congratulatory messages when you receive a certain amount of good ratings. This surely proposes some kind of transitory state in which nothing (or no-one) is ever really good enough.

To find the foundations for this current promotion of surplus desire, we can look back to third wave feminism. In the 1990s women happily shopped and fucked, all the while looking fabulous. Brilliantly, feminism was sold by the media to the masses through the Spice Girls and programmes like *Sex and the City*. Women in advertising campaigns were depicted wolf-whistling men, wearing power suits, drinking Diet Coke. At its most confused, we were cheering on Carrie Bradshaw for cheating on her boyfriend and frequently indulging in something that was referred to as 'retail therapy'. Women realised they could get what they wanted, and more.

In his essay 'The Implosion of Meaning in the Media', Jean Baudrillard discusses how the over-consumption of media would effectively result in the implosion of the social. The process of socialisation that occurs as a result of the consumption of information, which should result in 'an excess of wealth and social purpose', actually results in the inverse: 'rather than creating communication, it exhausts itself in the act of staging communication. Rather than producing meaning, it exhausts itself in the staging of meaning.'[56]

We can apply this hypothesis to internet networking. By placing ourselves within the online social spectrum, in this case dating websites, we intend to socialise ourselves by joining the masses; swimming through this giant ocean with plenty of other 'fish'. But the very nature of the internet surely destroys the meaning behind our intentions. In the act of scrolling, opening up different profiles and closing them when you realise they're into something weird like 'Lindy-hopping', any sense of our own individuality is lost when another is presented with our information alongside a whole host of other potential datees, perhaps with taglines underneath them suggesting that we are 'more adventurous!' or 'more kinky!' than the profile you're currently viewing.

Likewise your online libidinal stratification is encouraged to

tend to all moods you might find yourself in. We don't always necessarily want the 'girl next door' type. Maybe it would be interesting to go on a date with that weird guy who likes Lindy-hopping.

Perhaps the process of elimination deployed when browsing internet sites has leaked into the real: the time we spend arbitrarily clicking through profiles, to meeting someone, to forging a 'relationship' and, finally, to said relationship ending. Only for the process to begin again.

17. Getting Google's Approval

Pornography is abundant. For most of the Western world, it has never been easier to access explicit material to satisfy almost any desire. From an era in which (generally male) adolescents got their titillation from stolen glances of page 3 or Channel 5's humble offerings of softcore erotica, there is now Wi-Fi, and with it, instant access to an immense range of entirely free pornography.

To find their pornography, many, if not most, will rely on their trusty (and when necessary, discrete) search engine: Google. The user types in whatever they are into, one click and Google will whisk them away. Before the click however, during the act of keying in the desired material, an interesting thing occurs. Or rather, doesn't.

When you begin to type a word such as 'porn', in place of the usual autocomplete and drop-down bar full of suggestions, the search engine offers only blankness. After the click the searcher will of course be presented with their material and Google will perform its standard duties of sifting, ranking and compiling the information into an easy-to-navigate list. Before, however, Google keeps its usually loquacious mouth shut and will do so even while 'incognito mode'—or 'private browsing'—is active.

Put plainly, Google will help satisfy sexual desires, but it won't acknowledge that it is doing so. It will assist access to almost any explicit material wanted and organise it in the same way it would DVDs or fishing equipment, but it will feign complete ignorance until the moment the searcher confirms their desires. Like the clichéd cop uttering 'nothing to see here, folks', this conspicuous nothing marks a something, the absence marks a presence.

Derrida's notion of the *trace* emphasises the absences that make the sign's apparent presence possible. All language,

according to Derrida, depends upon and contains traces of what it is not for its signification. The 'full-presence' or 'pure-presence' of signs is thus an illusion, albeit a helpful one that allows us to put language to use and avoid endless searches for meanings that are constantly 'deferred'. In the case of Google, however, the self-imposed absence is so glaring that it screams out confirmation of the presence it refuses to acknowledge.

Is there not also something pornographic in the logic of this omission? In the hackneyed, yet nonetheless widely reproduced porn set-up, a teacher, nurse or maid will enter the scene. Uniformed in a simulacrum of their apparent employment, they will proceed to perform the duties of their role—a bit of ineffective dusting or threatening classroom discipline—and create a display of bad faith that would make Jean-Paul Sartre nauseous. These actions will be extremely provocative, but performed in all apparent innocence. That is, until the moment of instigation or confirmation, when all pretences and continuities of character are thrown off as easily as the maid's 'regulation' pinafore. This tried-and-true pornographic formula and Google's policy of omission thus essentially partake in the same logic: *Yes, I will enable your desires but I will not acknowledge initially that I am doing so.*

What emerges from this analysis? Only that Google is attempting to have its cake and eat it too, but doing a very poor job. With the intention of adding a veneer of decency, the corporate powerhouse feigns ignorance towards one of its most utilised services and, in doing so, reproduces the logic of the thing it barely manages to censor. This is less of a campaign to get Google to drop their self-enforced silence and more of an attempt to point out the ridiculousness of trying to hide erections behind fig leaves.

18. An Archive of Your Ex

Pop music has a longstanding interest in the same way that traces of our former lovers remain stubbornly associated with places and material objects long after an affair is over. The jazz standards 'I'll Be Seeing You' and 'These Foolish Things', Bacharach and David's 'Always Something There to Remind Me,' and Paul McCartney's 'Junk' all adopt the form of a catalogue of such remnants of the ex. But what would it mean to write a song like this in the age of interconnected social media platforms? In his great study of Freud, *Archive Fever*, Derrida wonders what form psychoanalysis would have taken if its main innovators in the early twentieth century had had access to email. The development of ideas between Freud and his colleagues was so conditioned by the kind of gradual, considered argument imposed by traditional letter-writing, that recasting those debates within the instantaneous and ephemeral form of electronic messaging would have produced an unrecognisably different discipline. Similarly, whereas the old pop songs map the involuntary feelings brought up by 'all the old familiar places', or 'a cigarette that's stained with lipstick traces', our past lovers today are more

chaotically inscribed within the technologies we have increasingly allowed to condition our private lives.

Predictive text takes a chance on his name when you type its first letter, and his address appears when you do the same in your email address bar. Her face, with profile linked, appears in the photographs of Facebook acquaintances. Soundcloud, having logged how often you used to listen to his band, invites Spotify to have you do so again. Her enthusiasm for Korean animation is forever reflected in your Netflix and Amazon recommendations. And Twitter, after observing how 'similar to you' his friends and family are, retweets his tiring missives into your feed. Platforms designed to seamlessly flatter our interests based on how we have used them in the past come up against a limit at the end of a relationship. At this point, they start behaving like Mr Krook, the mad keeper of legal documents in Charles Dickens's *Bleak House*, who, though illiterate, keeps unwittingly throwing up old secrets by randomly transcribing passages from memory on his walls. We tend to think of archives as neutral receptacles, reliably compiling and compartmentalising information. Yet the traces of our life in the digital archive are obviously rather more difficult to manage or even to predict. For Derrida, this is the maladroit and potentially malignant form that archival processes always take: the idiom in Derrida's French title, *Mal d'Archive* suggests both a destructive sickness in the archive's relationship to what it stores, and our own crazy passion that it should store more and more. If there is a difference between the ghosts emerging from memories in old pop songs and those that emerge from our electronic devices, perhaps it is that the ones on our screen are even more persistent because someone is trying to sell them to us. When, in its misguided obsequiousness, the digital archive serves up the ex, this is uncomfortable for more than emotional reasons: it shows that we've hired out our unconscious.

Art by Kirsty Harris.

Digital Culture

19. Social Media Image-Crafting and Hyper-Analysis

Somewhat strangely, social media seems to have come under a renewed bout of criticism recently. The focus for such criticism has been what social media itself is calling 'image-crafting' and 'FOMO' ('Fear Of Missing Out').[57]

It seems that the most heinous of crimes one can commit on social media is that of trying to cultivate an inflated online profile of oneself. This includes jealousy-inducing posts about one's career, relationship, etc., as well as the 'humblebrag', selective photograph tagging, making private communications public (giving off the appearance of being popular) and even posting philosophical quotes and proverbs ('look how intellectual I am!').[58] Image-crafting is practically impossible for any regular social media user to avoid.

But why this strange backlash against 'image-crafting' now? Image-crafting is not the latest hobby for a self-obsessed youth but a necessary and continuous way of life for us as socialised beings. In *The Presentation of Self in Everyday Life* Erving Goffman explicates the process we go through when we interact with one another, of performing a role for our audience which we know to be at least a partial façade; 'to the degree that the individual maintains a show before others that he himself does not believe, he can come to experience a special kind of alienation from self and a special kind of wariness of others.'[59]

Much of the appeal of social media comes from its capacity to sculpt a more impressive self and put it on public display. But what is different now is that in the realm of online hyper-reality, we find ourselves engaging in a sort of hyper-analysis of this process, in which it is as if we have already read Goffman, and know that is what we are doing, and yet somehow find another way to trick ourselves in the process.

Like Goffman's dramaturgical model, we are performing to our audience according to how we would like them to view us. We cut and we edit, deleting drunken statuses, un-tagging bad photos and profile-picturing good ones, until we have the perfect identity. But we are all aware of each other's online behaviour and interpret it according to our knowledge of social media. Every 'like' or 'share' carries with it a load of unread data which we can interpret according to the 'social reality' of the internet as we know it.

The end result is a deeply scrutinised exchange of communicative action between individuals. Unlike face-to-face interaction you can withdraw at any time by 'appearing' to go offline. During this time you can cross-check details by scrolling through old conversations, you can ask a friend for their input, you can acquire academic knowledge of conversation topics via a Google search, or you can simply analyse, perhaps unconsciously, through your own ever-developing frame of reference, before you respond.

Of course, your recipient is aware that you have the means to do this, and that they do too. So they may, in turn, deconstruct your every word and ponder your motives; they may never express them directly to you, but their inferences will shape their response. This hyper-analysis could lead to the questioning of the smallest of details, creating a constant suspicion and paranoia. Paranoia leads to more analysis and vice versa. It is this process that we want to feel that we are masters of, as if we are the one who can see through social media the clearest, judging and working out everyone else, the same drive that produces the critical articles referred to above.

What drives this backlash against those who 'image-craft' is not a sense that the guilty party is not being true to themselves (a concept we are all at least unsure of anyway) but the fact that they are acting in a way we can easily see through, and our fear that our own actions should be seen through too.

What we are left with is a new version of the 'alienation from self' and 'wariness of others' that Goffman describes. The perfect self we create is not the one we project to others but the one we imagine is capable of the highest level of analysis, seeing through all this social media jargon to the truth of things. The wariness we feel of others is not that they will see the real us beneath our profiles, but that they will notice something we haven't, making us the one guilty of something easily analysed.

20. #nomakeupselfies

In early 2014 women started posting pictures of themselves with no makeup to various social media sites, using the hashtag #nomakeupselfie. At the same time, they publicly donated money to a cancer charity via text on their mobile phones. Soon, men started to donate money, too, but as #meninmakeup. This was not an organised campaign; the text-to-donate number was pre-existing. It went 'viral', as some commentators suggested, 'organically'—the charity only started to promote the donation-spree that would earn them eight million pounds once it was well underway. Some sceptical commentators have asked what exactly the relationship between no-makeup selfies and giving money to a cancer charity is supposed to be. Others have debated whether making the connection was even ethically acceptable. But leaving these debates aside, what can the no-makeup selfie tell us about everyday life online?

The selfie is commonly considered a feminine and a sexualised phenomenon; the no-makeup selfie only accentuates that by drawing attention to the absence of makeup—or the histrionic addition of it in the men's charity version. Taking a picture of yourself on a smartphone means looking at yourself looking at yourself, in order to look as good as possible for other people. Evidently, men can do it too. This is not about women's bodies as such; it is about a cultural artifice defined as feminine, and a way of embracing that artificiality.

In this way, the selfie can be read as a privileged example of what French critical collective Tiqqun call the 'Young-Girl': the Young-Girl, according to Tiqqun, is not a concept *about* female teenagers but one *derived* from their situation.[60] Under traditional capitalism, young girls produce nothing, but must both consume products and turn themselves into sexualised objects for consumption. Today, we have arrived at a point where everyone constantly turns themselves into a product for consumption— social, sexual, at work—and prominently so via visual media. For Tiqqun, everyone has become Young-Girlified—even the Pope. David Cameron, we can say, with his policy of never refusing to take a selfie with a passer-by if asked to, is Britain's first Young-Girl Prime Minister.

But self-commodification is hardly a new phenomenon. In Ben Jonson's 1609 play *Epicene*, a husband complains about his wife's spending on her face: 'all her teeth were made i' the Blackfriars, both her eyebrows i' the Strand, and her hair in Silver Street. Every part o' the town owns a piece of her.'[61] Everyone else in the play, male, female, or ambiguously gendered, will use whatever social prostheses they can muster to sell more favourably on the sexual marketplace. In Shakespeare's *King Lear*, the king bitterly quips that his daughter Cordelia's price has fallen after her filial rebellion, only to soon find himself on the heath and outside the family economy.

So what is different now? If the Young-Girl, for Tiqqun, is

what they call the *'model citizen* as redefined by consumer
society', 'a *polar figure'* that orients society's direction, then
perhaps the selfie is the model activity orienting our behaviour
in digital capitalism.[62] We are invited to take photos by smart-
phones that so easily flick their cameras around at us, to then
post them on social media platforms via convenient apps: not
only to render our bodies objects for social consumption, but in
order that we *'self-valorise'*. We post in a format that predeter-
mines, as the basic element of exchange, the collection of 'likes'
and 'favourites' to confirm the success of our digital labour,
however quirky we might think it to be. As Tiqqun note: 'each
person is called upon to relate to themselves as value, that is,
according to a central mediation of a series of controlled abstrac-

tions. The Young-Girl would thus be the being that no longer has any intimacy with herself except as value, and whose every activity, in every detail, is directed at self-valorization.'[63]

Perhaps, then, there is an uncanny pertinence in the apparently random link between no-makeup selfies and donating money. With makeup, and even more so without, we know our selfies to be the most careful, artificially mediated product of our digital labour. And the financial transaction coupled to it, charitable or not, is a reminder that we turn ourselves into a sort of money online and offline—not just because companies are selling our data, but because we are daily encouraged to look at ourselves as 'living currency'.

Art by Stef Murphy.

21. Use Your Imagination!

The above is a familiar command, which immediately conjures up the subject positions involved: the well-meaning parent and the obstinate child. But what does this injunction entail, and how

do we follow it?

Does not the fact that the statement is a command already deconstruct it, pointing to the element within it that undoes its own claim? The intention of the phrase is to allow the child to 'be itself', to act away from the distractions of modern culture (video games, television, etc.). By issuing this as a command, we see that while we like to think that imagination is something which we must 'allow' the child to have—as if it were something that culture limits but which would otherwise naturally flourish—it is in fact something we demand that they have, a commandment that they have to follow.[64]

In terms of commandments, it relates to the difference between 'Thou shalt not' and 'Thou shalt', which have long been part of discussions of the parent/child relationship in psychoanalysis. For Žižek, the prohibitive superego formulated by Freud not only says 'No!' but also 'Enjoy!', forcing the subject to obey a cultural demand to enjoy itself in the terms prescribed by culture. The point is that the two, 'do' and 'do not', are not so different. Allowing something and prohibiting it are both productive gestures; they *produce* a desire to act in relation to the law. And here we have another superego command: whether we say 'stop daydreaming' (*do not*) or 'use your imagination' (*do*), we produce a desire for something, and produce that something at the same time. In short, we command our children to have imagination, and in doing so produce both 'imagination' and a desire for it. Imagination is not spontaneous. One has to learn an imagination and how to use it, as in a remarkable Disney-style step-by-step guide to using your imagination, 'with pictures!'[65]

But what have we produced, as an object of desire, in this strange thing called imagination? What do we want to convince ourselves that our children have when we say that they have 'a great imagination'? What desire of our own are we locating in our children, and asking them to possess, which we lack?

A previous *Everyday Analysis* article has shown that the virtual

and the real are counterparts of each other.[66] It is the creation of the virtual, which allows a concept of the true reality to exist underneath—and it is this constructed 'true reality', allowed to come into being by the supplementary 'falseness', that is where ideological values are really imposed. This is part of what is in play here; it is no coincidence that when we get our children away from the games console, they go off to play imaginary games in which the most banal traditional structures are rehearsed: 'Mummies and Daddies' perhaps, or even the exchange-based 'Post Offices'. It is when we are telling them to be themselves that the figure of the parent is most dangerous, constructing and forming the child's ideology by telling them that they are being themselves when they are internalizing cultural expectations.

But while imagination functions in this way—as a tool for constructing the unconscious of children—it also has another dimension. There is always something elusive about imagination, something we do not have access to. We use it to make our children 'be themselves'—by which we mean the selves we want them to be—but we also paradoxically hold something back from ourselves, and feel alienated from our children's imaginations, as if they have something we do not have. Their imagination contains their genius, and indeed that is one of the meanings of the word (as in *A Midsummer Night's Dream*: 'And as imagination bodies forth/ The forms of things unknown, the poet's pen/ Turns them to shapes').[67] Though we control imagination, we also want to believe that there is an unknown element to it. What do we imagine that imagination is? We can only imagine.

But these are actually two sides of the same coin. We create imagination precisely as something unknown, so that it can appear to be the cause of the way our children are, their great imagination, their genius, that which is truly them; away from us and away from culture. We need to do this precisely in order to

hide from the first point, that really we are responsible for the construction of what is 'truly' them. Thus the message from our-culture-as-parent to our children is: you must be what I ask you to be, and also something beyond that, which I am able to pretend is the cause of how I asked you to be.

Art by Kat Maycock.

22. Big Data, the NSA, and Heidegger's 'Standing Reserve'

Big data is huge. In a matter of months the phrase has come from nowhere and is now a regular fixture in newspapers, in adverts and on social media. The *Guardian* continue their campaign against the National Security Agency, which needs little introduction now; the NSA have long been collecting and storing data from hundreds of millions of phone calls, internet browsing history, emails and chat services.

There are various ways in which this cultural phenomenon could be approached. One could focus on the surveillance aspect and follow Foucault, looking at the effects of an apparently centralized surveillance system, as another EDA article does.[68] To be truly Foucauldian here one would need to ask not just why we are storing Big Data, but why we so verbosely say, with so much passion and repetition (the *Guardian* included), that we store big data.

But the focus here is something different and, it is hoped, something more particular to what is in play with the NSA and Big Data discussions in the media today.

In his essay 'The Question Concerning Technology', as one of three or four important concepts developed there, Martin Heidegger argues that technology turns the world around it into a 'standing-reserve'. This concept holds the key to a particular function of Big Data.

For Heidegger, technology transforms the 'natural' world into raw materials. The Rhine, once 'a river in a landscape' becomes 'a water power supplier' as soon as the hydroelectric plant is conceived of and built.[69] What seems straightforward is a complex issue; for Heidegger there is no room for nostalgia for the 'natural' past, which would be completely impossible, because his point is that once the river has become a potential

power supply its very essence is changed; it now contains something to be harvested and yielded, as if it always-already contained that potentiality. One can never view the Rhine as they once did; its actual essence has been changed. And perhaps one can speculate about the effects of this. When we look at water and are captivated by what we see as its potential power (as explains garden water-features), perhaps our doing so is constructed by this potentiality that we think is natural but which has in fact been ordered into the water technologically.

Technology, for Heidegger, turns everything around it into this potentially useable raw material:

> Everywhere everything is ordered to stand by, to be immediately at hand, indeed to stand there just so that it may be on call for a further ordering. Whatever is ordered about in this way has its own standing. We call it the standing-reserve.[70]

Everything is ordered (both put into order and commanded) to be a raw material stood in reserve for future use in technology's development for the greater good. A huge part of this is man's attempt to dominate over the world. As Heidegger says: 'whatever stands by in the sense of standing-reserve no longer stands over against us as object'.[71] Man makes himself feel at the centre, as if the natural world appears only as potential for his use; technology makes man feel in control.

But as Heidegger knew, this is a trick, and in fact man, too, is technologized, subjected to technology. With Big Data we see this become apparent. Man has become the raw material; we are the data in standing-reserve, ordered to have use-value, to see ourselves as raw materials containing potentiality.

But we also see something else: that we don't know what this use-value is, what this Big Data is for, what this potentiality will be in the service of. We know it will be of value, and we know it will be of use, but we don't know for what use or to what ends it

will be used; we blindly and furiously store, and are stored, without certainty of what the future of this storage might be. And so we see quite clearly what Heidegger attempted to show in 1954: with technology we irreversibly transform our way of seeing the world and ourselves, but we are not in control of this process, or where it will go.

23. A Plea for Self-Expression(ism)

There is a certain neoliberal ideal involved in the notion of self-expression. The injunction—ostensibly permissive—to put pen to paper, or whatever artistic tool to whatever artistic medium, and to vent one's spleen and 'get it all out' through artistic 'catharsis' creates the ubiquitous singer-songwriter, poet and painter, bemoaning their losses and displaying their angers in front of others in the name of a supposedly ameliorative 'honesty', and 'relatableness'; these figures cut a shape in modern culture that apparently opposes itself to the flipside: the injunctions of mainstream entertainment—to go out, *enjoy* unabashedly, and to 'twerk'...

There is a risk in the 'self-expressive' manifestations of art and 'alternative' entertainment, however, to slide out of honest representation and into vindictiveness, apathy and vitriol, in the portrayal of others, for example, or of the extolling of individualistic traits and selfishnesses (see Alex Niven's *Folk Opposition* for a summary of some of these perils, in relation to the trend of 'nu-folk'). These traits may then elide the wider social and structural contextualisations and connotations, and even revert back, invertedly, to the non-communitarian ethos of the mainstream.

The art of this kind of movement of life narrativisation also becomes questionable on the point of the actual locus of production of narratives: does the narrative produce the work, or the mode of working—'self-expression'—the narrative? Lacan formulates his aesthetics of psychoanalysis—in relation to the critical concept of sublimation—on these very questions, and they are those that insist that we do not give an *ism* to the genre of self-expression, like we do, for example, to Expression*ism*.[72] Nonetheless, there remains self-expression's therapeutic aspect: as Lacan quotes Freud quoting Heinrich Heine in his first Seminar: 'illness is no doubt the final cause of the whole urge to

create. By creating, I could recover. By creating, I became healthy.'[73]

But there are perhaps other areas in which self-expressionism should be championed and have an apologia produced for it. Our modern social milieu situates us in an interstice between our social media profiles, for which image-crafting and hyper-analysis are everything, and the (prospective) working world, for which image-crafting and hyper-analysis are, in fact, also everything. The 'status anxiety' that thus goes with this maintenance of an online self has become epidemic, situating us in a strange interval between panopticism and narcissism, schizophrenia and anonymity; but it is also becoming an anxiety enforced by employers, and even *potential* employers. To put it glibly, profiles are leading to profiling, and surveillance culture is finding its breeding-ground in the virtual world (the virtuality involved in what you may post one day affecting a decision on your *employability* on another is hyper-real to the extent of Orwellianism). Electronic media has become a Repressive-Ideological State Apparatus of the Employer, to put it in Althusserian terms.

Of course, psychoanalysis stresses that the effects of an enunciation at any juncture will find realisations in future manifestations, but for this lesson to have been learned and subsequently negatively deployed by the symbolic order of the working world is a step (too far) in completely the wrong direction. This lesson is now deployed in such a way that a job can be lost due to a picture of oneself taking an alcoholic beverage appearing on Facebook (as happened to American teacher Ashley Payne, posting from the Guinness Storehouse in Dublin, no less); or that an email criticising working conditions creative of stress and excessive pressures can be quashed with charges of 'gross misconduct' (see Professor Ian Parker's ordeal at the hands of Manchester Metropolitan University last year); or even that some apprehension arises in us if we wanted just to angrily comment on, say, a four-hour unpaid interview for a

cinema job (such as encountered by this contributor earlier this year), over whether this will go to show a certain unwillingness to future employers...[74]

The question thus arises whether social media are, like our pub tables, platforms for self-expression, or not; if so, this is a simple plea that they may be so. Indeed, let CVs be CVs, and 'What's on your mind?' statuses be 'What's on your mind' statuses.

24. For Peaches

Why should a hardheaded cultural theorist, a savvy media critic, or anyone suspicious of the way popular culture constantly asks us to sympathise with the rich, nonetheless feel genuine pity at the death of Peaches Geldof? The daughter of a well-known musician, sometimes a model, sometimes a fashion columnist, and always an object of tabloid attention, Peaches Geldof's public presence belonged to the fag ends of a culture for which fame in itself—disembodied from any founding act, achievement or great 'work'—is a legitimate object of fascination. Peaches Geldof died cruelly young and, like her own mother, leaves very young children behind her. But these tropes of tragedy do not account for the nature of the feeling her death provokes, and especially for the way our intellectual resistance to mourning the loss of 'just an ordinary person' who 'we didn't even know' seems to be overcome in the face of it.

How does our response to the deaths of the 'famous for being famous' compare with those of people who are celebrated on more conventionally legitimate grounds? Hester Thrale Piozzi, the friend and frequent hostess to the eighteenth-century moralist Samuel Johnson, said that what made Johnson so simultaneously impressive and difficult to tolerate was that, whereas most of us encounter great cultural achievement in the mercifully mediated form of books, she had to put up with it in her house. Living with Johnson made her believe that books were invented not to bring greatness closer to us, but to shield us from it: and in the same place she remarks that having known Johnson's extroversion in life, she was grateful to have been spared witnessing his death. In a similar way, the 'works' of the great gently de-personalise their deaths for us. In our book, *Why Are Animals Funny?*, *Everyday Analysis* has commented on the way the deaths of certain actors can be experienced as just a

further exploit in the careers of their most famous roles.[75] We are shielded from the deaths of poets and directors by the opportunity they give to reappraise and applaud their work. Among those who did not know them personally, such deaths are marked by philosophical shrugs as we return to their records and films, or as we get older, a sense of our own encroaching mortality as we remember what certain lines, songs and scenes were to us in our youth.

There can, by contrast, be no such 'mediation-by-the-work' to shield us from the personal specificity of the death of Peaches Geldof. This is not because—to anticipate the ungenerous charge—she did not work, or produced no 'works'. On the contrary, it is because the 'works' she produced were precisely the works of her personality. We knew her mainly through her documentaries about her own life, her aspirational columns about her lifestyle, the carefully planted scandals about her wild nightlife, and—in recent years—her meticulous documenting of her domestic existence across a range of social media platforms. When someone's personality is her public 'work', it is impossible to take her death other than personally. This is why the deaths of the 'famous for being famous' justifiably affect us far more than those whose works we admire independently of the creator behind them.

Education

25. What Really Goes on in an 'Outstanding' School?

The Ofsted framework currently grades schools using a four-tiered system. After an inspection, usually lasting between one and two days, the grade given is either 'Outstanding', 'Good', 'Requires Improvement', or 'Inadequate'. The importance of this grade cannot be understated; a 'good' or 'outstanding' judgment ensures job security for the leadership team, satisfied parents and the knowledge that there will be no repeat visit for three to five years. Obtaining a lesser grade is, educationally, a disaster (*as it should be*, you might be thinking, but we'll come to that in a moment). Requiring improvement means that the inspectors will be back repeatedly throughout a two-year window to ensure that standards have improved; inadequacy means that the school will be classified as needing 'Special Measures'; the headteacher will almost certainly be 'disappeared' and the school may, ultimately, be rebranded an Academy.[76]

The system itself is straightforward enough. What is more interesting is just how a school becomes 'outstanding'. The things that immediately spring to mind are, perhaps, high-quality teaching, engaging lessons and superior performance in end-of-stage testing. Whilst these things are measured to a degree, they are by no means the most important factors. Under new regulations brought in in 2010, nowadays it's all about *progress*. And progress is altogether rather more tricky to identify.

Schools are now issued with targets of how much progress children are supposed to make during their time in each phase of their education. These targets are measured in something called APS points. Each year, to be seen to be making 'satisfactory progress' a child needs to make 4 points progress. 'Satisfactory', however, is not good enough, so children need to make 5-6 points (good) or 7-8 points (outstanding) progress per year instead.

Currently, an 'average' 7-year-old has an APS score of 15 and an average 11-year-old has an APS score of 25.

Children enter formal schooling after completing their Reception year. Here they are assessed and given their starting point from which these scores begin. The lowest ability children will start with 1 or 2 APS points on which to build their progress; the more able children will start with a number that fits their assessment. When assessments are completed fairly, for an able child this may be as high as 11. It is from this starting point that children have to show progress across the school. To be seen as 'outstanding', schools need as many children as possible to make 7-8 points of progress a year. Now, if your starting point is already as high as 11 and you make 7 points progress in Year 1 and another 7 points progress in Year 2, the score at the end of the Key Stage would be 25, the same score as an average 11-year-old. We'd assume this outcome would be very unlikely, but under the current system it's actually impossible. For a very able child then, if they are given an accurate starting point, it is impossible for them, and thus the school, to show outstanding, or even good progress.

So what happens? In order to show this outstanding progress, children are given unrealistically low entry scores. If the same very able child is given an inaccurate starting score of 3, it's amazing how quickly they can make progress during the course of Year 1. They will then achieve highly in Year 2 and the school will look as though they have done an 'outstanding' job of ensuring this child makes rapid progress. The reality, however, may well be that it is simply an able child making acceptable progress.

At the other end of the spectrum there are schools who take children from much lower starting points and give them a more genuine starting score of 3. For these children progress is naturally going to be slower and, whilst they will make progress, it may not appear as rapid. Often, it is these schools that will

then be found to be 'requiring improvement', when in reality perhaps they simply do not have the same scope with which to manipulate data.

Nor does it end there. Another, albeit less important, basis for an Ofsted judgment is results. Now this may seem obvious and, again, perhaps fair. Schools need to produce children who are capable of continuing to the next stage of their education or heading out into the workplace. However, there are two factors that make this judgement dubious. The first being that tests on which the results are based are the same across the country. This takes no account of children's backgrounds. A school that has a 75% pass rate, yet only 15% of children who speak English as a first language would be ranked below a school that has an 80% pass rate and 100% of children speaking English as their first language. The second is that results are also looked at based on 3 years of historical data, so even if a school has gone through hard times, it will take three years before this is acknowledged by Ofsted in the results. Results, therefore, tell us very little about the journey some of the children have had to take, or, rather, the *progress* they have had to make, to get to the point they're at now.

We clearly see that logical inconsistencies appear in the societal obsession with progress, and when grafted onto its earliest manifestation—the primary education sector—they expose this obsession's structural illusions, and the reactionary 'attempt to support [these] illusions with arguments,' as Freud puts it in *Civilization and its Discontents*.[77]

26. Sneamp, Queep, Bamph, Pleesh:
The Phonics Screening Check and Educational Testing

By the time English children leave school they are among the most tested in the world. There is a constant clamouring among politicians to ensure that education is 'rigorous' and that children are ready for employment, and yet when worldwide educational comparison tests are completed Britain ranks a lowly 25th.[78]

Michael Gove responded to these test results with, unsurprisingly, more tests. From September 2016 four-year-olds will be subject to a national 'baseline assessment' which will rank them based on ability.[79] Soon, it is likely that there will be standardised tests at the end of every year of primary school. Even under the existing system, before children reach the end of their primary schooling they will have taken three separate national tests, ranking and labelling them thrice over before they reach their

twelfth birthdays.

Nothing illustrates the futility of this testing more than the national 'Phonics Screening Check' for six-year-olds, which was imposed in 2012. Administered at the end of Year 1, the PSC is designed to make sure that all children have met a required standard in reading. Children have to read forty words, of which twenty are 'alien' made up words to test their decoding skills, e.g. 'fape', 'squeap', 'sneam'. Children who are unable to achieve the pass mark are noted, and retested the following year and every subsequent year until they meet the required standard.

Like so much assessment that happens in schools today, the PSC becomes devoid of any meaning. Learning to read is a far more complex series of skills than simply decoding letters on a page. When fluent readers come across an unfamiliar word in a text they have a multitude of strategies to help them decide what it says; for example, reading the rest of the sentence to give the word meaning, looking at the shape and pattern of the letters, hearing sounds and making connections with other known word families (the very 'word games' and 'family resemblances' in language that Ludwig Wittgenstein uncovered in his *Philosophical Investigations*; who, incidentally, became an elementary school teacher in the years between the *Tractatus Logico-Philosophicus* and that much later work). Very few fluent readers read by using phonics alone; in fact, English is a language that by its very nature makes this impossible. And yet across the country we will be labelling thousands of six-year-old children failures at reading, simply because they cannot adequately use one strategy.

This 'failure' does not mean the child is incapable of reading. Some children learn to read very well, with excellent under-standing, without ever using phonics. Yet in the current system they will still fail, and be continually reminded of this failure every year until they conform to a strategy they can often succeed perfectly well without.

Taken in isolation the PSC may seem fairly harmless, but it is

just one example of the many pointless tests children are put through in their years of education. If children fail these tests multiple times, how long is it before that message of failure begins to sink into the child's consciousness? This continued meaningless testing will eventually give the children a message that they 'cannot' read, simply because they couldn't decode words in the *correct* way. They will begin to consider themselves 'bad' at maths, because they don't score the required standard in a very arbitrary test at aged seven, a message reinforced when they're tested again at eleven. These children will have alarmingly fixed ideas about their educational standing before they've even begun secondary school. What motivation can there possibly be for these children to achieve well in GCSEs and A Levels when they have already received, multiple times, the message that they are no good at learning?

Perhaps what children need instead is not more testing, but the chance to explore new ideas, be shown skills in analysis and evaluation and taught that a range of different learning styles are valuable. If they receive this message throughout their early education then maybe when they come to sit formal tests at the end of their secondary schooling they will be ready for them and achieve in a way that is truly reflective of their abilities. Perhaps then Britain might find it performs more successfully on the world stage.

Art by Sky Nash.

Film and Television

27. *Nymphomaniac*: The Male Gaze Meets its Maker

Lars von Trier's *Antichrist* came out at around the same time as James Cameron's *Avatar*. There was something of a misplaced controversy at this moment, *Antichrist* bearing the brunt of it all whilst *Avatar* became the highest-grossing film of all time and garnered the odd Oscar... The reasons for the controversy surrounding *Antichrist* might seem obvious to anyone with an idea of what's in the film, but what about *Avatar*'s contradictions? For all its supposed pontificating about environmental issues, has any film ever generated so much waste? (Having cleaned screens at a cinema between each sold-out showing—of the spilt popcorn, the food combos boxes, the 3D glasses and their packaging, strewn tickets—it's hard to think of a contender...) And what about its plot's very premise? *An indigenous people can only be saved from their enemy by an all-American jock who bests his dead brother, who was really the lame one because he was a scientist* (or, as *South Park* puts it, a '*Mr. Scien-tist*')—something along those lines: ecological, racist, racialist and imperialist issues abound...[80]

All the while *Antichrist* posed questions concerning the concept of Nature, misogyny, and the psyche, but it met such bigoted responses as that found in the exchange with the *Daily Mail*'s Baz Bamigboye, who, prior to even seeing the film, asked the director to 'explain and justify' it and charged him with: 'this is the Cannes Film Festival and you've brought your film here and you have to explain why you made it...', to which the auteur responded that in fact it is to his movie those at the festival were guests, not the other way round.[81] But now, even the *Mail* seems mostly to be on board with von Trier's new venture, *Nymphomaniac* (apart, of course, from some commenters, certain of whom have even called for it to be banned—probably, like

Bamigboye, without having seen it), the finale of which this article will deal with, ergo: *spoiler alert*.

To discuss the film in terms of the construction of story initially raises a few points, the first being that of a process found in psychoanalysis: *retroactivation*. Objects from the room in which Joe (Charlotte Gainsbourg) sits, and the way in which those objects are discussed by her and Seligman (Stellan Skarsgård) affect the way in which she tells her past. The things in the room 'remind' her of elements of her past, as when Seligman tells her that Edgar Alan Poe died of *delirium tremens* and she remembers the visions her father had on his deathbed. This lends a 'random' aspect to the narrative she tells, and Seligman even wonders whether he is supposed to 'believe' the coincidences. The coincidences are not entirely random, however, but elements from the present affecting the past, determining which parts of it are remembered.

More than this though, the things around her in the present influence the way the past is constructed completely; it changes not just *what* is remembered but *how* it is remembered. A fishing fly-hook on the wall of the room and an analogy Seligman makes between fly-fishing and Joe's sex-life (almost as a joke) leads her to construct her young behaviour as sexual 'baiting'. A discussion of Bach's polyphony as having three parts makes her choose three lovers to embody her sexual history in the next chapter. Joe realises that this is arbitrary and says that she doesn't know why she's chosen three, but von Trier shows the viewer that it isn't arbitrary at all, but the subject's present brought to bear on their past. And these reflections can be extended even further with reference to *Nymphomaniac*'s own backtracking reference to *Antichrist*, in which the chronologically-former film's opening shots are recreated, but without the fatal fall of the baby, and in so happening not only is a past revisited and revised, but a future—that of Gainsbourg's in this film replicating hers in *Antichrist*—is diverted.

The main thrust of the film and the discourse surrounding it, however, has been the question of its feminine or feminist position, and its dealing with *feminine sexuality*.

In Seminar XX Lacan jokingly berates women analysts for withholding from the school of psychoanalysis any clues to the mystery of feminine sexuality. What is in part going on in this statement—*from within it*—is the exposition of the very position from which the notion of 'The Woman' is espoused; that is, precisely, a male position. Lacan maintains that 'The Woman doesn't exist', by which he doesn't mean women, or *a* woman, but the notion of *The* Woman as created—in idealised and degrading forms—by the *male gaze*.[82]

From the beginning of *Nymphomaniac* we are met with this problematic, for a woman—Joe—speaks, but her stories and history are constantly reinscribed into a male paradigm by Seligman's finding everywhere parallels, allegories and analogies inspired by her tales (from likenings to Izaak Walton's *The Compleat Angler* to visions of James Bond's Walther PPK), the flashbacks of which are thus not fully Joe's own.

That the film deals with feminine sexuality, that in it a woman speaks her story, or that it *lets* a woman speak, are instances which have met with feminist approval, but which are at the same time complicated by the fact of the male (gaze) at its helm. The truly radical moment of *Nymphomaniac* is then its very end. Whilst a woman *has* spoken throughout the film, it has been to a male interpreter, been in front of a male gaze. No matter how friendly, virginal, and sympathetic that male gaze may have been, its threat nonetheless palpably lingers. In the last scene Joe shoots Seligman after his insipid rape attempt. This shooting— left somewhat open and unconcluded—is thus not the *death* of the male gaze, but rather its *confrontation* (and possibly also the confrontation with *the speculum of the other woman*—to use Lacan's most famous female student, and detractor, Luce Irigaray's term—which leaves open the door to new takes on the film's

subject matter). It is here then that von Trier brings a certain euphemism for death formidably into its own, for it is at this point that the male gaze precisely *meets its maker*.

28. *Poversion*: The Perverse Position of Poverty Porn

'Poverty porn' is a new term describing any media that exploits the position of the poor, particularly to sell a product. Channel 4 seem to be the highest profile network cashing in, with 2013's show *SKINT* (a new series of which is forthcoming) and this year's *Benefits Street* (Channel 4's best-rating programme since 2012) amongst the biggest successes in the genre to date. It's a recent phenomenon, which betrays something particular to our current moment; in February 2014 'Poverty porn' got its own *Wikipedia* page.

Politically, the term is deployed by those on the Left to indicate that such shows give deliberately misleading impressions of the lives of poorer people, in the process victimising them (by selling the lie intended to create a class prejudice). On the other hand, those on the Right see such shows as an indictment of the Welfare State, with all the rhetoric of benefit scrounging and underclass ferality that goes with it. Both shows have received complaint and protest; there have been motions from the residents of Grimsby and the *Grimsby Telegraph* to stop the new series of *SKINT* taking place there.[83] *Benefits Street* was always designed to be controversial in this way and we should not be surprised that it will be investigated by Ofcom after it received so many complaints.[84] Charlie Brooker made the point that *Benefits Street* is a title cynically chosen to push buttons.[85] His point, which remains undeveloped, is perhaps the crucial one to make about these shows, in that it is in the *setting-up of the terms of this debate* that its politics really operate.

After the backlash, Channel 4 commissioned an extra episode to run at the end of the series, which featured a debate (followed live by the *Guardian*) allowing people to air their views, placating those who felt aggrieved and misrepresented by the show. Any

viewer could see that Richard Bacon's job was to stir up a fight, but also to give the reassuring impression that the residents of Birmingham's James Turner Street were shown to have plenty of time on the mic.

The real politics in play here is this setting-up of the debate so that what appears to be an 'open' argument only occurs within the confines of a limited structure. Karl Marx argues that ostensibly oppressed and excluded classes 'cannot represent themselves; they must be represented. Their representative must appear simultaneously as their master [and as a] power which protects them from the other classes and sends them rain and sunshine from above.'[86] Thus, this 'debate' functions by making it appear that the subjects of these shows act and speak freely, that everyone is 'given their chance' to say their piece, that the residents of James Turner Street (in the case of *Benefits Street*) or Scunthorpe (in that of *SKINT*) have been given camera-time sufficient to have had '*their voice*' heard.

Postcolonial theorist Gayatri Spivak glosses this quotation from Marx in her famous essay 'Can the Subaltern Speak?' She explains that a trick is played in which we are made to believe that beyond this 'speaking *for*' those who are unrepresented, there is a place where 'oppressed subjects speak, act, and know for themselves.'[87] We imagine that it would be possible for oppressed subjects to express themselves, given the opportunity. For Spivak this 'leads to an essentialist, utopian politics.'[88] It is not, of course, that people of a certain 'class' *cannot* speak, but rather—when a certain people have been made *subaltern* (i.e. of a lower status, or rank)—a question of from where the subaltern is *spoken*. Her point is thus that once the subject in question has been defined by the presiding culture as 'subaltern'—that is, singled out as someone who needs to be given a voice from a subaltern position—the subject can then only speak back in the language given to them by their apparently generous governing class. In being asked to speak, such subjects are being asked to

conform to a position that *wants* to speak in the language and terms set by the very system into which they are invited precisely as *subaltern*.

The main criticism of both of these *subalternising* poverty porn shows has been that they are *selective*, only showing certain elements of the lives they represent. On the contrary, it doesn't matter how much of this they show, it is the very *position of the showing* (one that is perversely wealth-making) that determines these shows' stance and their subjects' representation, a position enframed by a dominant language that at once constitutes the subaltern class...

29. *Mars One*: A New Future for Reality Television

The *Mars One* project is a bold, and some might say overly ambitious, enterprise to place a Human colony on Mars by the year 2025. In my current adopted country of Canada, 54 Canadian men and women are currently in the running, with the not-for-profit *Mars One* agency, for a chance to leave Earth permanently and create a permanent settlement on the planet Mars (36 are currently in the running from the United Kingdom). One of the frightening aspects of this mission is the knowledge that once out of Earth's grasp, there will be literally no turning back, no sudden change of heart, no rescue mission. The successful candidates will go through a rigorous physical and mental training regime that will test the limits of human endurance. As the candidates are whittled down to four champions of space exploration, their fame will become something extraordinary. In the ten-year run-up to the first mission, *Mars One* will become the subject of a major reality television programme; we will see the triumphs and challenges played out in real time, we will watch the candidates grow from flawed, eager, and anxious, to almost superhuman and in full acceptance of their own mortality as they are blasted into the ether forever. All the time, we as the audience will be fully aware that their mission to Mars may be fatal; in fact we will be constantly reminded of the fact, and most certainly we will witness their deaths, either naturally, years after they have landed, or from a tragic accident, at some point during the mission. This to me feels like the inevitable conclusion to reality television's sombre and cynical projections, although in fact it also offers a welcome change in perspective. Since its upward spiral of popularity in the mid to late 1990s, from shows such as *The Real World* and *Big Brother*, to *Britain's Got Talent* and *The*

Voice, we have slowly succumbed to expecting more treachery, verbal abuse, belittling and public humiliation from those involved. Although we have yet to witness a real death in real time, we have witnessed and savoured the rise and fall of thousands of contestants on reality television and vote-based talent shows. We have in essence witnessed their demise from fame and fortune and seen them fall back to the life from which they came, and we have openly mocked their descent. The prospect of *Mars One* offers us a fresh perspective on cynical reality television culture. The inevitable deaths of the brave candidates will finally give us the martyrs of reality television we so desire. For years after their death, their story will be continually played out in the standard slow motion, and their sacrifice will be forever remembered. A contestant on the receiving end of a bitter putdown by a then greying Simon Cowell will seem completely redundant and meaningless in comparison. In this outlook, reality television will instead have to begin to favour the heroic actions of a few brave men and women, and dispense with the trivial pursuit of fame. For once we might actually begin to strive for a better future than the promotion of one's meagre and mediocre talents.

30. The *Bling Ring* 'Thing'

The transcript of Jacques Lacan's Seminar dated 25 May 1960 records a 'murmur of pleasure' when the great psychoanalyst recommends that his students attend Federico Fellini's new film, *La Dolce Vita*.[89] In the film's final scene, the fashionable guests of a decadent all-night party walk through a beachside wood towards what Lacan refers to as 'some disgusting object that has been caught by a net in the sea'.[90] For Lacan, the enormous staring sea creature to which the celebrities are oddly compelled encapsulates what he had formulated in the seminars of that year as the sublime 'Thing': the true lure and motivation behind all desire. In psychoanalysis, the objects we crave—whether sexual or material—are only arbitrarily connected to the desire itself, allowing momentary physical form to be given to a kind of blank and motiveless force of desire that Freud calls 'drive'. The Louis Vuittons and Ryan Goslings that periodically seem to have harnessed this drive in order to occupy the position of the object of our desire are in fact standing in as a sort of socialised version of this empty 'Thing'. In itself, the 'Thing' could only be represented either as a blank void, or as a traumatising impossible-to-symbolise monster, such as Fellini presents us with in his extraordinary representation of celebrity life at the start of the 1960s.

What can this new *La Dolce Vita*, Sofia Coppola's *The Bling Ring*, tell us about desire today? In the film, a group of teenagers realise that the Beverley Hills celebrities from whom they derive their whole frame of reference may be burgled with a certain amount of impunity, simply because they are unlikely to notice when a small proportion of the priceless jewellery, clothes and accessories in their possession go missing. Just as Fellini's celebrities charge towards the monstrous fish, Coppola's teenagers are driven self-destructively towards the night club-like homes of Paris Hilton and Audrina Patridge, dressing in

their clothes and taking their drugs. 'Desire' in this film, to take another famous Lacanian maxim, is 'desire of the Other'. This doesn't simply mean that I want the objects that other people want, but rather that what fascinates me is the extraordinary mystery of their ability to want them: the unexpected union of drive and object manifested in 'the Thing'. In truth, I am far less interested in Lindsay Lohan's handbags, shrugs and tennis bracelets for any of their essential properties, than for the way they seem to mark the field of Lohan's desire: the boundaries of the monstrous Lohanian 'Thing'.

Coppola allows for a certain amount of conventional meditation on what makes the teenagers vulnerable to pursuing their desire so destructively in this way (alienation from peers, crazy religious home-schooling and so on). But over the question of what, in the first place, *makes the celebrities want the stuff the teenagers subsequently want*, it is brilliantly silent. When one of the teenagers ends up in a cell previously occupied by Paris Hilton and next to the currently-incarcerated Lindsay Lohan, the difference between being beautiful, hedonistic and absurdly rich, and being beautiful, hedonistic and not all that rich, becomes less clear, as various commentators have noted.[91] Whatever the reputations of Fellini's and now Coppola's films for glamourising vacuous celebrities and their most committed admirers, what is most remarkable in their films is actually their commitment to the monstrous vacuity of *all* desire. Whether exemplified as a beached fish or a washed-up actress, the motivation for desire exposed by the two films' respective finales is, supremely, the monstrous vacancy of the Lacanian 'Thing'.

31. *Epic* and the Hysteria of Modernity

Of the family movies released in 2013, those who chanced upon Blue Sky Studio's *Epic* witnessed the most non-normative of the lot. The film, described by *Time Out* as 'a Freudian lineage anxiety drama for all the family', treats questions of parenthood and of the symbolic value of the parent in truly complex ways.[92] Further, it presents a case study of the 'hysteric' mechanisms in place within our culture.

The story begins with the heroine MK—played by Amanda Seyfried—mourning the death of her mother, and the more metaphorical 'loss' of her father, who, since his wife's death, has become absorbed in a fantasy of finding fairies in the garden and ignores his daughter's needs. The tale takes its *Alice-in-Wonderland*-style twist when MK encounters the fairies she thinks her father has imagined. Wandering into the forest she meets another dying matriarch, the Queen of the fairies—played by Beyoncé Knowles—who on her deathbed entrusts MK (in a child-friendly way) with the task of restoring order to a world that has lost the figures who provide it with structure. Entering an imaginary world in which the need to restore a Master figure, in order to 'save the world', is the sole task of every character; MK encounters a huge number of other missing father and mother figures (including one played by Colin Farrell), a string of orphans, and a world of disorder in need of a leader. The world of the film can be explained using part of a seemingly complex Lacanian equation:

$$\frac{S_1}{\$} \rightarrow \frac{S_2}{a}$$

The above diagram describes the 'discourse of the Master.'[93] It is only the two upper terms in the equation which concern us here.

The first position in the equation is the 'driving seat', the position that starts things off. In it sits S_1, which represents the 'master signifier'; this can be thought of as something like the King in a feudal system, a giver of meaning and order. The second position, the S_2, represents all knowledge. S_1 drives things, creating and constructing all knowledge in relation to its primary position. What happens in *Epic*, we might say, is that S_1 has disappeared. The film represents a search for the missing master signifier. It's something Lacan discusses. To describe the 'modern master' or the 'discourse of the University' he places S_2 in the driving seat; we have knowledge, but not the master signifier. We have to use knowledge to work towards this overall truth and order, as modern science does. In *Epic*, Beyoncé tells MK: 'You're here for a reason. You might not see the connections yet, but just because you can't see it, that doesn't mean it doesn't exist.' We don't know what the master signifier is, but we must work towards finding it.

But *Epic* isn't as straightforward as this. In fact it requires a third Lacanian discourse to explain what is in play. The equation below describes the 'discourse of the Hysteric':

$$\frac{\$}{a} \rightarrow \frac{S_1}{S_2}$$

Here, the $\$$ represents the subject. The subject is now in the driving seat. The subject produces the master signifier, rather than the other way around. This is why Lacan describes the hysteric as 'the subject with many masters'; the subject is always producing masters. It's something MK does repeatedly in the film: 'He can help right? He's like the wise old man of the forest.' 'Nah, he's more like the mad uncle.'

This sort of mistake is so common in the film; every potential S_1 figure, every figure who could provide centralized order, turns out to be just another character like the others, with no stable

central reference point, nothing to guarantee the order of the world. At the end, although things return to how they were, little has really been *resolved*. What the film demonstrates, then, is a kind of hysteria that reveals something about the family film in Hollywood. The modern world has been abandoned by the master signifier that provides it with order, and it no longer believes that it's working towards the recovery of that 'truth', but it still desperately believes in this signifier, continually placing new false masters in the position, and never settling, just like the hysteric.

32. The Banking Crisis in *Deal or No Deal*

Comedy often illuminates truths of which we are already half-aware. When describing his military-based game show *Skirmish* in his autobiography, Alan Partridge writes: 'I hadn't been so excited by a quiz show format since Noel Edmonds explained the winning formula for *Deal or No Deal*.' The humour of Partridge's comment is the blindingly obvious fact that Channel 4's evergreen show has nothing to do with strategy and everything to do with chance. Granted, there is a certain formula to the secondary task of weighing up the banker's offer, but at its foundations, the task of picking one red box over another is one of sheer randomness. Assuming the boxes are not rigged, it makes no difference whether one picks in a 'strategic' fashion or in simple numerical order. And yet *Deal or No Deal*'s contestants are probed repeatedly on their method; they are asked to explain the cosmic significance of their selections ('Well, my grandson has just turned 8 so I went for box 8') and applauded by the audience for making 'good' choices.

On the surface this all seems easy to explain. The drawing out and inflation of the contestants' role thickens the show's substance, it adds drama, intrigue and the illusion of skill to a game whose fundamentals are no more challenging than Snakes and Ladders. There may be a deeper explanation, however, of why the show's contestants and millions of viewers so readily accept this blatant illusion. It's all to do with randomness, or rather, our resistance to it.

In his study, *The Drunkard's Walk: How Randomness Rules Our Lives*, Leonard Mlodinow attempts to explain humanity's predilection for finding patterns: 'Sometimes those patterns are meaningful. Sometimes they are not. In either case, the fact that our perception of the patterns of life is both highly convincing and highly subjective has profound implications.'[94] We like to

'uncover' patterns in randomness, to see meaning in meaning-lessness and this structures our experience of the world in ways that are sometimes obvious, sometimes imperceptible. A notable example Mlodinow gives is Apple's reprogramming of the iPod's shuffle feature, which initially worked according to 'true randomness'. The problem is that true randomness 'sometimes produces repetition' and when iPod users 'heard the same song or songs by the same artist back-to-back, they believed the shuffling wasn't random.'[95] According to Steve Jobs, Apple had to make the iPod's shuffle 'less random to make it feel more random.'[96]

The effects of our resistance to randomness, however, extend far beyond the qualia of the shuffle feature. While the assurances of a larger order might be useful on an individual level (in managing anxiety, for example), on a wider societal scale, it can have catastrophic effects. Written in 2008, Mlodinow's study considers society's inflated perception of successful stock-brokers, arguing that we tend to retrospectively attribute skill and foresight to those who happen to achieve success in a system that is either completely or incredibly close to being random. This perception operates under the 'hot-hand fallacy'—the 'mistaken impression that a random streak is due to extraor-dinary performance' and thus deserving of extraordinary levels of remuneration.[97] Recent years have shown that faced with the crises of capitalism it seems we prefer to generate compensatory narratives of the reckless and the responsible, rather than consider capitalism's inherent contradictions or the randomness of the market. To do so may be the first step in actually beating the banker.

Žižek argues that if we are to deal effectively with the ecological crises running parallel to the economic ones, we must relinquish both Enlightenment notions of nature's domination *by* humanity and its perception as a realm of perpetual stability *for* humanity. Instead we must recognise the 'contingency and

unreliability' of the world: 'the only way to confront [the ecological crisis to [its] full extent is to assume fully the experience of radical contingency that it involves.'[98] We often interpret our experiences as unfolding according to some grander plan, design or order. This sheds light on our tendency to read our lives in terms of narrative and the attribution of fate to the opening of red boxes. But we also should see the toxic aura of resignation and irresponsibility that surrounds banalities like 'everything happens for a reason' and 'it just wasn't meant to be'. We tend to ignore randomness and contingency because we prefer the feeling of control and assurances of ultimate meaning. Appreciating the radical contingency of our current situation— that ecology is not underwritten by a larger guarantee, that maybe everything *won't* turn out OK—we may gain more authentic control of the future. The consequence of contingency is heightened responsibility: it's a deal we should probably take.

Language

33. The Word 'Popping'

The amount we hear the word 'popping' in slang and popular culture seems worthy of being noted. We speak about 'popping pills', 'popping caps', 'popping cherries', and even clothes shopping as 'popping tags'. All these things appear to have a kind of fetish function: clothes, drugs, guns, virginities. We are talking not about things of indifference, or arbitrary items, but about things to which we attach our identities, things which people define themselves by.

For Freud this is exactly what a fetish is: something that we use to define ourselves as complete identities; this thing explains or supplements me, completing me. It covers up the fact that really I feel incomplete, lacking. Freud remarks 'the fetish is a substitute for the woman's (the mother's) penis that the little boy once believed in and – for reasons familiar to us – does not want to give up.'[99]

The fetish object or act is not a means to an end, some convoluted way of achieving sexual satisfaction or some strange way in which sexual satisfaction has been diverted from its normal course; rather, the fetish is something which comes to replace the sexual because the sexual encounter forces the male to face the threat of castration that comes with the recognition that the woman does not possess a penis and that he could therefore lose his (and become incomplete). The fetish 'remains a token of triumph over the threat of castration and a protection against it'.[100]

As such, the fetish is that which covers up lack. Indeed, the original meaning of the word 'fetish' is nothing to do with the sexual but rather 'an inanimate object worshipped by preliterate peoples on account of its supposed inherent magical powers' (OED). The fetish is that to which you attach magical meaning in order not to face the lack of completeness that you are really

experiencing.

But haven't we in this case, the case of 'popping', replaced the item with the word? Very different people, defining themselves by very different things, use the same word. Without us knowing it, the pleasure we take in 'popping', whatever it is that we 'pop', has come to define us; but now we have to see that the connection we have with that which we think completes us is nothing other than a function of language. We relate to items only in language. This explains why we need not 'pop' anyone or anything; it is only important that we talk about doing so.

34. *Fail* is the Ghost of Success

Language, as usual, is in crisis, and one symptom of this is an accelerating tendency in various areas of discourse to use verbs as nouns. A television writer might promise a big 'reveal' in a forthcoming episode, a manager will demand a 'solve' for a problem in the company, and many of us have become accustomed to describing a favour as a 'big ask', a blog post as a 'long read', or a discrepancy between two opinions as a 'disconnect'. It can work the other way too, and the best examples of nouns-into-verbs come from parodies in British sitcoms. 'Do you desk?' asks a hipster media-type to a new office-mate in *Nathan Barley*, while a publicity consultant's training exercise in *The Thick of It* turns the name of a brutally convivial popular entertainer into a verb for group participation: 'Let's McIntyre this: stand up, chairs to the side'.

If management gurus are the imposing superego of this kind of semantic jumbling, then the chaotic *id* is to be found in that other hothouse of linguistic experimentation: internet youth culture. The online world of videoed skateboarding accidents, poorly judged selfies and obscene mobile phone autocorrections has produced one of the more distinctive instances of the verb-into-noun in its employment of the word *fail*.[101] Those who humiliate themselves in public, on message boards, or in the vicinity of a camera phone may have the offending action described as a *fail*. *Fail* as suffix can be appended to other specific spheres of life, so *dating fail*, *parenting fail*, and *dancing fail* are all popular search terms. These individual *fails* are widely archived on blogs and in YouTube compilations.[102]

The verb-into-noun of which *fail* is such a vivid example might remind us of an episode in Jonathan Swift's great satire *Gulliver's Travels*. Swift imagines a group of scientists who, frustrated with the language's inherent instability, devise 'a

Scheme for entirely abolishing all Words whatsoever'.[103] Reasoning that 'words are only Names for *things*', the scientists replace words with objects, advising people to simply carry around everything they might want to refer to on their backs.[104] 'I have often beheld two of those Sages almost sinking under the Weight', says Swift, 'who would hold Conversation for an Hour together; then put up their Implements [and] take their leave'.[105] Today, the verb-into-noun betrays a similar impulse. Suspiciously ineffable abstract processes such as *revealing*, *solving*, and indeed *failing*, can now be transfigured into reassuringly concrete nouns: 'names for things', of the kind one might sling onto one's back.

But the idea that a *fail* in particular could, in being made into a noun, be treated in language as an object with material properties of its own, seems rather troubling. Failure, conventionally, is negative: it denotes an aspiration or intention that, through some chance contingency or personal inadequacy, has not happened, or has not come into being. The insight that this seemingly innocuous example of internet slang imposes on us is that an instance of failing is actually never a simple absence or *lack-of-happening*. Rather, it imbues this lack with what the philosopher Alenka Zupančič has called 'a certain – rather ghostly – materiality of nothing'.[106] Treating the *fail* as if it were an object in its own right drags this *lack-of-happening*, however imperfectly, onto the plain of reality, as a sort of ghost of the event as it would have been if successfully executed. In which case, describing somebody's screw-up as a *fail* is hardly the ungenerous jibe it initially seems. In doing so one is gifting at least this ghostly material hint of the event as it could have been if successful. To put it in terms that would easily fit into a management consultant's training manual: *fail is the ghost of success*.

35. Yeh No But

In public places in the United Kingdom you'll find it pretty common to hear the response to some statement: 'yeh no but', or just 'yeh no'. 'Yes no' (like its individual parts) is always a response. The 'yes' must always come first, meaning 'yes, you are right', and so with generosity we could allow it some real use as an agreement with a negative statement: 'yes, you are certainly correct, there are no working toilets on this train (oh well).' Perhaps the 'yes no' also acts as a kind of fearful bridge from one side of the conversation to another, admitting that what follows may or may not be connected to the initial statement; the sighing breath if a 'yes no' has none of the self-defeating excuse-making of Vicky Pollard's 'yeah, but no', though both phrases might indeed have something defensive about them. 'Yes no' is a diction that is unconscious and unlearned: it would never be taught to foreign language learners, and even when raised to the slight deliberateness of its writing, appears odd and mistaken.

The proper treatment of a little phrase like this really is to ignore it, instead of removing it from its place in the natural conversation of fluent English speakers. We could postulate that there are many parts of communication, and that not all of them rely on linguistic meaning: eye contact, body language, tone of voice, all communicate with as much clarity as language, but without language's demands of attachment to a world of meaning beyond the word itself. 'Yes no' could easily be thought of as an equivalent member of those parts of speech, not making a wordy kind of statement, but performing some other conversational operation (and this is a question of conversation: to write 'yes no', even as an instant message, would require less thought than the act of writing itself involves).

That would be alright, except that the words 'yes' and 'no', unlike a grunt or a sigh, each have as clear an agreed-upon

meaning as it is possible to have, and adding them together results in a statement as contradictory as it is possible to have in two words (without forgetting, though, that single words like 'cleave' can contain in them as much of a contradiction). 'Yes no' may have once started out as the phrase 'yes, I know', and maybe this is what speakers would claim they are saying; but just as any useful member of society could tell the difference between 'left right' and 'left, then right' or 'left, not right', the (perhaps) contracted phrase has not carried clarity through the process of abbreviation.

To be fair, there are a multitude of questions in which a negative agreement is a perfectly fine response: anyone who answered 'do you really not want to eat this chipolata?' with the 'yes no' would be understood as indicating 'yes, contrary to all reason, I truly have no desire to eat the chipolata.' But the phrase often goes beyond a simple response: 'yeh no, no, I do like working at the bowls club' is strange, and perverting the syntax might mean 'in spite of what you might think (even though you haven't raised any specific objections), I do actually like working at the bowls club.' Covering all bases, it's as if there's a deferred expectation of an opposition and discord that never came in the first place, an origin inoculated even as it's needlessly created in the past.

The 'yes no' assents to an exchange, while meaning is quietly swept under the carpet. A preference to appear agreeable, even when being combative; a preference to appear slightly confused, especially when rehearsing a well-wrought position; a preference to be stupid when intelligence is possible. In stating its importance, 'yes no' is necessarily expunged from formal speeches or those operating with a certain level of care; but nonetheless, every hour, across the land, it is at work in mouths and in minds.

Media

36. Nooks and Kindles: *Media en Abyme*

The first chapter of Marshall McLuhan's seminal work *Understanding Media* is entitled 'The Medium is the Message'. Along with 'Hot and Cool Media' and the 'Global Village' this title has become something of an immediate catchphrase associated with the media 'guru', but we will look again to this chapter for its precise definition. 'The medium is the message' 'is merely to say that the personal and social consequences of any medium—that is, of any extension of ourselves—result from the new scale that is introduced into our affairs by each extension of ourselves, or by any new technology[;] it is the medium that shapes and controls the scale and form of human association and action.'[107] For example, in terms of 'electric light', McLuhan says that it 'is pure information. It is a medium without a message, as it were, unless it is used to spell out some verbal ad or name.' But he goes on to say that even if it does do this, 'the "content" of any medium is always another medium' too.[108]

In an earlier EDA article—'Old Spice and the Structure of Advertising'—which discussed Walter Benjamin and the detective novel in relation to an Old Spice ad, the pronouncement was made that 'the advert has read Benjamin'.[109] Here, Amazon has read McLuhan, as is shown in their new ad for the Kindle. In it, 'the medium is the message' itself is extended. The ad shows a bunch of kids reading their Kindles and waxing lyrical about how involving books are: 'when I'm reading a book, it's as if I'm on a different planet, I'm oblivious to everything else around/Sometimes I just giggle to myself and people are like, *what you laughing at?* and I'm like, *just the book*', etc. Ostensibly, this is an advert *just about books* (the word 'Kindle' is not even spoken once, it only softly comes into focus, written, at the end). It is an ad that has seemingly cleverly covered the tracks of the medium itself, presenting only the message: 'books'.

'Forget the kindle as a device, as medium, or mediation', it says, 'it just *is books*'. But in this respect, the focus of the advert is nonetheless still only on a medium itself: indeed, books.

In its double bluff it gives its game away and forces us into a concentration on books as a 'medium without a message' (what McLuhan called 'the Gutenberg galaxy').[110] It forces us to realise the gap in the advert too: no *book* is being advertised here, just the 'universal' and supposedly 'universally beneficial' experience of reading, collapsing all literature into this experience, without any distinction between individual works. It's an advert about reading, which, handily, the Kindle is the platform of...

But, if we read the advert closer we'll see it's actually something else: a *medium en abyme*. A *'mise en abyme'* is the descriptor for the abyssal reflecting-in-on-itself of, say, a TV monitor being filmed, on which you can see an infinity of TV monitors disappearing into the vanishing point, or similarly of two parallel mirrors, which do the same when you look into one, from the point of standing between them. To start to disentangle ourselves from this *medium/mise en abyme* we'll have to realise we are already two removes in. By focusing on the medium *books*, we're already eliding the medium *the Kindle* (the advert's ostensible goal: its saying 'it's not just a medium, *it is* reading'), and the medium the *viewing platform (TV/YouTube/etc.) of the advert*. The content of the ad begins to elude us when we look for it; at its irreducible point there is no content, no real message: there is no book, but only books, as a medium—*'the Kindle is books'*— being advertised. McLuhan gives an explanation of this effect in an Australian TV interview: 'what's in print is nothing compared to the effect of the printed word. The printed word sets up a paradigm, a structure of awareness, which affects everybody, in very, very drastic ways.'[111]

The Kindle is such a structure or paradigm. It is still the printed word, but the printed word as an *electronic medium*. And

the Kindle's latest manifestation, the Paperwhite, can now illuminate its pages with light. 'If the student of media will but meditate on the power of this medium of electric light', McLuhan says, 'he[/she] will have the key to the form of the power that is in all media to reshape any lives they touch.' 'The message of electric light is total change. It is pure information without any content to restrict its transforming and informing power.'[112]

Barnes and Noble's rival to the Kindle, the Nook, goes to prove just how transformative (and *informative*) privileging the medium over the message can be: at one point its 'search and replace' function changed every instance of the word 'Kindle' in their e-book version of Leo Tolstoy's *War and Peace* to 'Nook'; an instance in which the medium completely usurped the message. How many will have noticed this content flaw of their own accord it cannot be said, but the response of Elif Batuman—a Russian literature specialist and memoirist—beautifully sums up its own surprisingly subversive force in redirecting concentration back onto the medium (*as the message*): 'it's kind of great', she says, 'to have one's attention drawn to the shared connotation of lighting something up from within'.[113] The backlit e-reader itself.

37. Points of View: *The BBC's Gaze in Media Hegemony*

Dan Hancox's recent article on opendemocracy.net, 'No Platform for Billy Bragg', raises important issues: it points to a tendency in BBC and other mainstream media representation for representing the past nostalgically; in this case, remembering in the 1980s a golden age of opposition and protest in music, spearheaded by the 'red wedge' vanguard of the likes of Billy Bragg and The Style Council.[114] As Hancox notes from Bragg's interview on *The Culture Show*, many such musicians and artists are swept up into this nostalgia hegemony; in Bragg's case, due to the umpteen interviews he's been featured in of late, all concerned with the state of politics today, in which the same question is asked for the umpteenth time: where's today's red wedge/musical and artistic protest/media-represented opposition? But the bigger question is: *where*, indeed, *is this question* asked from? What is the BBC's point of view in this question and is its standpoint fixed? Is there a BBC *gaze*?

From terrestrial television to the universe of Sky and beyond, the plethora of channels and unlimited choice of programming can be seen to offer as free a platform as the BBC's own *Points of View* for access to wide-ranging perspective and opinion. But, despite their apparent infiniteness, these mainstream outlets in fact operate as a tightly interwoven knot of all in all not-too-dissimilar coverage, with their channels' songs of praise often being sung from the same hymnsheet; this is what gets called 'hegemony'. The endless coverage of the birth of the new royal is a prime example, to which this hopeful tweet from Newport West MP Paul Flynn lends credence: 'Congratulations to BBC/ITV/Sky for concentrated boredom initiative that's converted millions from indifference to fervent Republicanism.'[115]

It is this sort of reportage that Louis Althusser describes the hegemonic operations of in his indispensible 1970 essay, 'Ideology and Ideological State Apparatuses': 'the communications apparatus', he suggests, 'cram[s] every 'citizen' with daily doses of nationalism, chauvinism, liberalism, moralism, etc, by means of the press, the radio and television'...[116] What is at stake in this is the sacrifice of representation of non-hegemonic perspectives (alternatives to the narratives of 'nationalism, liberalism, etc.') in the name of a broadcasting company's damage limitation.

After Jacques Lacan made his digressions on 'the gaze' in his seminar on *The Four Fundamental Concepts of Psychoanalysis* his thoughts about it were taken up by film theorists like Laura Mulvey, who spotted in many movies a distinctively 'male gaze'. Notably, for example, this occurs in *Pretty Woman*, in which the camera always tends to gaze from Richard Gere's eye-level (or thereabouts) *at* Julia Roberts (*as* an object) with whose perspective the audience is rarely matched. Thus, implicit in the gaze is an *objectifying* rather than an *objective* position.

Particularly pertinent to the BBC, then—often championed for its *unbiased* and *objective* reporting—is this notion. Of course, in rewatching or listening to earlier interviews with the likes of Billy Bragg and Paul Weller in the 80s, there are arguments against their views given in the reportage (for the sake of *objectivity*, no doubt). What becomes interesting is that these other sides are subsequently lost in the interviews with them in this era, in which their political influence isn't quite as threatening as it was, so destabilising it is not of the utmost priority to hegemonic maintenance. They thus become part of the *culture industry*, their artefacts put into a museum that the current generation, *so aloof and apolitical*, are recommended to visit. Naturally, however, as Hancox points out, we're not as aloof and apolitical as all that; culture has changed, and if the BBC really wanted to chart what can be done politically today they would do well to dig a little

deeper into the cultural here-and-now as opposed to focusing solely on the cultural *heritage*.

Here-and-now is a space and time of tightening hegemony in the mainstream (due, no doubt, to its encroaching outmodedness), and its effects seep through all areas of society, including the workplace. For example, in a franchised call centre this contributor worked at—one that answers the phone for many different companies—an operative can expect to take a call for the *Guardian* one minute and the *Daily Mail* the next; in this space and time we must keep on the lookout for the force-feeding of those ideologies that Althusser points to in his essay, and add to his list historical disarmament enacted by nostalgia. Alternatives, however, are arising, and, whilst there might be a slight uncanniness for those who have grown up with the Beeb, in watching the Max Keiser Report on *Russia Today* or Amy Goodman's hour on *Democracy Now* (on which interviews with the likes of Billy Bragg find a slightly different inflection), it should not be forgotten that this might only be felt due to the fact of stepping out of the former's gaze.

Miscellaneous

38. On Almost Bumping into Someone when Walking Around a Corner

You're on the way to work, and you're in a hurry. You walk quickly down the street, focused on getting to your destination. Then, appearing out of nowhere, like an ethical policy in a Conservative party meeting, someone comes from around a corner, walking directly into your path and almost bumping straight into you.

You look at each other, fury in your eyes, and you place the blame on the other individual. Perhaps you even tut, or mutter something to yourself, as you step aside and continue your rushed journey. Perhaps you detect a momentary trace of anger in their face too, and this makes you more annoyed with them. Certainly you feel a wrong has been committed against you, albeit minor.

But a moment's reflection as you walk along leaves you feeling a little differently, a little disappointed in yourself for getting so angry, perhaps even a hint of fear that the other person heard your tut, as you realize that they were in precisely the same position as you. The corner has hidden a reality of perspective; you realize that from their perspective, quite literally, you were them, and they were you.

Speaking of perspective, in his groundbreaking study of Walter Benjamin, *Ways of Seeing*, theorist John Berger comments that:

According to the convention of perspective there is no visual reciprocity. There is no need for God to situate himself in relation to others: he is himself the situation. The inherent contradiction in perspective was that it structured all images of reality to address a single spectator who, unlike God, could only be in one place at one time.[117]

The corner-incident forces the unfortunate bumbler-bumper into precisely this realization. As you walk away you realize that it has been your mistake to imagine that all images of reality—in this case the street you saw in front of you—address you as a single spectator; it is, in fact, precisely the same for another. But it's more than just a reminder that you are only one of an infinite number of subjective positions. The incident shows you that at a visual level a trick is played, and that your own way of seeing is constituted by another imaginary one in which the look comes from a privileged and all-seeing position.

Lacan explains this way in which your own gaze is constituted by an imaginary all-seeing gaze that precedes the way you yourself see. This might be thought of as the imaginary third position of the one who has seen the incident coming, from a bird's-eye view perhaps (situating the all-seeing in the position of God) or perhaps from the subject-position of the viewer in a photographic image of two people approaching a head-on collision around a corner, both coming from opposite ways, obscured from each other's view by the corner itself.[118]

What this shows you is that even long after believing in God, the way we view our world is still structured by an imaginary omniscient and all seeing Other, which is capable of structuring how we ourselves see. When you bump into someone on a corner, you realize, perhaps unconsciously, that you aren't in charge of your own perspective.

39. On Seeing Yourself on a Big Screen

These days, many large sporting events and concerts feature a big screen on which the audience can watch the action or performance as it is taking place, expanded to vast proportions. This footage may also be transmitted to a television audience, as during Wimbledon or Glastonbury festival. It often happens during these events that the camera is turned on the audience, perhaps during a break in play, to film the crowd, or pick out one or two unsuspecting individuals. On such occasions something seems to take place which Lacan has described in the following terms: '*I see myself seeing myself*'.[119] We recognise ourselves on the screen, and at the same time recognise that we are outside this image, looking at it. We might respond by waving, smiling, laughing or hiding, as our inclination dictates. For Lacan, this idea of 'seeing oneself seeing oneself' is a way of describing what is usually referred to as self-consciousness: the ability we seem to have to reflect back upon our own perceptions. Self-consciousness produces the impression that I am in control of these perceptions, since my recognition that I am seeing is simultaneously a recognition that someone is doing the recognising, and that this is me. In Lacan's words, 'the privilege of the subject seems to be established here from that bipolar reflexive relation by which, as soon as I perceive, my representations belong to me'.[120]

Lacan argues that this impression is mistaken though, introducing instead the concept of the 'gaze' (see the above reflections on almost bumping into someone when walking around a corner). The gaze is a point of vision which originates from outside, and which sees me before I see it. This means that I am not, in fact, the author of my own perceptions. The structure of the gaze can be illustrated by the phenomenon of the 'double take', often played for comedic effect in slapstick or cartoon films.

This occurs when someone initially looks past something, which seems innocuous, before suddenly looking back as they realise something is radically amiss. Rather than me doing the seeing, something has caught my eye, reversing the conventional direction of visual agency. In comedy, the audience is usually allowed to recognise immediately what the character misses, reinstating the sense that vision is rooted in the subject—just not the subject who double takes. If I am the person doing a double take, however, the unexpected sight catches me before I am able to assert my privilege as the subject of my own perceptions. Like a joke or slip of the tongue for Freud, it is a moment that reveals the existence of something outside my control, which nonetheless determines my subjectivity.

Seeing yourself on the big screen operates in a similar way: when the camera picks me out, for a split second I fail to react, either because I am not expecting to see myself, or because there is a slight delay between the camera filming me and the image appearing on the screen. What I see, therefore, and what everyone else in the crowd sees, is my own moment of recognition, in which mastery over my image is reasserted. As with comedy, the audience—and even I myself—are able to catch the moment in which I fail to be the author of my own vision. In recognising this moment, agency is restored, or seems to be restored. A failure to recognise myself would be another matter; for Freud, this would be a form of the uncanny.

Self-consciousness, then, always works to elide the existence of the gaze and reassert the authority of the subject. There is a disjunction, though, in the experience of seeing yourself on a big screen which cannot be elided, and which always renders it slightly unsatisfactory. The camera and the screen are not identical, so that in seeing myself I cannot catch my own eye as I can in a mirror. I am faced with the choice of looking directly at the camera (the point which stands for my self-recognising self), in which case I cannot see my image on the screen, or of looking

at the screen, in which case I cannot meet my own gaze. In this second case, the point my image-self seems to be looking at, which is off to the side, is the point where I want to be in order to catch my own gaze. To reach this point while still looking at the screen would be the equivalent of looking at Hans Holbein the Younger's painting *The Ambassadors* head on, while also being in a position to see clearly the anamorphic skull. In order to unify my subjectivity and close this gap, I would have to split myself in two. This moment does not last however. The camera moves on, the game re-commences and I can imagine that I really did see myself seeing myself.

40. Secret Santa: *A Christmas Analysis*

> Suppose someone unthinkable for us, one of those gentlemen
> who, we are told – if indeed any have ever existed, don't
> believe I attribute any importance to such hearsay – was ever
> capable of such self-discipline that he no longer believed in
> Father Christmas.
> —Lacan, *Seminar III*[121]

In the market town of Chippenham in Wiltshire, Santa Claus's
secret has been revealed...! by a vicar of the Church of
England...! to an assembly of primary school children...!
The local news story has now made the nationals: Reverend
Simon Tatton-Brown's apology for apparently denying the
existence of Father Christmas to pupils of the Charter Primary
School is filling the town's paper's front-page headlines, and the
country's papers' stocking-filler columns; his parabolic
derivation of Santa's origins in the St Nick story having caused
uproar and furore with angered parents everywhere.[122]

A comment from kimcrawley at the bottom of the story on the
Gazette & Herald website asks: 'Exactly when do they [the
parents] think their children become aware that it's all about
money and not giving – when they are teenagers?'[123] The point
of course is that there may be something like this at stake: we all
remember the rumours going around the playground that '*he
doesn't exist*' —filtering down from the higher years to the lower
between games of bulldog—but the fact is that to receive this
word from an authority figure creates a quite different symbolic
dimension. In the symbolic framework in which the position of
authority maintains the tradition of Santa Claus, the kids—even
if they *know better*—defer to this sustained belief, so as both *to let
the adults have their fantasy* (sustaining Santa Claus through

fulfilling the role of 'subjects-supposed-to-believe'), and to keep the coordinates of the symbolic order unperturbed. It is perhaps the very *presence* of the secret of Santa (a presence which keeps his non-existence as strictly only a *possibility*)—which always goes unspoken in official moments—that sustains this system of belief. As Žižek asks in this dinner party scene in *Less Than Nothing*:

> What is presence? Imagine a group conversation in which all the participants know that one of them has cancer and also know that everyone in the group knows it; they talk about everything, the new books they have read, movies they have seen, their professional disappointments, politics... just to avoid the topic of cancer. In such a situation, one can say that cancer is fully present, a heavy presence that casts its shadow over everything.[124]

Perhaps similarly, in the rituals of the child's Christmas, the question of Santa Claus's existence is kept precisely at bay through its full and heavy presence; that is, through all the talk of red-nosed reindeers, elves, and naughty and nice lists, whilst the rumour, or secret, circulates ever more encroachingly under the surface; no one speaking it, despite all knowing that everyone else knows it.

It is this structure, however, that avoids the disruption that an authoritative and definitive pronouncement on the subject—such as the vicar's—would create (that which might force the kids to really 'traverse the fantasy' of Santa; that is, the opposite to the 'suspension of disbelief' in play in the maintained tradition). Žižek sums these belief systems up by suggesting that 'this is the paradox of public space: even if everyone knows an unpleasant fact, *saying* it in public changes everything.'[125] Although he may have been making this point in relation to *WikiLeaks*—through which *change* can only be revolutionary—it can yet be applied

here: the *unpleasant facts* of the St Nicholas story, the secret of the truth of Santa's existence; these change everything if said, disrupting the symbolic edifice of belief as if an intervention at the level of the divine might really have come about. Indeed, as Lacan put it: 'you are all, myself included, inserted into this major signifier called Father Christmas. With Father Christmas things always work out and, I would add, they work out well.'[126]

41. *Capitalistrology!* Astrology as Another Stupid Adaptation to the World of Capital

According to the pundits of astrology, the celestial bodies, which glimmer against the sable void of night, reflect back to us a certain kind of preordained, though partially engaged, fate. But more than being just a sort of stargazing fatalism, astrology, according to critical theorist Theodor Adorno, strives to situate our mundane lives within a transcendental system that puts everything in its proper, precise place—insofar as we comply with its nuanced demands, that is.

In other words, today's astrology is a regressive gesture that refers to a pagan order of all things and happenings, an all-encompassing circle of cosmological (read, ideological) closure. Mercury's retrograde movement offers the pagan subject a coruscant vector that traces one's emotional memories to their roots. The moon is one's mother. Mars is one's passion. And whichever constellation maps out the subject's subjectivity—whether it is Gemini, Cancer, or what have you—it proffers an understanding of one's own life-world. And so on.

Well, let us quickly dispel with this quasi-Jungian drivel. Suffice it to recall Lacan's assertion apropos 'understanding': it is brought to mind only as an ideal relation. That is to say, paradoxically, we 'understand' precisely because we do not. To say that astrology offers to us, for us, an alternative way to understand the complexity of our subjecthood, and our place within the complexity of this world, is, strictly speaking, an imaginative defence-formation against not just the pre-symbolic Real, but against the contingent twists and turns of today's chaotic universe of capital, too; mapping meaning to where, originally, there is none to be found. To put it a certain way, it is to situate the entire array of stars and planets in the place of the big Other as such, the place of God Himself—'the Other supposed to

know', another space where all knowledge and meaning wanders about. Hence astrology's pagan nature: its 'infinite wisdom' resides in its pre-Christian pagan cosmological insight, a 'divine hierarchical order of cosmic principles', as Žižek puts it, which demands of its subjects 'a global balance of these principles', and where meaning is provided insofar as we obey the precepts of this order.[127] (This is why, should this paradigmatic order of things ever supervene, fully, upon the social field, an order of controlled balance as such, an order that would issue us our 'meaningful' lives... well—oh-oh—would we not be knocking on despotism's door? I should be glad to tell you more about this, but I better leave it to one side for now; once one has begun on that topic it is hard to pull back; so we must return to what we were talking about.)

At any rate, the efficiency behind the illusive nature of astrology derives from an ideal relation to an imaginary network of meaning: thus it acquires the capacity for what Kant and other German idealists called 'intellectual intuition (*intellektuelle Anschauung*)': a form of intuition that generates the very object it perceives.

Can we not see, then, how the relationship between astrology and its addressees makes for a great simile for ideology and its subjects? As J. M. Bernstein put it in the introduction to Adorno's *The Culture Industry*: by providing 'strategies and compensations that appear as more than imaginary, astrology [i.e. ideology] permits belief and obedience without demanding its readers [i.e. ideology's subjects] to *overtly* sacrifice the claims of rational evidence and reflection.'[128]

That said, there is nothing 'authentic', 'alternative', or 'extreme' (or rational) about astrology. It is a rather conservative specular image of society and its status quo. The astrologist, Bernstein tells us, unwittingly promotes the image of social conformity, precisely by way of the 'implicit and ubiquitous rule that one must adjust oneself to the commands of the stars at

given times.'[129] With astrology, then, one is presented with rationality in the form of advice, while what remains completely irrational is 'present in the source and structuring of this advice.'[130] Exactly like ideology, astrology exhibits an immutable pretension to correspond to reality.

Well, this is precisely what makes astrology so compatible with capitalism these days. Capitalist society has become so dynamic, so fragile, so uncertain, that if you are completely absorbed in the world of capital then its orbit begins to take on such an unbalanced form. The world begins to appear as chaotic, as 'too complex to understand'; and one effectively fails to grasp an enduring, irreducible sense of self-identity within this hyper-fluxed world. Therefore, astrology becomes the perfect ideological supplement to tolerate such an unstable orbit, offering the subject a (false) sense of balance, a (false) sense of place, an illusory place that transcends the real world of capital by locating the subject somewhere 'out there' in the stars, as it were, while simultaneously keeping the subject rooted in the real of capital, which, of course, is obfuscated by the illusive identity that astrology so welcomingly bestows upon the subject. In other words, astrology obscures the surface of social reality, thereby obscuring the subject's actual place in the social field (that one is a subject of capitalism), while at the same time, habituating the subject to the rules of capitalist society.

It is in this strict sense that we are warranted in our claim that astrology, rather than being a source of authentic self-knowledge, is simply a perverse way to circumvent that which we do not know we already know about ourselves: the fact that, if one is constantly reading the astrology charts, one is effectively disregarding their direct relation to capital while concurrently following its stupid rules, playing its stupid game.

42. A Homeless Person of One's Own

Frame after frame of smiling weather-beaten faces stare out at us, their tired contours captured in beautiful high definition black and white. This is the website of HandUp, a recently founded charity in San Francisco, offering what is in effect the opportunity to 'adopt a homeless'. What does this form of giving that requires no actual physical encounter with that dangerous object 'the homeless person' tell us about the middle class' developing relationship to poverty?

HandUp is designed to get around our wariness that the people who beg from us on the street will simply spend what we give them on drugs and alcohol. Homeless people register with the company and instead of begging, hand out business cards to passersby, encouraging them to read their stories online and—if moved to—donate money that is then converted into credits for food, clothes and medical supplies. The scheme has all the strengths of the American West Coast: smart but intuitive, satisfying in its finding in modern technology solutions for age-old social problems, and humanely committed to the therapeutic ideal that everyone has a story to tell. Clearly HandUp does the recipients of its online visitors' largesse a great deal of good: but there is also something deeply troubling about the strategy of this latest means by which we are invited to encounter the poor.

Animal welfare charities have long employed a very similar marketing approach. Rather than simply making a donation to the World Wildlife Fund or to the Born Free Foundation, donors 'Adopt an Animal'—Kamrita the Bengal tiger for instance, or Springer the whale—and receive regular updates about that animal's particular activities and progress. In the meeting of these two approaches to charity, we are as so often treating humans like animals and animals like humans, but with one key conceptual difference. In the 'Adopt an Animal' strategy, the cute

marketable Panda presents one anthropomorphised animal in particular on whom donors can focus their sense of having done good, while the proceeds themselves go to help the species at large. In the Handup model, however, the homeless people with the most inspiring story and the most effective combination of pathos and defiance in their photograph benefit personally, while those with problems less marketable in the online arena get nothing.

The implications of this can be drawn out with reference to the philosopher Alenka Zupančič's notion of 'bio-morality'.[131] Zupančič suggests that in the past, the Left has only had to respond to the 'pull yourself up by your bootstraps' model of conservative morality, for which social misfortune is ultimately the result of idleness and poor decision making. The situation of bio-morality, meanwhile, has gone yet further, promoting the view that 'feeling good' and 'seeing the positive' are markers of moral goodness in themselves, intimately related to social status, and inscribed at the level of a person's biology. This is what has allowed healthy eating and exercise to take on the status of a moral virtue, and one explicitly linked to getting ahead. As such, the supposed enjoyment of junk food and cigarettes among the unemployed becomes imaginatively intertwined with their social predicament, making it seem like poverty was always inscribed biologically. The ease with which antidepressant drugs are now prescribed in the West is also part of this trend: unhappiness is presumed to be always biological, and the only socially responsible reaction to it is to chemically change our biology. And this is also why we are now encouraged to reformulate all misfortune into a 'learning experience', a welcome challenge, or as a near miss with some even worse fate. In the bio-moral regime, to be conspicuously unhappy or sickly without finding some source of positive inspiration inside that is to risk the perception that we had it coming.

This is the responsibility HandUp imposes on its clients: the

responsibility to prove their worth at the level of bio-morality. Whether to become a child psychologist, to start crochet classes for other indigent people, or to find work as a mechanic, all the narratives given on the website include some inspirational dream or ambition. At the same time, the classy portrait photographs show good-humoured, kindly, basically healthy-looking people. In other words, the kind of people for whom misfortune is a temporary episode in an otherwise positive story, and not the kind of people who are damned to unhappiness by a knot of bad morals, bad luck, and bad biology at the heart of their being.

The inspiring stories are an undoubted part of the website's pull, which together with the assurance that the donations will only be spent on 'the right' things, allow us to see the effects of our charity. But clearly there is an intellectual glitch here as well. What HandUp seems to offer is an approach to the homeless that allows them to speak for themselves in all the variety of their experience. But its effect is to encourage us to donate to the client whose ambitions and experiences most resonate with our own. While it is their apparent uniqueness that draws us to the homeless person we sponsor, the result is only that we normalise and impose our own priorities back onto them. There is a reason why the animal charities market 'Adopt an Animal' to children: it is because to be willing to offer help to the Other only when he or she appears in a reassuringly identifiable and upbeat form is a childish ethics indeed. To allow ourselves to associate deserv-ingness not only with need, but with a constitutionally positive attitude with which we can presume to identify, is a dangerous habit of thought to be getting used to.

43. On the *Stehzellen*, Block 11, Auschwitz I: *An Analysis Based on a Visit to the Concentration Camp*

If I could enclose all the evil of our time in one image, I would choose this image which is familiar to me: an emaciated man, with head dropped and shoulders curved, on whose face and in whose eyes not a trace of a thought is to be seen.
—Primo Levi, *If This is a Man*[132]

I

Levi suggests that the Nazis sought to 'annihilate [camp interns] first as men in order to kill [them] more slowly afterwards.'[133] They stripped prisoners down to the very last vestiges of personal identity; replacing their names with numbers, providing only ill-fitting clothing and derisory food portions; making of humans mere vessels of attrition. Levi was prompted to say of Monowitz-Buna (Auschwitz III) where he was interned that 'the Lager *is* hunger' and of himself and his fellow inmates: 'we ourselves are hunger, living hunger'.[134] And yet the inmates were each to be reminded of their non-individual but *conglomerate* 'crimes' against the Reich. Forced to wear a symbol demarcating which sect of prisoners they belonged to ('a red triangle denoted a political prisoner, green a criminal, purple a Jehovah's Witness, black a 'shiftless element', pink a homosexual, and brown a Gypsy. Jews displayed the Star of David'[135]), each could be identified for particularised treatment, denigration and ridicule by the ruling SS and other camp 'prominents.'[136]

Auschwitz, often seen as a well-oiled extermination machine, could be viewed just as well as a chaotic vehicle for administering profound realisations of hatred through an uninhibited manifestation of evil creative of the state 'between-two-deaths': the (symbolic) annihilation of a person prior to their (real) death, as

146

Levi describes in his stark 'image of evil' above.

Amongst the voices of those of our group visiting Auschwitz sixty-five years after its liberation could be heard theories attempting to commensurate the atrocity of the Holocaust in terms of its functionality and mechanisation (some positing the killing centres as being examples of factorial and clinical precision) and also the sharing of hyperreal comparisons and opinions (someone asking another, 'what was the nastiest bit for you?'), whilst others remained silent ('rendered aphasic by Auschwitz', as Jean Baudrillard put it).[137] These multiple reactions to the Holocaust (and its proximity spatiotemporally) perhaps 'bespeak a desperate process of abreaction in response to the fact that these events are on the point of escaping us on the level of reality', in Baudrillard's words.[138]

II

Levi describes the renovated Auschwitz I as 'a museum in which pitiful relics are displayed: tons of human hair, hundreds of thousands of eyeglasses, combs, shaving brushes, dolls, baby shoes, but it remains just a museum—something static, rearranged, contrived.'[139] Questions of appropriateness, always, occur with the mention of Auschwitz; concerning its presentation and representation. If 'we ourselves no longer exist sufficiently to sustain a memory' of the Holocaust, should it subsist in a hyperreal 'hallucination', in a 'static' and 'contrived' museum?[140] It would appear that, however the figures might fluctuate and the arguments vary, the facts of Auschwitz and the Holocaust remain and speak themselves as a veritable 'cry of despair and a warning to humanity.'[141] Their being clearly recounted (as accurately as current scholarly consensus permits) on the guided tours of Auschwitz, without value judgements, without redirected hate discourses or invectives, by informative tour-guides, allows the visitors to the camp access to the actualities thereof; tourists are not 'put in the shoes' of the sufferers

and are not made to feel discomfort, fright or guilt, but are verifiably reminded of what is here summated by Levi, that:

> Many people – many nations – can find themselves holding, more or less wittingly, that 'every stranger is an enemy'. For the most part this conviction lies deep down like some latent infection; it betrays itself only in random, disconnected acts, and does not lie at the base of a system of reason. But when this does come about, when the unspoken dogma becomes the major premiss in a syllogism, then, at the end of the chain, there is the Lager. Here is the product of a conception of the world carried rigorously to its logical conclusion; so long as the conception subsists, the conclusion remains to threaten us. The story of the death camps should be understood by everyone as a sinister alarm-signal.[142]

The true sinisterness of this *final conclusion* is the illogical aspects it allows of; rather than acting merely as an efficient, yet nonetheless diabolical, 'factory' to remove those the Nazis regarded as the scourge of the Earth from the Earth itself, it became an outlet for the realisations of tortuous fantasies, morbid experimentation, and easy transgressions from ethico-moral codes individuals (employed in the camp) had hitherto held, ostensibly *re-encoded* as they were by propagandist hate doctrine; a sort of *carte blanche*, in the most dastardly rendering of Kierkegaard's teleological suspension of the ethical.

Against the notion that the Third Reich implemented its genocidal regime in anything of a factorial manner, proof resides in the ruthless torture and endless degradation that occurred across the board (from the humiliating use of Jewish gravestones as paving, for example, to the actions at Treblinka, of SS officer 'Kurt Franz, [who] was described by [...] survivors as a sadist[;] he trained his dog Barry to attack the genitals of his victims').[143] The efficacy of a factory, even a 'death factory', relies on its swift

production (or, in such a case, 'destruction') and cost-efficiency. The euphemistic output of Auschwitz—its 'cleansing[,] elimination, solution', as were the words employed in an attempt to conceal its barbarity—was manufactured not with these clinical headings in mind (if they were, they were only in the ironical spirit of camp slogans such as '*Arbeit macht frei*'), but with an especial hatred and a hellish administration.[144]

III

Examples of this are the *stehzellen*, 'standing cells'; or the 'standing bunker,' which was located in Block 11 at Auschwitz I, often referred to as the 'Death Block' by prisoners there:

> The "standing bunker" was an Auschwitz speciality[. It was] the collective name for four cells, each smaller than a square meter. A prisoner ordered to the standing bunker had to crawl through a small opening near the floor. The condemned was locked into the standing bunker, where he could not lie down, for a number of nights, while having to march to work during the day. When several inmates were imprisoned in one of the standing bunkers, the already restricted space became even tighter. A prisoner could be sentenced to several nights in the standing bunker if he had relieved himself behind a building or had picked fruit from a tree near his workplace.[145]

An epitomic example of its use is the report of a young Jewish boy from Warsaw's condemnation to there in the autumn of 1943 for drinking from an SS man's water bottle; without hearing, he was locked in the bunker until the next selection, after which long torture he was shot against the black wall.[146] If anything, Auschwitz was a factory allowing of the production of *evil* itself, with all its mythical and classical connotations; from the rewardless punishing work equal to the toils of Hades to the devilish deception—from Levi's warning about which we must

take heed—that caused the inmates of Auschwitz to appear, at the time, as

untouchables to the civilians. They think, more or less explicitly – with all the nuances lying between contempt and commiseration – that as we have been condemned to this life of ours, reduced to our condition, we must be tainted by some mysterious, grave sin. They hear us speak in many different languages, which they do not understand and which sound to them as grotesque as animal noises; they see us reduced to ignoble slavery, without hair, without honour and without names, beaten every day, more abject every night, and they never see in our eyes a light of rebellion, or of peace, or of faith. They know us as thieves and untrustworthy, and mistaking the effect for the cause, they judge us worthy of our abasement.[147]

Music

44. LONG.LIVE.A$AP: *The Voice as Trill*

One of the biggest and most important hip-hop albums of 2013 was released only two weeks into the year on 15 January. A$AP Rocky's *LONG.LIVE.A$AP,* featuring Kendrick Lamar and Drake, who Rocky is closely associated with, has already had a huge impact on US hip-hop; its appeal stretches to audiences of all tastes, from rap to mainstream to dance (as the single featuring Skrillex shows).

Despite high praise from the vast majority of the music world, including *Pitchfork* and *NME,* it has also drawn unsurprising criticisms from some sectors. A$AP's album is full of a language that is sexually, racially and culturally offensive, endorsing violence towards women, drug-taking and heinous crime, amongst other things. These are criticisms that A$AP is used to; even Jonah Weiner of *Slate,* who ranked his debut 2011 mixtape *Live.Love.A$AP* in his top 5, called Rocky 'hip-hop's abiding misogynist.'[148] Online reviews have gone a lot further, with contactmusic.com claiming the album is 'ruined by a backdrop of violence and misogyny', and various blogs attacking papers such as the *New York Times* for celebrating his misogyny.[149] A look on Google will uncover a string of complaints and even online petitions to boycott his music. As low-level as these criticisms might be, and despite approval of Rocky's talent from the music world, the question seems a fair one; should there be a place for a misogynistic and violent rap music?

But A$AP Rocky's album is supposed to be shocking, and shocking it certainly is. The real radicalism of the album though, is not to be found in his willingness to use words and language that others find offensive, but somewhere completely different; it is in his use of the voice.

A$AP's trademark noise, which cannot be transcribed in language, sounds something like a pig snorting. Anyone who has

listened to even one song will know what we mean by this. We could try to transcribe it: 'URGHH' or 'AHH' or perhaps the closest literation possible is 'UUU' (we'll run with that). The noise crops up in every track; it simply wouldn't be A$AP Rocky without it. Kendrick Lamar even has his own go at it at the start of his rap in the new single with Rocky, 'Fucking Problems', The noise is deeply disconcerting and shocking, but also something we are intensely drawn to; it is both horrible and appealing, both repulsive and desirable. The noise contains the real brilliance of A$AP Rocky.

Psychoanalyst Mladen Dolar has written an insightful book on the subject of 'the voice'. There he notices, in a way that is relevant to our discussion of music here, that the two conventional ways that the voice can be seen are 'as a vehicle of meaning' or as the object of 'aesthetic admiration', i.e. what we consider to be a beautiful voice. In the course of the book Dolar asks us to think about a third way in which the voice functions, as something which is neither of these two, which instead has some power of its own to be uncanny and disconcerting, to dislodge our sense of both meaning and the beautiful.[150]

So what of A$AP Rocky's voice? It certainly cannot be described as 'beautiful'; if I describe it as I did above as 'like a snorting pig' few people take issue, but if I start talking about A$AP Rocky's 'beautiful voice' I will find few sympathisers. Likewise, it seems dubious that it can be described as 'a vehicle of meaning'. As the tension surrounding the criticisms of Rocky's misogyny indicate, the content is hardly the point, we listen to the music anyway, and critically acclaim it. Furthermore, what meaning are we to attach to our favourite trademark A$AP noise, 'UUU'? Clearly it fits neither category.

The first words that the world ever heard from A$AP Rocky, the first line of the first track on his debut mixtape, are: 'UUU, god damn, how real is this [...] how trill is this?' This needs close reading; we are offered the noise, on its own, and then we are

asked to think about how real that noise is. The answer is: it is so real that we cannot handle it. The noise expresses a reality of the voice that we usually repress, it shows us that the voice is not our tool which we use to express ourselves but something beyond us, something which is just a material noise, something which is out there, against us as much as for us, out of the control of the speaker.

From the first line he raps, Rocky's fame was set in stone; we are faced with something new, a voice that does not fit any existing model, and with the need to recognise that this teaches us something deeply real about voices. The voice is neither an object (of admiration) nor a form (the conveyor of meaning) but something that shows that there is no true distinction between those two things, both are material.

His second line introduces us to the word 'trill', a hip-hop term probably dating from around 2007, but which A$AP has made his own. 'Trill' means both 'true' and 'real' and also 'too real'. The message from A$AP Rocky is that the voice is 'too real' — it shows us how it is no one's voice, no human's voice, with no relationship to beauty, and no relationship to coherent meaning; it is a reality with nothing to organize it, nothing behind it. From 2013, with A$AP Rocky, the voice has taken over from meaning in the hip-hop world.

45. Robin Thicke and the Position of Feminism

It's taken *Everyday Analysis* a while to get around to discussing Robin Thicke ('#THICKE'); one of the most talked about instances of popular culture in 2013.[151] Thicke's performance with Miley Cyrus at the MTV VMA Awards at the time surpassed Beyoncé's famous Superbowl act as the most tweeted-about event in history. It's the single 'Blurred Lines', performed that night, which has been the major point of discussion in Thicke's brief time at the top of pop. Even putting aside seemingly legitimate accusations—and a lawsuit from Marvin Gaye's family—that the song stole a significant part of 'Got To Give It Up', 'Blurred Lines' has been condemned for its lyrics, which without a stretch of the imagination can be read as condoning rape, as well as generally taking part in the wider objectification of women in pop music, an issue which has raised its head again with Lily Allen's somewhat problematic attempt to weigh in on the issue.[152]

This article, whilst not ignoring the need to take a stand against 'Blurred Lines' and Robin Thicke himself, focuses on the fact that Robin Thicke is not solely or even principally to blame here, and nor are the admittedly much more valid targets of Sony Records and contemporary hip-hop legend Pharrell Williams, who should have known better but have seemingly got off scot-free while Thicke takes the blame. There are structures in place here on a far more entrenched level that need a feminist analysis. This article focuses on an inadequacy of our responses to the song. The response that we have seen, as a collective group joining hands against 'Blurred Lines', has almost universally been one of *pretending that we are not complicit in the mechanisms that have produced it.*

Attacks on Robin Thicke have emphasized his stupidity, with

the obvious joke that the clue is in his name in regular employ across social media. In the unlikely event that you haven't had the conversation yourself, a quick look at the comments at the bottom of any article on the topic will show that Thicke's sympathizers have also been characterized as blind to the effects of the song. The gesture we make to those who like it is: 'you just don't understand what's wrong with it'. Of course, this has the (in some way) positive effect of placing a kind of feminism in the position of enlightenment, condemning those incapable of seeing the song's misogyny.

But this position of 'enlightenment' *can serve to limit feminism and keep it where it is,* as something assimilated into normative rationality and not as something that continually questions that normality. Further, in emphasizing the enlightenment of the knowing commentator and the naivety of the popular and those who enjoy it, the divide between the intelligentsia and the everyday is widened. The aftermath of '#THICKE' also brought out a number of reiterations of feminism as the general position of the conscientious subject, such as that of the website areyouafeminist.com, which went viral, and which frames anyone not feminist as an idiot. There is of course a value in making the feminist position a kind of common sense, but in distancing ourselves from the 'idiots' who don't know how it really is we simply make ourselves free of admitting any part in what we criticize. We also avoid doing anything about it, since presumably the audience for our accusations of idiocy will not be the 'idiots' but our fellow enlightened classes. Even if this weren't so, and the 'idiots' actually heard our accusations of idiocy, they would presumably not take much interest in such antagonistic and patronizing criticisms.

The '#THICKE' saga took another intriguing turn showing exactly this problem when Robin Thicke himself attempted to switch from one register (the blind and stupid everyday) to the other (the intelligent and conscientious) by claiming that the

song's intention was to exaggerate and mock the way the music industry objectifies and unfairly treats women, that the song was in fact a kind of feminism itself.[153] Whether we believe it or not, there was nothing to stop Thicke making this switch; he could easily occupy this position instead. The point of course is that this would not change anything; the song could still be interpreted as it first was, operating to condone misogyny and even rape. In other words, Thicke's intention has nothing to do with it, whatever side of the divide he himself is on (whether it is that of the side which can see its misogyny or of the *fools* who don't understand how problematic it is), the divide itself is still reinscribed. Thicke's attempt to get out of trouble, implying that it's not his fault if idiots misread it, actually shows the problem with all of our responses in the first place, that they were little more than a distancing of ourselves from the issue, which does nothing to solve it.

Whilst it might have served a purpose to align feminism with common sense, what feminism needs to do next, and specifically in cases like this, is not reiterate that the world is full of 'idiots' who don't understand feminism. Instead it needs to continually question what complex patriarchal and misogynistic structures exist inside what we call 'idiocy', which we may ourselves be complicit in, and which allows these problematic norms to exist in the first place. Analysing idiocy, and not just saying it exists, has been feminism's strength from the start.

46. The *Sinthomic* Blank in Future Bass and Dubstep

In classical psychoanalysis a symptom is roughly a sign of something that ails us, which speaks through us by 'hooking onto language'. 'It', our unconscious, speaks when we are on the analyst's couch—and in everyday life—through the now-familiar means of slips of the tongue and pen, and in our dreams, jokes and bungled actions. But Lacan, in his late work, introduces something slightly different, which is yet connected to the symptom: the *sinthome*. This unfamiliar concept, which is beginning to get some airtime (it's got an entry on *Wikipedia* now), has many meanings, and means of meaning, but in an attempt to draw some together in a definition we can say that it is the *unanalysable, interminable and irreducible symptom* which ties our unconscious together; that inner something without which our mental apparatuses could oscillate out of control. It is not a purely essentialist idea, however, as whereas we all have *sinthomes*, they are not the same simple thing in all of us, but are

little singular meaningless and repetitive bits that link to our ownmost primitive *enjoyment*; that of life itself. Žižek labels them an 'elementary matrix of memes' in his book *Organs Without Bodies*.[154] Structuring us, it is our *sinthomes* that we must 'come to assume'.

So, where can we find examples of them today? In music, among other places, we can argue. Lyricists may have always found an outlet for their ailments through the form of versifying in song, cataloguing their symptoms therein, but in genres like dubstep and future bass we may now be able to discern the emergence of the *sinthome* too. Pearson Sound's masterpiece 'Blanked', for instance, will give us a first indication. The idea of the *blank* itself is a good way in: if there is a matrixial measure (a blank) to be filled in the quantised structure of a track, into it may be inserted a sound source that extends that measure, and therefore gets cut down to fill this blank. The cut-up repetitive bits of singing amongst the soundscape of 'Blanked', then, are instances of this type of *sinthome*; the words, their *meaning*, are no longer there, or are not whole, but their effect, their *enjoyment*, still is. In Burial too, in his dark tinges of mood made by manip-ulated fragments (those fragments so dear to Baroque creation, Benjamin would remind us)—the transposition of voice into tone, of lyrics into audible glitches and memes—we see a similarly advanced means of composition from the matrix of *sinthomic* blanks. Thus, in this *sinthomic aurality*, we meet the unanalysable, interminable and irreducible soul-jazz of our futures head on.

Art by Simon Levy.

47. Are Rammstein Fascist or Postmodern?

In Žižek's latest film, *The Pervert's Guide to Ideology*, he raises the connection between Rammstein and Fascism, which has been a familiar talking point since the band formed in 1994. The band's repeated use of Nazi-like militarism and, more directly, their references to material such as Leni Riefenstahl's film *Olympia*, made for the 1936 Berlin Olympics (but not screened until 1938), has led to numerous accusations that the band has various kinds of fascist sympathies.

Žižek's argument, as usual, is that this general position needs to be completely reversed. For Žižek, far from being sympathetic to Nazi ideas, Rammstein show us the ridiculousness of Nazism by allowing us to experience its emotional structure and the way it works by stirring us up into a violent frenzy, whilst attaching this to something divorced from Nazism completely. This shows us how Nazism works, and undermines its claim that our emotions are stirred by its greater cause or anything like that; they can be stirred up in this way for anything, even for a New German 'Hard' band like Rammstein. For Žižek then, 'the way to fight Nazism is to enjoy these elements [...] suspending the Nazi horizon of meaning and undermining Nazism from within.'[155]

Yet, this reading frames Rammstein as something strangely 'postmodern'. The band use and mock a style, showing that there is nothing unique about it. Frederic Jameson describes postmodernism as the style that undermines the previous belief in a 'unique, private style, as unmistakable as your fingerprint'.[156] In mimicking other styles, postmodernism aims to show that all there is is mimicry, repetition and quotation, and nothing individual, original or unique. Rammstein, in these terms, mimic Nazism, showing that there is nothing unique or essential about it.

The most famous definition of postmodernism is that given by

Jean-François Lyotard, who writes that the postmodern condition consists of 'incredulity toward metanarratives'.[157] Fascism, perhaps along with religion, is the ultimate example of a metanarrative, and has been discussed as such by many sociologists. A metanarrative is something that makes truth-claims, tries to explain things, to fix itself and appear 'right' or 'natural', and this is what postmodernism mocks.

So, would this be the opposition between Rammstein and Fascism; that it is Rammstein's postmodernism that makes it a criticism of Fascism, undermining the Nazi metanarrative by showing how there is really nothing behind its claims to stir up our emotions for its cause?

Perhaps. In asserting that there is nothing behind these emotional processes that are happening to us, by showing that one's emotions can be stirred up and directed at anything, used for any purpose, yes, one may exhibit incredulity towards metanarratives such as Fascism and Religion, which claim that there is something essentially right or true evidenced in their ability to 'move us' emotionally. But, one also risks something else in this assertion. That is, promoting a view of the world in which there is little or nothing behind that to which we attach ourselves. If this is so, then we must also ask: is this not the very world—in which it seems we have nothing to anchor our beliefs—out of which Fascism itself arises?

Ultimately what we might see is that there is something fascist about postmodernism, the two categories often opposed to one another. Jameson's work expresses the danger of promoting a culture in which one cannot 'believe' in anything, in which we assert that 'meaning' was only ever an appearance. Whilst metanarratives are obviously a problem, what Jameson could perhaps see that Lyotard could not was that *incredulity towards metanarratives' does not only come after Fascism (as a response to it) but also before it (as a cause of it)*. The very world that asserts a fragmented life in which there is nothing to believe in is

the same world that is allowed to believe in anything, even if that which we choose is a metal band like Rammstein. We buy 35 million copies of their albums, attend gigs, and cover ourselves in tattoos for them, defining ourselves by them. In this way at least, Rammstein are a symptom of our culture rather than a critique of it. This is the world in which we live, a 'postmodern' one not only passionately incredulous towards Fascism but in danger of falling back into it.

48. Anxious About UK Grime

The above *Everyday Analysis* article—'LONG.LIVE.A$AP: *The Voice as Trill*'—attempted (perhaps unconvincingly) to recover a radical element—of the voice, as *'trill'*, or 'too real'—in a modern strain of rap music which contains deep-rooted misogyny and advocation of violence. That article, however, did point out that in rap the voice can be thought of neither as an object of beauty ('what a beautiful voice') nor as the conveyor of meaning ('what a meaningful lyric'); we may not agree with what is being rapped, and we may not find the rapper's voice beautiful to listen to, so what is this enjoyment of the voice about?

The appeal of a repellent voice connects rap to genres like metal; both walk the line between fear and desire, a connection psychoanalysis has been interested in for years. In Freud, whilst fear can be thought of as directed at a particular object, anxiety is more unplaced and undirected. One moves from anxiety to fear. 'An internal, instinctual danger' (that of unplaced anxiety) is replaced by an 'external, perceptual one' (that of fear directed at a particular object).[158] Fear deals with anxiety. For Lacan, desire is also a way in which we deal with anxiety; the subject chooses particular objects of desire, in order to imagine that their unplaced anxiety will be solved by the acquisition of their particular object of desire.

Bringing anxiety into the discussion is the key to explaining the link between fear and desire in rap music. Desire *for* and fear *of* are both directed processes with an 'object', whereas anxiety does not have an object—according to Freud—it is unplaced and undirected. We deal with anxiety by producing something to fear and something to desire, so that our anxiety seems like something we can potentially get away from, by avoiding what we fear, and seeking what we desire.

In metal we get a slippage, a moment where the two acciden-

tally happen at once, what we fear and what we desire in the voice are the same. In certain other forms of music though, this relationship to anxiety seems less accidental and more unconscious.

UK Grime is a genre characterized by anxiety. Dan Hancox's recent book on Grime reminds us how the popularization and Americanization of Grime has slowed it down.[159] In traditional Grime 'spitting' is twice as fast as US-Style rap. An MC has 16 bars to rap (or 21 seconds, as So Solid Crew put it), before passing the mic. And the need-for-speed on the mic is related to the feeling of insufficient space in the Grime scene in general. The point is made by JME; the Grime scene is defined by being overcrowded: 'You'll get no air time like *Spaced*/Frankly there's not enough space/There's already too many stars like space' ('96 Bars of Revenge'). As an MC, there is no space for you, you're up against it, up against every other MC on the circuit; there are quite simply 'too many man.' The object of fear is the other MCs, and so is the object of desire. One has to target the success of those above them, 'I spread Grime like disease[/]I will not stop till my name rings bells like Dizzee's', and continually put down those below you or on the same level as you; 'you will never be like JME' ('JME'). The atmosphere is one that repeats the desperate search for an object for your anxiety. What it shows us is not that we must avoid what we fear and seek what we desire, but that as long as we have an 'object' to fear and desire, we can hold anxiety at bay.

49. 'I am Burial': *Anonymity, Gaze, and The (Un)True Self*

Who is Burial? Why doesn't he want us to know, and why do we care?

The recent discussion over the identity of electronic recording artist Burial began when an online magazine claimed that musician Kieran Hebden, who goes by the stage name Four Tet, was also Burial.[160] Burial is elusive—he doesn't do DJ sets or live performances, and has described himself to be 'a bit like a rubbish superhero'.[161] The resulting social media commotion tells us some interesting things about anonymity and the desire for unified identity.

EDA being mainly an anonymous collective, we have something in common with others who want to remain unidentified as a particular (group of) individual(s). One way to explain anonymity would be as an attempt to move focus away from the identity of the author or artist, and onto the work itself.

Anonymity is an attempt to avoid the 'gaze': a complex set of power relations that are in play in any relationship. Michel Foucault coined the term 'medical gaze' to explain the power dynamic between a doctor and a patient. According to Lacan, any gaze involves a 'blind spot'. As Žižek puts it: we can never see anything as it 'really' is, because our gaze (and thus the way we perceive things) is always already conditioned by numerous factors outside of our control.

The desire for anonymity, then, is also produced (at least partially) by the anxiety of being misunderstood. Removing an individual identity from Burial's music ensures the main relationship is between the listener and the music, rather than the listener and the persona of Burial, which could bear other influences, and possibly alienate listeners from music they might otherwise enjoy. Daft Punk take the same approach. Their quasi-

anonymity means that they don't risk some of the dangers associated with celebrity status: people's judgement of their personal lives doesn't affect the reception of their music.

For superheroes, though, as for Burial, their hidden identities attract fanatical desires to find out who they 'really' are. The desire to know the name and face of the anonymous person is the desire for unified identity. For Lacan, this comes from the mirror stage, when one sees their 'whole self' as a unified thing. Yet the unified image in the mirror is not the self, but an image of it: the self we see in the mirror, on which we base the idea of our unified self, is not ourself.

The unified self is an illusion, but a necessary one. Seeing ourselves as a unified whole enables us to feel a certain level of autonomy and control. This illusion of autonomy exists despite the fact that subjectivity is produced (according to Marx) by power relations, the needs of capital and the discourses of institutions like education, religion and popular culture.

Thus, Four Tet must (and does) deny that he is Burial to preserve his 'true' identity, to prevent having his identity split and associated with music he did not produce, and, also, so that the public *can retain the desire* to find out Burial's 'true' identity.

50. Record Store Day, and Why Home Taping *Should* Kill Music

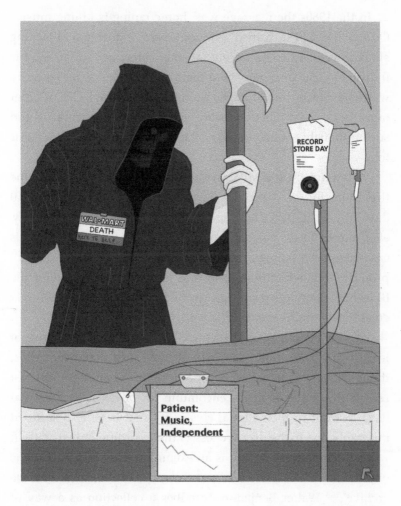

It's that time of year again: Record Store Day. As the likes of Joy Division, Nirvana, R.E.M., and Frank Zappa get set to have albums and singles posthumous- and post-disbandingly released and rereleased, and the cream of the crop of current artists and bands release special editions (including a reduction of The Flaming Lips' genre- and limit-pushing 24-hour song, '7 Skies

H3', to 50 minutes and 12 inches of wax), we look at where the spirit of recorded music has got to today, in this year of our Lord, 2014.[162]

In the 1980s the message was 'home taping is killing music'. Oddly, the BPI's (British Phonographic Industry's) attacking slogan was aimed squarely at the consumer—that is, the industry's *own* consumer—and their den of iniquity, *the home*. As well as the recording of music from the radio, vinyl, CD, or other tapes to cassette, this doomsday prophecy supplementarily and surreptitiously seemed to target the home taping *of our own music* too.

More recently, the MP3 revolution has come under this same fire, following on especially from the headier and more radical days of peer-to-peer sharing, before Big Music (iTunes, Spotify, etc.) moved in to make sure money could be milked from this cash-cow-in-becoming (The Pirate Bay torrent site, however, still proudly and defiantly display the logo that accompanied the BPI's home taping slogan—a cassette in the place of a skull over crossbones—on its ident ship's sail).

We now inhabit an age in which 'music'—in the BPI's sense, at least; that is, *the music industry*—is more alive than ever. Alive, though, in an *undead* sense. Record Store Day celebrates those last record shops standing; it's encomium for physical formats that have lost out to their digital rivals, but that have also suffered miserably due to the divisiveness of the recording industry itself.

Paul Mawhinney's story is an exemplary case in point, as the once-owner of the world's largest record collection, known as 'the archive'.[163] Walter Benjamin describes a collection as a way of 'divesting things of their commodity character by taking possession of them', and states that it is thus 'the most intimate relationship that one can have to objects'.[164] Mawhinney's collection—a forty-year labour of love, valued at $50 million, that he now needs to sell—hasn't been able to find a buyer even at the asking price of $3 million, and has been undergoing a disman-

tlement into individual sales over the past few years. As he has himself lamented, it is *history itself* that is here being broken up and subsequently disseminated. Although he argues that in part the MP3 has killed off the desire for the physical music format (as opposed to the virtual), he has identified that the hegemony of the chain retailer (Wal-Mart, for example, in America) has been instrumental in bringing his independent record store, Record-Rama, down.[165]

This then is not the inevitable, yet sad, overcoming of the record store model which is giving way to a more convenient mode of music vending, but something more, something that has drastically changed the selective structures involved in music production itself. As David Graeber has put it in relation to the Occupy Movement and its championing of the 99%: 'if 1% of the population controls most of the disposable wealth, what we call "the market" reflects what *they* think is useful or important, not anybody else.'[166] With the over-competitive forcing-out of the smaller-scale music vendor, and the (only ever attempted) exclusion of the free sharing of digital music, we see the music industry getting closer to being dominated by what Žižek might call a 'master-signifier'; something which totalises a field after exempting itself from it (i.e. makes it into a hegemony). The master-signifier here is this 1%; the same 1% who (most likely disingenuously) sounded the alarm about home taping—what was really at stake was not the music or recording industry itself, but its business interests (and the only interest of business is money).

It is therefore worth wondering what effect this corporatist ideology behind the home taping slogan has actually had on the music, recording, and record-selling industries it was ostensibly set up to protect. Its resulting forecast would look like this: that after the death of the independent record shop, the death of independent music (although indubitably its *drive* will always remain, however far underground it may be driven). If we view

popular music (in however microsocial a form) as a series of historical ruptures and epistemological shifts, then in its current prescriptive manifestation—that dictated by the false and falsifying world of *X-Factor et al*, which sells the hollow goal of superstardom at 15 minutes a pop, and allows no *new* music to win the day, a manifestation that aims to perpetuate and reinscribe itself in the very same manner as capitalism does—no new dimensions will be able to open up.

As Félix Guattari perspicaciously put it (in uncompromising terms):

> As for young people, although they are crushed by the dominant economic relations which make their position increasingly precarious, and although they are mentally manipulated through the production of a collective, mass-media subjectivity, they are nevertheless developing their own methods of distancing themselves from normalized subjectivity through singularization. In this respect, the transnational character of rock-music is extremely significant.[167]

This formative moment of self-creating through music is precisely that which is being (purposefully) effaced—and replaced by a process of *creation in the image of the market*—by this master-signifier that is ruling the mainstream music world. The other side—the truth—of the false prophecy 'home taping is killing music' is that it is becoming so much harder for a revolution in music to actually occur again; that is, harder for 'music' (in its stagnated, business-interested form) *to be killed*. In the ethos of those movements in popular music—rock & roll, 'krautrock', punk, grunge, etc., that have overcome old and stagnated orders—it may now more than ever be the time to advocate killing music with home taping!

Art by Ali Hoff.

Philosophy

51. Big Questions, Age-Old Debates, and Problems We Will Never Solve

Recent scientific developments in cell research have re-opened questions of sexuality and genetics, subjects worthy of far more detailed discussion than a short *Everyday Analysis* article can provide. It's another aspect of the 'debate' which is the issue here: the use of phrases and language which insist on the 'age-old' nature of these debates, their status as 'big philosophical questions' that 'we will never solve'.[168] This article is about the way in which we desire to construct a continuity (these questions have *always* been questions) out of discord (the idea that there are things we will *never* agree on).

First, the idea that there are questions we will never solve appears to be comforting rather than disconcerting. When the phrase is uttered, 'ah, it's that age-old debate again', it's usually to dissipate or end a discussion, perhaps to prevent it becoming too passionate. Perhaps at other times it is employed to simplify matters: if you are discussing complex gender issues, and I pipe up with reference to the 'good old nature-nurture debate', I impose something I can understand onto your complex conversation in order to make sense of it. Edward de Bono's *Lateral Thinking* precisely addresses this simplification and its consequences when he states: *'it is historical continuity that maintains most assumptions – not a repeated assessment of their validity'*; when we imply that things have 'always been' we prevent further interrogation.[169]

What this framing-of-the-debate-as-endless does is make us think that there is a reality beyond our knowledge that we can discuss and debate over, but the truth of which (and we insist there *is* a truth, be it one side, the other, or a complex fusion of the two) we will endlessly be working towards. In saying that there are things we will never know, we protect the possibility of

knowing, and the idea of an objective truth outside of our subjective knowledge.

This is something Immanuel Kant knew there was a problem with. As Gillian Rose elucidated in the 1980s, his concept of objective validity, in which things themselves and our experience of them take on meaning only in relation to each other, means that 'it makes no sense to retain 'reality' for something beyond our knowledge.'[170]

In his recent book, *Demanding the Impossible*, Žižek uses Kant similarly, saying that he follows Kant in a preference for politics over ethics. This is not just another moment of deliberately provocative Žižekianess, but (also) a serious point. Politics, like that which we find in (a particular reading of) Kant, is purely formal and does not relate to an outside reality, whereas ethics pretends to relate to 'age-old' issues of a right and wrong, which is found outside our knowledge. For Žižek, 'what we define as our good is not something we just discover [...] we have to take *responsibility* for defining what is good.'[171] What we need is an ethics which is political, and a politics which does not pretend to be ethical.

The language of 'the age-old big philosophical debate' is the opposite; it pretends that the good is just out there, whether we get there or not, and ends the discussions that are really needed to take responsibility for defining it. On the other hand, if we do away with traditions of ethical good and state that the good is only what we define it as (as Žižek says), perhaps we face another danger, that one can make 'good' into whatever their politics wants it to be.

52. On Žižek Writing for the *Guardian*

Over the last few years it has become increasingly prominent and publicized that Slovenian philosopher Slavoj Žižek, to whom *Everyday Analysis* is much indebted, has been writing regularly for the *Guardian*. The collaboration is benefitting both, making the *Guardian* seem to be a space for truly radical thought, and making Žižek seem to be in touch with the 'real world', not confined to the ivory tower of academia.

Žižek writing for the *Guardian*, like his film-making (*A Pervert's Guide to Ideology*, his second written-and-presented film, being out now) is part of a popularized Žižek, which, for his close followers, has often been troubling. It is part of Žižek's success that he has been able to turn himself into a kind of commodity, an object of desire himself; 'the Elvis of cultural theory', as he gets called. Speaking of Žižek's early career, Ian Parker comments that 'readers found themselves bewitched and fascinated by something inside his first book—something like the 'sublime object' itself—that they could not grasp.'[172] Žižek has since then developed this further, and has been continually able to make people feel there is something more about him, above and beyond what he writes, something charming, attractive and alluring about the man Slavoj Žižek himself. His writing for the *Guardian* is a major part of this construction.

In 2008 Žižek wrote what is probably his most talked-about article for the *Guardian*, 'Rumsfeld and the Bees'.[173] In it he made a smart point, bouncing off Donald Rumsfeld, and in his typically charming way, made clear what is often an obscure point in psychoanalysis. Žižek quoted Rumsfeld's comment:

There are known knowns. These are things we know that we know. There are known unknowns. That is to say, there are things that we know we don't know. But there are also

unknown unknowns. There are things we don't know we don't know.[174]

Žižek then adds his own bit of genius:

> What Rumsfeld forgot to add was the crucial fourth term: the "unknown knowns" – things we don't know that we know, all the unconscious beliefs and prejudices that determine how we perceive reality and intervene in it.[175]

The point is wonderful, and makes clear what the Lacanian unconscious is: it is the thing which we don't question, which we assume is a 'given' but which is really crucial in structuring our thoughts.

We are charmed once again, in the typical Žižekian way, by this smart quip lobbied against someone we already want to think is stupid; he charms us by gratifying our desire. But there is a blindspot of Žižek's own here, which shows an issue with the charming newspaper-writing and filmmaking part of his persona. While focussing on making a clever quip, he leaves the biggest problem with Rumsfeld unquestioned—the idea of 'unknown unknowns'.

Unknown unknowns, meaning things that we don't even have the ability to realize we don't know, implies the future. The gesture is, we cannot even imagine what we are yet to know, since the future brings with it all sorts of new and revolutionary knowledges that we are nowhere near even perceiving the possibility of. It feeds into Žižek's belief in the revolution-to-come: he has for years insisted in a revolution from nowhere, from outside, which could come and shatter current thinking, an unknown unknown that could change our problematic status quo. The thought of Derrida can point out a problem with this; he writes that revolution is always deferred, always 'to come', something we project into our future. Lee Edelman's book on

queer theory, *No Future*, has made a similar point; any projection of the future is a projection from within your own present, created by the terms in which you live.[176] Even when we say that we can never know what the future will be, this 'unknown', something undefined, is not really ever unknown, it is rather what we mean by unknown in our present moment; it is determined, even when we claim that it isn't.

The point here is something that other elements of Žižek's project could themselves point out: in fact there is no 'unknown unknown'. There are only 'known unknowns,' and nothing beyond them. In other words, there is nothing beyond what we know that we don't know, because what we don't know is conditioned by what we do know; it is the other side of it. The desire to believe in 'unknown unknowns' betrays a desire to believe in something out there, something other than our own limited knowledge, which is potentially more dangerous and radical, a future that is or could be coming. In fact this 'unknown unknown' is one of the 'unknown knowns' that Žižek so cleverly points out to us. What he fails to question shows his own point; he, like Rumsfeld, thinks he does not know what he means by unknown unknowns, but in fact, unconsciously, he does.

Politics

53. Go on Ahead, and Write a Letter to Your M.P.: *On Not Getting Through*

Sound advice is offered by McCarthy in their 1990 song, 'Write to Your M.P. Today'; indeed, advice to 'oh, go ahead, don't be afraid, go on ahead, and write to your M.P.'... The question is, however, is it the same thing to do so *today*, in 2014, as compared to writing to your M.P. in 1990? (not exactly a golden age of grassroots representation, but there may be important differences between these dates...)

The method of conveyance might be different in the first place; electronic mail is a much more common means of communication now, and an easier and quicker method, too, than snail-mail. But with that also comes new technologies for responding; as many letter-writers' testimonials will attest, the automated response is now part and parcel of how we hear back from our M.P.s, and this is often followed by a posted letter from the House of Commons—usually a standardised note written from a *pro forma* explaining why what you've written in opposition to is being gone ahead with regardless...

After this the constituent will likely also find that their email has been added to their M.P.'s mailing list, and will thus receive regular policy updates to their email address. The whole of this process of postal relay then begs the question whether McCarthy's valiant advice still stands, in the face of a technologised postal system so driven by hegemonic market and marketing forces, but it also asks whether a letter always arrives at its destination, which Lacan argues it does, and which Derrida staunchly contests.

In Derrida's words in his essay 'To Speculate—On "Freud"' in *The Post Card*: 'the letter makes its return after having instituted its postal relay, which is the very thing that makes it possible for a letter *not* to arrive at its destination, and that makes this possi-

bility-of-never-arriving divide the structure of the letter from the outset.'[177] For Derrida, the 'place of the letter' is divisible. In our M.P. scenario we may well be able to perceive our letter's fragmentation: from its originally having been sent with concern over a current policy put forward, or supported, by our constituency's member of parliament, through its being broken up into a glib response, minimally dealing with, or rather, reinforcing, the decision taken, to thereafter being signed up to an information-bombardment system, and receiving endless Tory mailouts to our email, which is the very last thing we wanted.

This being, in fact, our desire's complete inversion; but it is Lacan who maintains that the sender receives their message back from the receiver in an inverted form… It is perhaps, then, that processes of both fragmentation and inversion go on in writing to your M.P. today, but more so that the destination at which the letter always arrives is already elided.

54. What's Really at Stake in Women Serving on the Frontline?

The UK Defence Secretary, Philip Hammond, has recently announced that a review into the issue of female soldiers serving in frontline infantry and tank units will be brought forward to this year, and has recommended that they should be allowed to do so. So far, the debate around this announcement has focused on women's physical and mental capabilities, their potential vulnerability and the question of whether direct combat is fundamentally different to other military roles.[178] It is worth asking, though, what is at stake more broadly, both structurally and

psychologically, in this question.

What if the current situation is not really about protecting women but about protecting men? Simone de Beauvoir claims, in terms particularly appropriate to the armed forces, that a man's life is 'a difficult enterprise with success never assured', but yet that:

> He does not like difficulty; he is afraid of danger. He aspires in contradictory fashion both to life and to repose, to existence and to merely being; he knows full well that 'trouble of spirit' is the price of his nearness to himself; but he dreams of quiet in disquiet [...] This dream incarnated is precisely woman.[179]

Woman is the Other who secures man's existence, allowing him the security of peace even in the midst of war. Women enable the separation of external and internal worlds—of Afghanistan and home—by preserving inviolate a version of man which he himself cannot maintain. This is evident in the long history of women-who-wait, extending back at least as far as Penelope in Homer's *Odyssey*, who waits faithfully for Odysseus to return for twenty years, refusing all other suitors. In the nineteenth century there is Amelia in *Vanity Fair*, who stays loyal to her dissolute husband George Osborne when he leaves to fight at Waterloo, and long after his death.

Before assuming we have moved beyond this, we should recall that Gareth Malone's Military Wives Choir has recently played a similar role. Their single, 'Wherever You Are', which reached number one at Christmas in 2011, includes the lines 'Wherever you are our hearts still beat as one/I hold you in my dreams each night until your task is done'. In the military, more than perhaps anywhere else, the idea of Woman described by Beauvoir still persists: 'whatever may be the hazards he confronts in the outer world, she guarantees the recurrence of

meals, of sleep; she restores whatever has been destroyed or worn out by activity'.[180] This separation of war and home is particularly important because it cannot, in the end, be maintained, as Post-Traumatic Stress Disorder testifies.

For Beauvoir, the converse of the ideal woman-who-waits is the woman who 'inspires man with horror'.[181] There is something in Woman which is not captured by the ideal image set up by men, so that 'she is not only the incarnation of their dream, but also its frustration. There is no figurative image of woman which does not call up its opposite: she is Life and Death, Nature and Artifice, Daylight and Night'.[182] This is the threat from which, until now, men on the frontline have been protected. The woman-who-fights gives shape to this horror, indicating that the image in which man invests his survival is an illusion that might turn against him at any moment. As well as this, she brings home the reality that women, like men, are reducible to fallible, breakable bodies. It is not, then, because women are different from men that they have been kept from the frontline, but because allowing them there might demonstrate that they are not—and hence that the idea of Woman which has been relied upon for so long does not emerge from within women but is imposed upon them in order to compensate for a lack within men.

Should we, then, celebrate Philip Hammond's announcement as the demystification of an illusion? Perhaps. Or, instead, this move might be a symptom of the failure of a different illusion. Not the illusion of Woman, but of masculinist British military power, which in 2014 retreats from Afghanistan amidst a swathe of ongoing cutbacks. It is possible that women will be allowed to serve on the frontline during the first year since 1914 in which the UK has not been engaged in military combat. According to a *Guardian* article on this topic, senior military staff have referred to this as a 'strategic pause'.[183] At this moment of retreat, when it is the army itself that waits, the unacknowledged hope seems to

be that Woman might once again hold the key to restoring what
has been worn out and destroyed.

Art by Ada Jusic.

55. Resisting Arrest: *The UK Home Office's Tweets*

The UK Home Office's tweets of arrests of (suspected) 'immigration offenders' (with the all-important *'suspected'* clause being left off the hashtag itself, which presumably was designed to trend as just *'#immigrationoffenders'*), and the now-notorious racist 'Go Home' van, which was driven round targeted 'ethnic' areas of London, have rightly come under heavy criticism recently, not least on the social media platform itself—with tweet comparisons to Kristallnacht and so on abounding—and in most mainstream news media. It is indeed quite astonishing to see an establishment body, a governmental department, publicising arrests, which we expect to see more on pulp TV shows like *Cops* or in tabloid newspapers; and not just any arrests, but very specific ones; ones pandering to the shift right in electoral ideology, towards party-manifestoing (UKIP, BNP, etc.) predicated on producing racial difference as the key political factor negatively affecting the UK, and thus simultaneously propounding and popularising this tactic.

The operation is of that which Paul Gilroy describes succinctly in *There Ain't No Black in the Union Jack*:

> It is not, as many commentators suggest, that the presence of immigrants corrodes the homogeneity and solidarity that are necessary to the cohesion and mutuality of authentically social-democratic regimes, but rather that, in their flight from socialistic principles and welfare state inclusivity, these beleaguered regimes have produced strangers and aliens as the limit against which increasingly evasive national particularity can be seen, measured and then, if need be, negatively discharged.[184]

(David Starkey's comment on *Newsnight* that 'whites have become black', in response to the events of the UK riots, is an exemplary example of this *negative discharge*). How it works in this instance is by what Louis Althusser calls 'interpellation'. Althusser claims that 'ideology "acts" or "functions" in such a way that it "recruits" subjects among the individuals (it recruits them all), or "transforms" the individuals into subjects (it transforms them all) by that very precise operation which I have called *interpellation* or hailing, and which can be imagined along the lines of the most commonplace everyday police (or other) hailing: "Hey, you there!"'[185]

In this 'Hey, you there!' the individual becomes a *subject* through turning around to meet the call, and thus 'recogniz[ing] that the hail was 'really' addressed to him'.[186] They are *interpellated* by being given a specified place in the ideological order of things; and in these tweets and photographs and messages (of '[Hey, you there], go home!') interpellation is being deployed in the most propagandist way. In the UK Home Office's campaigning the message given is that *#immigrationoffenders* should be able to tell who they are by being specifically addressed (i.e. 'profiled'; the lack of initial photographs of white suspects being rounded up, for example, was an obvious contentious indicator); and the other implied targets of the campaign—the '*#anti-immigrationoffenders*'—are interpellated too, by proxy ('hey, you there that supports that, you can support this...').

Through this form of targeting, ideology has so often been able to slip into the public discourse unrecognised. It is now, however, that the racism inherent in these campaigns is to an extent being addressed, but nonetheless the clear message was put out there, and is out there still, and still circulates; and so such publicism, in its possible returns, needs resisting. As was discussed in an earlier article of ours, about the Scrabble squabble (below), online platforms are not always the easiest

place to make a mark in this regard, but resistance to such arrests has had some effect, and thus will its continuation remain necessary.[187]

56. The Mark Duggan Inquest: *Politicians and Fetishistic Disavowal*

The inquest into Mark Duggan's death ruled that he was 'lawfully killed' by an armed police officer, despite the fact that he was not holding a gun when the policeman fired, and that the police procedures that led up to the shooting were conducted inadequately. In the reaction that followed, there was anger and confusion at what seemed like a major internal contradiction in this verdict. Politicians and lawyers (groups which frequently overlap) dominated the public discourse after this event, as well as the shocked silence of the Duggan family and attempts by many sections of the media to smear them. The response of the vast majority of politicians who commented on the case ran something like this: 'The verdict is baffling; the police have many questions to answer; we must respect the jury system; we must restore public trust in the police'.

These statements are good examples of the logic of fetishistic disavowal, a term Žižek uses to mean the state where one admits the limitations of their own ideology and yet continues to conform to it, a typical situation in late capitalist democracy. The formula of fetishistic disavowal is: 'I know things are like this, but I will not admit to that (disavowal), because an investment in a part of the whole edifice of things allows me to ignore the contradictions in the edifice of things as a whole (fetishism)'.

In the responses to the Mark Duggan verdict this takes the form of a disavowal that the jury's verdict seems problematic, unjust, wrong, and that the police have behaved in a way that is at the least brutal and most probably racist, by fetishising the idea of juries as always correct and unbiased, and the idea of the police as honourable public servants.

Here we can see politicians and lawyers justifying their continued power through the fetish of the Law. There is a

disavowal that the most basic ideological state apparatuses have broken at their very centre, which is supported by an investment in the Law, an abstract idea which legitimates the continued existence of these apparatuses, and the politicians' ability to speak.

Mark Duggan's death caused riots. If politicians did not enter this structure of fetishistic disavowal, they would not only be seen as justifying those riots, they would be inviting them to reoccur with their justification laid bare.

57. The Knavery of David Cameron, The Foolery of the Coalition: *A Note on Political Engagement*

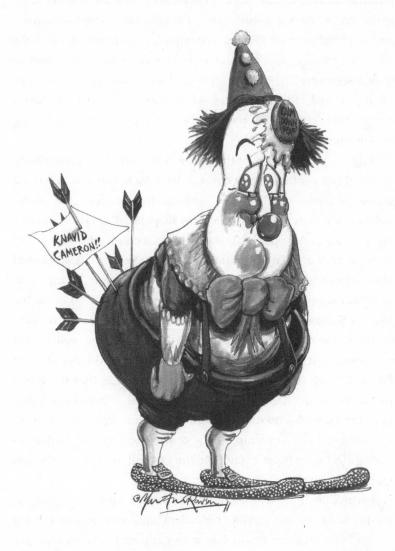

'Whether dost thou profess thyself, a knave or a fool?' is a question asked by Lafeu of the Clown in Shakespeare's *All's Well That Ends Well*.[188] Lacan discusses this distinction in *The Ethics of*

Psychoanalysis, and, in a move similar to that in Freud's essay 'The Antithetical Meaning of Primal Words', finds a trajectory towards similarity—if not synonymy—in both words in relation to their political bearings. 'The "fool"', Lacan says, 'is sometimes clothed in the insignia of the jester'—as is often the case in Shakespeare— and his fundamental foolery 'accounts for the importance of the left-wing intellectual.' The knave on the other hand is 'an "unmitigated scoundrel"[,] he doesn't retreat from the consequences of what is called realism; that is, when required, he admits he's a crook'; this 'constitutes part of the ideology of the right-wing intellectual'.[189]

Žižek irons out a few of the creases for us in further describing 'the fool [a]s a simpleton, a court jester who is allowed to tell the truth, precisely because the 'performative power' (the sociopolitical efficiency) of his speech is suspended', and 'the knave [a]s the cynic who openly states the truth, a crook who tries to sell as honesty the open admission of his crookedness, a scoundrel who admits the need for illegitimate repression in order to maintain social stability'.[190] With the former this is so often the case in Shakespeare in that the fool will advise queen or king (such as Lear) unabashedly truthfully, though the veil of *jest* disallows their statements' symbolic efficacy to make any mark in the real. With the knave, the odd short-circuit is that there is a risk to the maintenance of their dominant stance in not admitting to being a crook—as Richard Milhous Nixon was quick to find out—suggesting something of a compulsion in the that-way-voting electorate (who are not the *elite*) to will their own abjection and subjugation at the hands of the crooked.

Lacan's lesser-discussed qualification of these designations might assist in suggesting the whys and wherefores of this compulsion. The result for Lacan of gathering knaves who are crooks 'into a herd' is it 'inevitab[ly] leading to a collective foolery', and, 'by a curious chiasma, the "foolery" which constitutes the individual style of the left-wing intellectual gives rise to

a collective "knavery."'[191] David Cameron is undoubtedly a knave, as are his party cronies, as all the increasingly-overt rich-privileging and racist-courting Tory policy-making can attest, the crookedness of which is often openly admitted, but admitted, as Žižek says, '*as* honesty', which is its lie. The government's collective foolery is hinted at in the coalition by the Lib Dems' impotent scramblings to disagree with certain policies *a posteriori*; but this is in fact only a weak middle position, failing to attain to the *a priori* point of principle that constitutes the fool's 'jest'; as Jonathan Haynes demonstratively tweeted: 'so Nick Clegg has now laid into the "go home" vans. If only he was deputy prime minister and was able to stop them...'[192] So it might be that the only element of collective foolery that actually comes about in the herd of crooked knaves and their lackeys that is the coalition is the constitutive *inability* of the fool's position to emerge anywhere in their efficacious discourse. For the collective knavery resulting from the herding of fools in recent times, Tony Blair and New Labour are its epitome, with their hegemonic aspiration to an ideal of 'we're all middle-class now' in the midst of all their grave exploitations in this country and the world over; 'thou art both knave and fool' as Lafeu says.[193]

The point here, however, is not to disrecommend politics, as some sort of lost cause, or to promote apathy by suggesting all politicians are fundamentally 'the same as one another', but it is rather to prompt us to ask again the question that was always key for Gilles Deleuze and Félix Guattari: 'Why does desire desire its own repression?', and to always be on guard against that which is at the heart of its answer, which Ian Pindar and Paul Sutton point out: 'desiring oppression also operates on a global scale, when 'the workers of the rich nations actively participate in the exploitation of the Third World, the arming of dictatorships, and the pollution of the atmosphere''; even 'most leftist organizations such as trade unions and workers' movements are not immune to desiring oppression or micro-

fascism.'[194] In fact, little could speak as convincingly in favour of political engagement as this very lack of such inherent immunity; beware, then, the false foolery in knavery, but so too the knavery in foolery!

Art by Martin Rowson.

58. Nelson Mandela: *Symbol or Allegory?*

Nelson Mandela's recent death has been overshadowed, it seems, by two events that took place at his memorial service; the first, a 'selfie' taken by Danish Prime Minister Hella Thorning-Schmidt, which also featured Barack Obama and David Cameron, and the second, a controversy surrounding the sign language interpreter employed to translate the speeches at the event. Thamsanqa Jantjie, the man in question, apparently employed signs that had no meaning in any recognisable system, though to many of those watching who did not know sign language, nothing seemed amiss. In plain parlance, he made it all up. Or perhaps, as he now claims, experienced a schizophrenic episode. The honesty and mental health of Mr Jantjie are not, however, the topics of this article. We are more interested in what the whole episode suggests about how we interpret signs, and indeed, how we interpret Nelson Mandela.

It is not just Mr Jantjie who failed to interpret correctly; many of those watching in the stadium and on television misinterpreted his signs when we assumed them to have meaning, or, more precisely, to be linked directly to the words spoken by those on stage. In Benjamin's terms, we read the signs as symbolic rather than allegorical. A symbol, Benjamin points out, is a kind of sign privileged in Romantic thought, where it stands for organic unity and completeness. A symbol always 'insists on the indivisible unity of form and content'. If we view sign language as symbolic, we are also making a basic assumption about all language—that it conveys concepts, which are implicitly considered to be whole or complete, in something approximating a direct manner. It turns out, however, that Mr Jantjie's signs were not symbolic but allegorical. For Benjamin, allegory is not defined by wholeness but by incompleteness and disjunction. In allegory: 'Everything about history that, from the

very beginning, has been untimely, sorrowful, unsuccessful, is expressed in a face—or rather in a death's head'. Allegory does not claim any sense of mastery over meaning but instead implies our own subjection, especially our subjection to death. From this perspective, the failure of the sign language at the memorial service to make sense does not render it meaningless but means that it *comes to signify failure itself*. The signs work against any attempt by the speakers to assign a sense of completion or wholeness to Mandela's life. They are, at least for those who don't understand sign language, the optical unconscious of the visual field: that which we do not at first recognise, but which once revealed transforms what we are seeing. This should make us doubt not just the particular signs in question, but *the whole spectacle with which we have been presented*.

It has become a commonplace, for example, to refer to Mandela himself as a symbol; a symbol of hope, a symbol of freedom, a symbol of a united South Africa, and so on. This constructs a Romantic image of Mandela that allows us to invest uncritically in the concepts of hope, freedom or nationalism themselves as if they are complete and self-evident phenomena. Such symbolisation is, of course, important, and even vital, during times of political struggle—not because it is true, but because it offers a source of unity. But what if, post-Apartheid, we read Mandela not as a symbol but as an allegory? In this case, his meaning is no longer fixed, since in allegory '[t]he false appearance of totality is extinguished'. To read Mandela as an allegory is to read him as the sign of an incomplete project, as part of the history of the subjected rather than the history of the victors. It is to insist that we cannot talk of Mandela's victory, since placing him on the side of the victors would be to fix him within a political structure that ultimately serves to entrench power and privilege. Such a reading would protest against any suggestion that Mandela's long walk to freedom was ever, or could ever be, completed, since this would imply a false image of

totality. Far from closing down meaning, such a reading opens it up, since allegory is not fixed and restricted in the same way as symbolism. Seeing Mandela's life in the form of an allegory draws attention to its incompletion rather than memorialising it, and in this way reminds us of the radical political possibilities that he left unfulfilled, or partly fulfilled. The major significance of Thamsanqa Jantjie's hand signals is that they are the unexpected and unintended fracture of the visual field that allows this alternative reading to appear in plain view.

59. The Revolution, As It's Being Televised... *Brand, Badiou, and Voting*

What is your relation to democracy as such? Your group maintains that 'the principle of democracy [is] that every-one counts as one'. But you don't vote, you don't participate.

Democracy doesn't exactly mean that all individuals are counted as one in their own right. It's a matter of knowing how we are counted by the state. [...] This question of democracy is profoundly linked to the state in general. Lenin used to say that ultimately, democracy is a kind of state. The question is how people are counted by the state. Are they counted equally? Are some counted less than others, or hardly counted at all? [...] It is a matter of asking how things in society are counted, or go uncounted. It is through this kind of question that, in our opinion, democracy exists as a real and active figure, and not merely as a judicial, constitutional mechanism.[195]

To avoid this article turning into the Russell Brand/Alain Badiou equivalent of the popular online game *Who said it, James Joyce or Kool Keith?*, the above—to clarify—is a quotation from an interview with Badiou conducted by Peter Hallward in 1998.[196] There are remarkable similarities in its tenets to those recently espoused by Brand in his editorial for *New Statesman* and his interview with Jeremy Paxman on *Newsnight*, which have been doing the mediatic rounds recently.[197]

The main question Brand has come under fire for is the question of electoral voting; like Badiou, Brand doesn't vote, and defends this position as a politically-engaged response to the current system, which carries with it radical potential for change... indeed, revolutionary change.

Robin Lustig misses this point completely in his woeful response to Brand's pronouncements, in which he suggests that 'apathy is cowardice' (of course Brand premonitorily dismisses charges of apathy in stressing non-voting's engagement, which passes Lustig obliviously by), and that it is only voting that has ever effected change — *look at the minimum wage introduced after the Labour landslide,* he says.[198] Fellow comedian Robert Webb, in his open letter to Brand, takes a similar tack, suggesting that although Labour didn't do enough, they effected change for the better after being voted in...[199] But these panderingly moderate positions only pledge an allegiance to the hegemony that Brand seeks to deconstruct, even if only in terms of political 'consciousness' (to use his term); they both tend to only see a bright future in a past manifestation, whose flame was flickering at best then, and is now extinguished. To use any Tory's favourite words: *it is as a result of the last Labour government that we are where we are now...*

In his philosophy, Badiou stresses the importance of *fidelity* to an event (and, for him, an *event* can occur in the fields of love, science, art and politics). In politics, in the run-up to the election in 2010, the Liberal Democrat Party seemed like an event. In the unprecedented televised debates Nick Clegg cut a fresh shape, made some remarkable promises, and ultimately garnered a lot of votes. But as a great swathe of Lib Dem voters will no doubt agree, it has been impossible to keep fidelity to those votes, the reason for which being that just because the Conservatives stuck the word 'moral' before the word 'majority' (as the rhetoric was) and with that somehow convinced Clegg and co. that they actually had a majority, the major changes the Lib Dems promised have gone completely by the wayside: 'scrapped tuition fees' became tripled tuition fees; 'changing the voting system from first-past-the-post to proportional representation' became the 'compromise' referendum on the engineered-to-be-too-confusing alternative vote (AV) system...

This is what voting led to last time... Clegg betrayed every student in the country, the majority of his voters, and a sizable portion of his party, by swinging right (his latent rightist tendencies blooming in his ostensible 'power'-grabbing goes only to prove that it wasn't *defection* to the right). What the outcome of voting announced after the UK's last election was this: 'the country has spoken, and it has said it's undecided'; this clear message was simply annexed by the conniving Conservative party, parading under the populist banner of the bankrupted word 'morality' (with no empirical, or numerical, evidence to back it up). It is through this move that we see in fact *how votes have been counted*, as Badiou insists is what's really at stake here.

In the balance of the hung parliament of 2010 hung the way in which votes would be counted, and a violence was done to their counting through how they were. Instead of this abeyance being read as an indicator of the deep dissatisfaction of the public with electoral options and subsequently being addressed by those in positions of responsibility, it was capitalised upon by opportunists, and through spin.

So, what would be the consequence of Brand's non-participatory call? It would perhaps be to revolutionarily *prove democracy* to its own abusers... As Žižek writes in *Violence*:

What happens is that, by abstaining from vote, people effectively dissolve this government – not only in the limited sense of overthrowing the existing government, but more radically. Why is the government thrown into such a panic by the voters' abstention? It is compelled to confront the fact that it exists, that it exerts its power, only insofar as it accepted as such by its subjects – accepted even in the mode of rejection.[200]

60. Sending Shit to UKIP

What began as a harmless protest became abject... As UKIP disseminated its racist election leaflets, people who aren't racist decided to start sending the leaflets back to their Freepost address, sometimes with bricks attached, so as to cost UKIP more in taking receipt of them. People took it further, and began to send UKIP shit, blood and cum.[201] This can't be condoned, but only because it puts the health of postal workers at risk. It seems, however, to be the only form of protest that can be legitimately mounted against UKIP, and it has a powerful, theoretical underpinning.

Dirty protests occupy a particularly powerful position in our culture and cultural memory. They are so visceral that we can imagine the shit-smeared walls of a prison without ever having been there, without even having seen photographs. Dirty protests go alongside hunger strikes. They are the final recourse of people so silenced that the only way they can speak is by turning their protests back on their own bodies and their own space; that is, by *utilising* their own bodies (often, all they have left). They draw attention to the rejection and ejection enacted by the society that has radically *Othered* these protesters, by using what is rejected and ejected from their own bodies to confront this society. Whilst we haven't been degraded as an electorate to the extent that the political prisoner confined to her cell has, UKIP is beginning to hold an analogous position in our public life to the gaoler of the political dissident. The hegemony of the media has created a UKIP-as-prominent-and-'credible'-Party, since racism, xenophobia, transphobia, misogyny and homophobia—most of which is covered by the 'common sense, straight talking' discourse and 'everyman' image that Nigel Farage wields—sells papers. For all that the media exposes in showing up another 'unsuitable' UKIP candidate, it simultane-

ously silences protest against UKIP by effacing the voice of any real opposition. Politicians in thrall to the media and Farage's 'common sense' dare not call UKIP what it is. The UKIP-media machine has mechanisms with which to deflect any criticisms, often reducible to the catchphrase: 'No! *You're* the racist!'

However, it is UKIP that has been spreading shit: spreading shit about the *'immigrant scourge'*, and giving shit to the immigrant populace; so, how else to speak out against UKIP in return but to send them *shit*?

These metaphors stand, and have stood throughout the history of racial hatred in this country, and, in modern times particularly since the lie propounded by Enoch Powell—in his 'Rivers of Blood' speech—of the 'wide-grinning piccaninnies' shoving excreta through an old lady constituent's letterbox (a constituent who was never traced...![202]). Thus, what we see is this shit, this cum, this blood, these ejected, rejected parts of the body, revealing the oppression, the Othering, the hatred which is inherent in UKIP's ideology. Rather than being a case of protesters 'going too far' or being childish by using the Freepost address to send shit to UKIP, the protest instead reveals itself to be the only appropriate response to UKIP's hatred of the Other. As we know, in the practice of psychoanalysis Lacan says that a message is received back by its sender in 'an inverted form'. Is not the metaphorical shit spread by this ideology here being returned in an inverted, real form; that is, as the return in the Real of the symbolic/imaginary shit made up about the 'minority threat' here concentrated into this form of protest?

In her 'Essay on Abjection', in *Powers of Horror*, Julia Kristeva describes abjection as 'loathing an item of food, a piece of filth, waste, or dung[,] blood and pus[,] body fluids, this defilement, this shit'.[203] For Kristeva, these things which are ejected from our own body, or which remind us of things ejected from our own body, make us feel sick in order to protect our sense of an individuated self, a free and autonomous 'I'. These abject substances

remind us of the borderline we sit on between life and death, and disrupt our sense of subjectivity, and so we must 'permanently thrust [them] aside in order to live'.[204]

UKIP conceives of immigrants in the same way. To UKIP, immigrants represent a borderline between the 'I' of the 'pure' white Anglo-Saxon Briton (an imaginary construct, just like the individuated subject) and the Other, precisely because they have come to reveal the lie of this homogeneous society. Thus they must be radically excluded in order to reassert the borders of that subjectivity. All this is obvious. But it highlights the legitimacy of the dirty protest in the face of UKIP, to which we cannot speak in the socially legitimated discourse that it pretends to protect; that of 'free democracy'.

For Kristeva, if we put aside the questions of health and cleanliness that the unfortunate postal workers who have been undeserving intermediaries in this protest have faced, we see that in fact it is 'not lack of cleanliness or health that causes abjection but what disturbs identity, system, order. What does not respect borders, positions, rules'.[205]

Sending shit to UKIP confronts its supporters with the borderline position of their own bodies, and with the fact that what they reject from themselves is yet an inescapable part of them. In that sense it makes a mockery of the borders that they attempt to close to preserve a homogenous subject called the British. It draws attention to the very meaninglessness of the project they are attempting.

61. A Politics Now!

Keyser Söze famously said (or didn't say) that the greatest trick the devil ever pulled was convincing the world he didn't exist. We are perhaps witnessing something similar to this operation in

modern politics today. Throughout the recent European election campaigns—in the UK at least—the political emphasis seems to have been squarely set on *depoliticisation*. UKIP's discourse was most prevalent in this respect, with Nigel Farage consistently claiming defection not only from Europe, but from 'the political class' itself. The Lib Dems were in on the act as well; in their leaflets we saw them condemning UKIP and the Conservatives for 'want[ing] to put politics before people's livelihoods and our nation's future', as if politics itself were nothing to do with these things. The Tories, too, criticised the European Union precisely on the point of being 'a *political* project that is not right for Britain', in their manifesto.

In *On the Shores of Politics* Jacques Rancière claims that 'depoliticization is the oldest task of politics, the one which achieves its fulfilment at the brink of its end, its perfection on the brink of the abyss.'[206] As he explains, it is through this operation that politics can in fact attempt to exempt itself from everyday life. Through presenting politics as an outmoded activity, politics itself can fade into the background, operating shadily behind the scenes in its connections with, and in the interests of, corporations it's in thrall to and the privateers for whom the cloak of non-transparency is standard apparel.

What the electorate (the people, that is, in their everyday life) get left with is a tokenistic remainder in which prejudices are raised to the dignity of politics, whilst capitalistic mechanisms of economic expansion—through war-mongering, power-collation, cosying up to the rich and influential, careerism (how many politicians nowadays come from precisely the *working* class, as opposed to university courses designed specifically for a career in politics?), ideology, fundraising and promulgation; in a word, the 1%ing that should be regulated *in the name of politics*—takes place off the streets (by several storeys) in hushed boardrooms.

To describe the kind of remainder we get from this (per)version of politics, Žižek borrows a term from Derrida; that

is, the term 'without', as it is found in the formula 'X without X' (Derrida uses the phrase 'to see without seeing', for example, when talking about invisibility)[207]. Whereas in Derrida it tends to refer to something that remains operational whilst not going under that name ('religion without religion' can mean the seeping-in of religion into other areas, under the radar, for example), in Žižek it refers to something being apparent *in name only.*

Žižek specifically applies this to one phenomenon: decaffeination.[208] The injunction here is: 'coffee, yes, but without caffeine; beer, yes, but without alcohol; mayonnaise, yes, but without cholesterol...' Something, *but without that something itself.* In a 2004 article called 'A Cup of Decaf Reality' Žižek says: 'the list goes on: what about virtual sex as sex without sex, the Colin Powell doctrine of warfare with no casualties (on our side, of course) as warfare without warfare, the contemporary redefinition of politics as the art of expert administration as politics without politics[?]'[209] Is it not this artful kind of politics that we're now being sold here, even at face value, in these political leaflets and manifestos that put themselves across as precisely *without politics*?

This unabashed politics without politics seems then to aim to subtract the possibility and potential of politics from the real *political class,* the people themselves; to subtract politics proper from supposed 'everyday life', in the formula: 'don't let politics get in the way!' The remainder of this comes in the form of instances of extreme reactionary (as opposed to radical) views occupying politics' place and pretending they're the solution to society's ills, usually by condensing these ills themselves into such perennial figures—particularly in UKIP's case—as the immigrant. Apathy may often be blamed for poor political turnout and interaction, but are we not here mistaking the effect for the cause, as Primo Levi once put it? Apathy towards politics is being spread by this very kind of decaffeinated message, but

the message in its inverted form is really: '*you* can be apolitical; leave politics to *us*'. Perhaps instead politicians should not herald a political apocalypse, but should bring politics itself back to the fore and try their hardest to get us engaged. Instead of *apolitics*—in the negative sense of 'amoral', 'asexual', etc.—what we need is a politics now!

Art by Danny Noble.

Sport

62. Playing at Being a Sportsperson at the Winter Olympics

If the voices chirping up in the national conversation to express with pleasant surprise just how much they're currently enjoying the moguls or the curling in 2014 sound familiar, that's because you heard them four years ago, the last time the Winter Olympics rolled onto our television schedules. You may have also heard these voices more recently, when the summer Games came to London and turned an unexpected percentage of our population into handball and taekwondo fanatics. But the winter Games, at least in Britain, are more immediately associated with the primetime airing of sports nobody has heard of or understands. Increased funding to Winter Olympic sports, addressed recently in an interesting column by *Guardian* sports writer Sean Ingle, might be working to change this as partisan participation becomes more attainable for British audiences, but until the ice-bound equivalent of a Victoria Pendleton or Chris Hoy emerges, the question remains: why do we watch alien sports so intently? Or, to pose a more easily-tackled question, what do we see when we watch them? After all, even if we can piece together the rules for an unfamiliar event over the course of an afternoon's viewing, the narrative element will still be lacking: as journalist David Conn notes in his book *The Beautiful Game: Searching for the Soul of Football*, it is not the 'earnest strivings of millions of people out there playing it, week after week' that defines the national game; rather, the narrative armature of heroes and villains, league points gained and lost, 'came to be what we all think of as football itself.'[210] How do we orientate ourselves, and *enjoy* ourselves, without this body of knowledge?

In *Man, Play and Games*, first published in France as *Les jeux et les hommes* in 1958, Roger Caillois drew up a definitive taxonomy of play. First, Caillois names a continuum between *paidia*, most

closely associated with the unstructured play of young children, and *ludus*, the structured adult play found in ritual and organised sporting contexts. Four categories then nestle into this stratum: 'one *plays* football, billiards, or chess (*agon*); roulette or a lottery (*alea*); pirate, Nero, or Hamlet (*mimicry*); or one produces in oneself, by a rapid whirling or falling movement, a state of dizziness and disorder (*ilinx*).'[211] Sport as we know it, Caillois acknowledges, actually consists of a blend between terms one and three: *agon*, which deals in superiority, and *mimicry*, which deals in make-believe. When a footballer performs, he or she is not only *playing* football, but also *playing at being* a footballer, since stepping onto the field of play involves a kind of metamorphosis in which the rules of the game become not just a means by which one individual may exhibit their superiority over another in controlled conditions, but also a code which momentarily redefines the scope of possible action. *Agon* is actually relatively mute without a supplement of *mimicry*: Cristiano Ronaldo's 400th career goal would seem less of an indicator of inherent superiority had he scored all these goals in training, away from the theatrical stage of the sanctioned match.

When we watch a sport with which we are unfamiliar, this aspect of *mimicry* shifts disarmingly into focus. The concentration etched on the faces of the curling stone-handler, or the furious activity of the broom-wielder, appear comically arbitrary at first. Gradually, the terms and conditions of the contest become clearer, justifying the investment of the participants. But these terms and conditions would remain murky without some prior knowledge of organised sport: it is only by leaning on elements gleaned from other sport-worlds that we are able to make sense of something so seemingly arcane as curling. This tuning-in process can throw up some strange juxtapositions: curling is a lot like bowls, in that the aim is to land round objects close to other round objects, but also a bit like baseball in the variety of points that can be scored with a single action, and even

a bit like American football, in the importance placed on brute-physical blocking. Even during this process of familiarisation, then, tropes of sporting *mimicry* drift somewhat free from their customary applications. This turns the experience of viewing a curling match (or whatever) into something akin to the Olympic ideal of glimpsing *sport itself*, but in a way that Games founder Pierre de Coubertin couldn't have possibly predicted. While scrambling around for tools with which to construct a skeleton of meaning around the obviously intense but oddly amorphous performance playing out before our eyes, what we witness is a play of principles, a floating parade of contingent formulas that structure the relationships we entertain with our favourite sports, but which tend to hide in plain sight as a result of our fixation on narratives. In our encounter with an unfamiliar sport we find ourselves moving back and forth somewhere between *paidia* and *ludus* and, as with nearly all experiences which carry us back to the kinds of engagement we experienced as pre-adults, we find we actually quite like it there.

63. Dani Alves: A Banana Used as a Banana

Barcelona fullback Dani Alves recently made headlines by eating a banana during his team's league game at Villarreal's El Madrigal stadium. While the football press is frequently guilty of giving undue exposure to the minutest of insignificant minutiae, this was not one of those occasions: the banana had been thrown in Alves' direction by a fan in what has been unanimously accepted (and subsequently penalised) as a racist gesture. Alves' unique deflation of this long-standing trope of sporting white suprematism has thus been read as a shot in the arm for football's faltering anti-racist movement. With a swiftness characteristic of media flows in 2014, Alves' response generated a visual meme— players like his teammate and Brazilian compatriot Neymar Jr., Sergio Aguero, Robert Lewandowski and Luis Suarez all published selfies in which they were depicted on the verge of tucking into a banana—as well as the Twitter hashtag '#somostodosmacacos' ('we are all monkeys').

There are of course issues with this fallout. The eventual inclusion of Suarez in the selfie campaign—the Liverpool striker remains unrepentant after being found guilty of racially abusing Patrice Evra on the field of play in 2011—highlighted for some the tokenistic nature of this show of solidarity. As Jude Wanga pointed out in a column for the *Independent*, the impact of attempts by players like Suarez to join in attempting to 'reclaim' the insult launched against Alves is minimal, since these players are socially situated on the side of the abusers, not the abused.[212] Musa Okwonga characterised a wave of responses to the event in asking that the conditions that allowed the culprit to feel 'comfortable enough' to make such a public gesture be examined: the affirmatory nature of the selfie and hashtag campaigns, so the implication goes, is hardly the sharpest critical tool.[213] Finally, it was suggested some days after the incident that

the ensuing campaign had actually been premeditated by Alves along with his teammate Neymar, and carried out with the help of advertising agencies Loducca and Meio e Mensagen. As reported by Spanish sports daily AS, Alves and Neymar had resolved that if a banana were ever thrown in their direction during a game, they would make sure to be seen eating it, subsequently leveraging these images for their social media potential.

Does it matter that Alves' response was not spontaneous, or that it was conceived with its own mimetic capabilities in mind? Straightforwardly, the event's premeditation points with even greater clarity to the need for action on racism in Spanish football than the single, central offensive gesture ever could: it reveals the absolute assurance on the part of two men of colour that they *will* be racially abused in their workplace in the immediate future. Furthermore, the planned nature of the gesture does not erase its peculiar force, which is one aspect of this story that has gone relatively unremarked upon. While newspapers broadly pre-empted the banana selfie campaign by enshrining Alves' reaction as an iconic moment in football's ongoing anti-racist struggle, few really paused to consider the singularity of this incident: Alves did not simply renounce the slur, after all, or call out the individual who had thrown it in the manner of Australian Rules footballer Adam Goodes' intervention in a game at the Melbourne Cricket Ground last May. He peeled and ate the banana, not only mushing it into a non-signifying pulp but digesting it in the process. If the response of white players like Suarez, Aguero and Lewandowski erred on the side of safety, then Alves' was a particularly and pointedly risky strategy: as many have pointed out, the Barcelona player had no way of knowing that the banana had not been poisoned, laced with razor blades or some such. Even if the chances of a stadium attendee being sufficiently motivated to commit such an extreme act seem slim, the generalised paranoia regarding stadium security can never truly allow such possibilities to be precluded.

Alves' gesture—perhaps particularly now that we know it was premeditated—opens itself up to multiple readings besides the PR-mandated one. Marcel Duchamp provides us with an opening: the pioneer of the use of 'found objects' in visual art once advised that it should be possible to conceive of 'reciprocal readymades' like a Rembrandt canvas used as an ironing board. This gesture would serve to prick the bubble of artistic aura in an even more directly confrontational way than Duchamp's attempt to display an upturned urinal in a major New York art institution in 1917. To convert an object suffused with expressive and cultural significance back into a state of blunt facticity—to swap exchange value for use value, in other words—is to perform a kind of alchemy in reverse. In a similar way, the banana thrown at Alves, once peeled and chewed, suddenly underwent a dramatic structural shift, metamorphosing from symbolic prop with the capacity to wound to dumb, factitious foodstuff with the capacity to nourish. Racism of course perseveres in inescapably concrete ways, but for one tiny moment its symbolic basis was held up as fragile, easily rendered hollow by an unexpected act of wilful misreading.

There is a second figure of the early twentieth century whose writing ties up wilful misreading with gustatory metaphors, and he is Brazilian to boot. Oswald de Andrade's 1928 'Manifesto Antropófago' ('Cannibalist Manifesto') famously argued that Brazilian culture was formed on the basis of a 'cannibalising' of colonial cultures. Here Andrade drew romantically on mythologies around the supposedly man-eating indigenous tribes of the Brazilian coast, but did so in the name of avant-garde renewal. As Liladhar Ramchandra Pendse argues, Andrade's 'cannibalism' is not the same as simple ideological internalisation, since 'during anthropophagic discourse, we see a qualitative modification of the internalized values'—elite texts are chewed up to provide sustenance for a new, self-asserting postcolonial body.[214] In a much-repeated excerpt, Andrade

mushes Shakespeare together with the name of a native Brazilian tribe known for their anthropophagic rituals since the Bard's own epoch of colonial expansion: 'Tupi or not Tupi'. Dani Alves' *bananaphagy*, we can argue, has more than a little in common with this line: Alves is assailed from the point of white privilege with a symbol casting him as inescapably other, and his misappropriation is just so.

64. Loving Football

Oh Joey Garner!
You are the love of my life,
Oh Joey Garner!
I'd let you shag my wife,
Oh Joey Garner!
I want ginger hair too
(Sung to the tune of Frankie Valli's *Can't Take My Eyes Off You*)

Chances are if you're one of the few-thousand supporters that have loyally packed out Preston North End games during the 2013-14 season, you'll have heard these lines. As is usually the case when football fans adapt pop songs to their own ends, the chant has also appeared *mutatis mutandis* at clubs across the country, with the line about shagging a constant. What is it that this song is trying to say and, perhaps more importantly, what is it trying *not* to say?

In *Between Men: English Literature and Male Homosocial Desire*, Eve Kosofsky Sedgwick puts forward the assertion that there is a sliding scale between what she terms 'homosociality' (men mixing with other men) and outright homosexuality. In Sedgwick's words: 'for a man to be a man's man is separated only by an invisible, carefully blurred, always-already-crossed line from being "interested in men."'[215] One needn't reach far to find examples from mainstream culture that would back up Sedgwick's argument. From the Lad Culture staple of drunken group nudity depicted in shows such as BBC Three's *Sun, Sex and Suspicious Parents* to the bromantic refrain of 'I love you, man', to the abdominal phantasmagoria of *300*, homo-eroticism is one of the characteristic forces of the homosocial domain. But the interest of this argument for present purposes is not merely to say 'you know how I know you're gay' to football crowds (which

would in any case do these crowds the disservice of assuming that they are homogenously male and avowedly straight). Rather, Sedgwick's words help to bring into focus the constitution and mechanics of *homophobic* acts, among whose number we might count the lyrics reproduced above.

At first glance the lyrics might merely appear sexist—the fourth line depicts women as so much chattel to be traded between men, bypassing any suggestion of individual agency or subjectivity—but Sedgwick's argument enables us to read this line in a more sensitive way. When Joe Garner scored what many have dubbed the 'goal of the season' against Rotherham, it was all but inevitable that the act would come to be dressed up, through its dissemination on social media, in terms that leaned heavily on the erotic. This goal was 'beautiful', 'moan-inducing'; it gave Twitter users 'semis' or inspired them to watch replays 'in a dark room with some tissues and prepare for a mess'. If there's arousal in the way Garner controls and strikes a ball, is it such a stretch to imagine that some of this might transfer to the figure of the player himself?

The chant certainly seems to suggest so. Only, it doesn't quite go all the way. For what often accompanies that sliding back and forth across the always-already-crossed line between homosociality and homosexuality is an energetic disavowal, a generalised stance of homophobia balanced against a sense that all that drunken group nudity is just 'banter'. Since clear barriers do not exist between being a man's man and being interested in men, a not-necessarily-conscious homophobic defensiveness requires that they be invented. And so we (male, avowedly straight) Preston fans repeat and repeat the strange hybrid sentiment buried in the song's fourth line, admitting that our admiration of this season's top scorer is coloured with eroticism, but insisting on introducing the proxy of our real or imagined wife into the picture to fulfil this vague longing for us. By moderating the articulation of the chant in this way, we distance ourselves from

a desire which still barely dare speak its name in the structurally homophobic world of professional men's football.

65. World Cup 2014: *Sky Sports Live! and Alain Badiou's 'Event'*

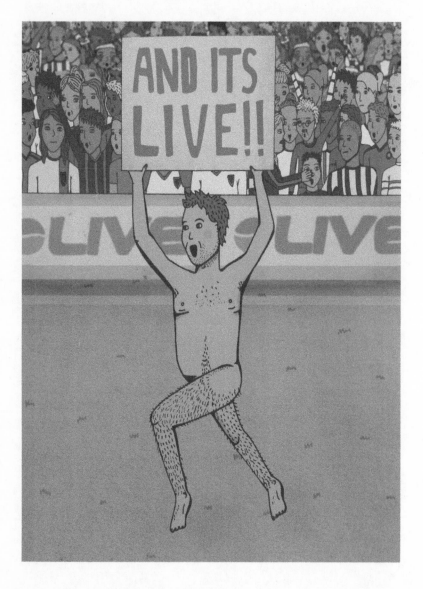

The emphasis on the 'live' nature of football coverage, particularly on Sky Sports, has become something of a joke lately in

football circles. Before each kick-off, official 'commentator of the decade' Martin Tyler, now with an emphasis so great it's as if he's trying to outdo last week's performance in a kind of parody, shouts 'and its LIVE!!!!' to the delight of everyone watching.

The appeal of 'live' coverage is of course not only relevant to the football world; there is a cultural appeal to the idea of experiencing the event 'in the moment', which stretches as far as *Saturday Kitchen* emphasising that its cooking and mundane chat, believe it or not, is going on absolutely LIVE in front of our eyes.

The 2014 World Cup will be an extreme example of this cultural phenomenon; all channels will advertise their LIVE coverage not only of the games but of the draw, the interviews and the injury updates. Live feeds will abound across the internet allowing the viewer to feel that they are always involved, there experiencing the moment when some news breaks, some man kicks a ball, someone turns an ankle or has an argument in training. We want to see everything LIVE.

What this seems to involve is an exciting experience of the moment that happens outside the mundane and predictable chronology of the normal course of events. It appeals because of the excitement, the unpredictability, the randomness not just on the field of play but everywhere in the game. The pleasure seems to come from something like a breaking of chronology; the 'normal' flow of events can be interrupted at any point, in game or out, changing the futures involved in the tournament and the way things will pan out. We want to be there at these moments, to see them LIVE, to see the future diverted.

On the contrary, what I argue here is that this involves not an instantaneous 'live for the moment' attitude of experience outside chronology, a pure moment of instant enjoyment which breaks the narrative and takes it somewhere new, but the absolute opposite. In fact, we enjoy the moment precisely because we feel that its future is *known* and *predictable*.

Alain Badiou's concept of 'the event' sheds new light on these

'events' we experience 'live'. The idea probably originates in Freud's concept of *Nachträglichkeit*, often translated as 'afterwardsness'. *Nachträglichkeit* is not just a later reaction to an earlier event but a recognition that the first event is invested with a new significance which turns it into that which it will then always-already have been. So the moment is constituted by what happens after, challenging the idea of chronological time because the past is influenced by later events as much as later events are influenced by the past. Badiou develops the concept, arguing similarly that 'the event' is not the culmination or result of something but rather that 'a site is only evental insofar as it is retroactively qualified as such by the occurrence of an event.'[216] In other words, all events exist only in relation to later events which turn them into what they are.

In footballing terms this can be easily demonstrated: a goal scored in the last minute of game 1 becomes something completely different when that team goes on to win the trophy in game 64. It will become an event that always contained the potential of its own future.

We are under the illusion that event A seems to contain within it the possibility of events B, C and D, etc. This means that every event that occurs must contain within it all the possible 'future' events, which may or may not occur subsequently. This is at the heart of the appeal of 'being there' at this moment of possibility and witnessing something that leads off into the future.

But this is a structure that is easy to believe in in football terms and more difficult to believe in when it comes to the bigger question of life outside football. Perhaps it can be connected to the 'big bang theory', another linear narrative in which infinite possibility comes from one moment. Whilst we might consider this scientific theory 'true' we do not, at least for the average subject, feel that it is evident and clear.

This is because it is only in a system in which the possible outcomes are limited and mapped that this illusion can maintain

the strength of its hold. One of the 32 teams will win the World Cup, retroactively turning everything that has happened to that team along the way into the path that led to victory. If we witness all the LIVE moments we can be sure that one of them will become what we project it to be.

Badiou shows that in life outside of football or the sports tournament the future, never determinate, can change our present into something which we have no idea (from our own moment) that it is. In sport, we have a comforting feeling of predictability which we enjoy, which might appear to us as the charm of randomness and unpredictability, but which is in fact its opposite. The feeling is one that gives us something we don't feel outside of sporting tournaments; that when we experience our own 'live' moment, we can enjoy it because we know what it will become, not because we don't.

Art by Hayley Seamarks.

66. Croatian Football and Racism

Those that remember as far back as Euro 2012 will know that much debate about Croatia's role in the tournament will surround the racist chants, banners and attitudes of the nation's travelling supporters. Last time around, the Croatian FA were twice fined for their fans' actions.

The usual approach to such racist behaviour is to state that these acts are 'outdated'. Of course, this criticism almost always comes from a good place, asserting that we have no time in the modern age for behaviour that we (largely) universally condemn as unacceptable. However, there is a strange distancing of our age and ourselves from the issue here. Can we say that these forms of expression are outdated whilst we witness them taking place in 2012, and are under the threat of seeing them again in 2014?

First, we must acknowledge that racism (in most of its forms at least) is closely connected to nostalgia. This is a point that hardly needs demonstrating; racism is almost always couched in a language of 'the old days', 'traditional values', and the 'great past' of the nation or race being celebrated. This can easily be demonstrated in the case of Croatian football; the banners shown in 2012 contained military images and a web address of a political site dedicated to 'the promotion of Croatian heritage and culture around the world'. Its motto is 'Pravda je izgubila ravnotežu', which is translated as 'Justice has lost her way'; the language of nationalism is one of nostalgia for a 'lost' past in which things were on the right track.

Second, and more complexly, nostalgia operates or can operate where there is nothing to be nostalgic *for*. Or rather, that which we are nostalgic for is often an imaginary space created from the present and projected onto the past which we conceive of as answering the problems we are faced with in modernity. As

Svetlana Boym notes, nostalgia is 'an affective yearning for a community with collective memory, a longing for continuity in a fragmented world'.[217] This once more is perfectly demonstrated by the place of Croatian nationalist culture. A fantastic article by Gordana Crnković on Croatian nationalist and non-nationalist culture demonstrates that whereas Croatian culture was historically very diverse, containing Serbian, Croatian, Slovenian and other cultural influences from the region, after the war and independence a new demand for a cultural identity 'truly its *own*' was borne in Croatia. Whilst it had a diverse history, it needed a singular one; the history it searched for was one that it never had.[218]

Croatian cultural commentator Jurica Pavičić put it another way, saying: 'we traded away our identity because it stank of our neighbours, and for that we got corporate goods, faceless global trademarks to whom we bow.'[219] The point again here is that what is missing now — a truly Croatian identity — never existed; it was always a miscellany of various cultural influences. It is racism that creates an imagined time in which justice had not lost its way, in which we had an identity truly our own.

Does not the criticism of this racism as 'outdated', whilst we see it around us in more forms than we would like to admit, not risk allowing this belief to maintain its hold? It asserts the existence of a time in which it was legitimate to believe such things, and distances our modern world from this ancient and *backwards* day (even the language celebrates the 'progress' of modernity).

Thus, this criticism of racism as 'outdated' gives racism the very thing it needs to lament: an imaginary world in which its unacceptable beliefs were permitted. In placing racism in the 'outdated' past we give it the very thing that it needs: an imaginary space in which racism was not only allowed but believed in. We simultaneously avoid dealing with the very modern presence of these problems by distancing our own world

from them, when in fact it can be our own modernity that creates this dangerous nostalgia for a different and even racist past.

What we see here is the danger of the World Cup functioning as a celebration of modernity that actually benefits from the appearance of its 'backwards' past—since it is that which it celebrates itself as having progressed from—but which does not deal (except perhaps by a measly £65k fine[220]) with its continuing role in our present.

Superheroes and Comic Universes

67. Superman vs. Batman: *The Quest for American Exceptionalism*

As work on the upcoming *Batman vs. Superman* film continues apace, it is worth asking what is at stake in a contest between these two all-American superheroes. Superman's roots are in Smallville as the adoptive son of a farming family, an archetypal small-town American background. His powers are inseparable from his identity, an otherworldly, even divine gift that imparts to him the ability and responsibility to protect the world (which is, for all practical purposes, synonymous with America). Though he protects his secret identity out of necessity, Superman is a journalist, hence symbolically dedicated to free speech and the uncovering of truth. His greatest enemy is Lex Luther, a villainous and amoral businessman against whom Superman implacably opposes his inherent morality. Superman, it seems, is America as it would like to see itself: inherently special, inherently moral, dedicated to truth and small-town values.

Batman, in contrast, is a fundamentally urban figure: he originates not from Smallville but from Gotham city (which is also, in its own way, a symbol for America). His powers derive not from his biology but from technological and entrepreneurial superiority; they are powers he bestows upon himself. Batman is not destined to be a superhero but instead chooses to be one. His family background is not that of a poor farmer, but a wealthy capitalist. He does not need to work for a living, since labour can be delegated to his company's employees. He lacks the secure, moral upbringing of Superman, having lost his parents at a young age (he has, we might say, 'issues'). His greatest concern is not truth or justice but social order. In Christopher Nolan's *The Dark Knight*, Batman conceals the crimes of Two-Face because he deems them too dangerous to be publicly known, taking the blame himself for Two-Face's murder. This allows the passing of

the Dent Act, designed to control crime: a reference, surely, to the Homeland Security Act of 2002. Batman's greatest enemy is the Joker, a figure of anarchy. Batman is closer to America as it really is: its power not a birthright but the result of wealth and the willingness to employ it in pursuit of advanced weaponry, its identity not rural but urban, its investment in social order not a defence of truth but of hegemonic capitalism, its sympathies not with journalists but with the security forces (as the recent NSA revelations have shown).

If Batman is a partial recognition of the reality of America's political position in the world, it is one that, in the very moment of recognition, reinscribes this unsettling reality as an alternative form of heroism. Batman allows the perpetuation of the myth of American exceptionalism through a strategic admission that its position is not natural but man-made, that it is not opposed to big business but on its side. This is all OK, because at the end of the day, Batman is still heroic. Ultimately, Batman vs. Superman is not a contest between the illusion and the truth about America, but between two different accounts of American exceptionalism.

68. The Beast, the Sovereign, and The Superior Spider-Man

In a current Marvel Comics storyline written by Dan Slott, Spider-Man's enemy, Doctor Octopus, has engineered to save himself from a terminal illness by swapping bodies with the superhero. In the usual running of this familiar sci-fi cliché, the identities are returned to the correct bodies before too much damage can be done. In this case, however, Slott has scandalously allowed the 'real' Spider-Man's mind to die with his enemy's body, leaving Doctor Octopus free to assimilate himself into Spider-Man's old life. Granted this second chance, Doctor Octopus has resolved to reform and continue Spider-Man's good work, but to use his insider knowledge of crime and ruthless lack of sentimentality to do so even more effectively. Hence the title of Slott's remarkable series: *The Superior Spider-Man*.

The philosophy immediately suggested by all this is that of the Nazi political thinker, Carl Schmitt. For Schmitt, the smooth running of power is structurally dependent on what he calls the 'the sovereign': the real or imagined figure in whom all authority is located, but who operates outside its strictures. Every act of imposing law occurs in the midst of what Schmitt calls the 'state of emergency', because the very need for it implies the inadequacy of the state of things immediately prior. For Schmitt, the law is paradoxically transgressive, appearing almost arbitrarily, and without stable license. While the theory has been influential for left-wing thinkers such as Benjamin and Giorgio Agamben who want to break with the model of political power it diagnoses, for Schmitt, it was only the groundswell of Fascism in his time that had the courage to admit its absolute necessity. Doctor Octopus's *Superior* Spider-Man reads like a figure of sovereignty in the true Schmittian sense: the upholder of law who, like the criminal he formerly was, regards himself as temporarily

excepted from it (even becoming it, like most superheroes do, and as epitomised by Judge Dredd when he asserts: 'I am the Law').

We need hardly turn to political theory to realise that many of the fantasies embodied in superhero stories are uncomfortably right-wing. The point has long been played on in the comics themselves: whether in Frank Miller's hand-wringing liberals who object to the 'social fascist'; Batman brutalising criminals in *The Dark Knight Returns*; or the rather shop-worn superheroes in Alan Moore's *Watchmen*, who range from paranoid sociopaths on good terms with the more reactionary tabloids, to billionaires who merchandise their own image in the form of action figures. But in this case, isn't *The Superior Spider-Man* just a more literal example of an existing preoccupation with the affinity between law-making and law-breaking violence within the superhero genre?

In fact, the superiority of *The Superior Spider-Man* should be located in its surreptitious development of Schmitt's argument along lines already articulated in the final seminars of Derrida. In *The Beast and the Sovereign*, Derrida argues that the heterogeneous tradition in political theory Schmitt initiated has overlooked the fact that the sovereign is not alone in inhabiting this special 'exceptional' status as regards the law. Animals do this as well, and Derrida cites many instances from literature and philosophy where the proverbial stubbornness or stupidity of beasts makes them overlap with the way in which tyrants and leaders are often popularly imagined. For Derrida, this can be explained by the fact that the radical incompatibility of animals with any kind of structured law makes them weirdly reminiscent of the sovereign in Schmitt's sense. 'Sharing this common being-outside-the-law', Derrida remarks, 'beast, criminal, and sovereign have a troubling resemblance: they call on each other and recall each other, from one to the other; there is... a sort of obscure and fascinating complicity'.[221]

Since 9/11, it has become common for the ordinary running of laws on international relations and—exemplarily in more recent news—personal privacy to be suspended in Schmittian fashion, the chief justification being that such compromises are necessary if we are to preserve supposedly transcendent Western human values. But the sovereign's authority to perform this violence in defence of the 'human' would become rather more dubious if we were to recognise that sovereignty's own beast-like dimensions make it curiously under-qualified to defend its actions on the basis of a stable notion of 'humanity' in this way. Whatever it is this beast-like sovereign can speak for, it can hardly be 'the human' conventionally defined. Spider-Man's enemies have, like him, always tended towards the animal—as well as Doctor Octopus, this bestiary would include Vulture, Owl, Scorpion, Lizard, Chameleon, Hammerhead, Jackal and Rhino, and the also-relevant Man-Wolf, Venom, and Kraven the Hunter—and Slott has been careful to include several of these characters in his recent work. At the heart of *The Superior Spider-Man*, however, is a development of Schmitt's notion of sovereignty that insists on uncovering its animal dimension in precisely this Derridean fashion. In its trade-off between the spider and the octopus, the enforcer and the transgressor of the law, a realisation of the pact between beast and sovereign, for so long only implicit in the superhero genre, is at last made beautifully clear.

Work and Play

69. Brecht, Benjamin and Bad Service

There has been a recent return to stressing the importance of good customer service in supermarkets and department stores. Customer service is once again regarded as the integral part of the contemporary consumer experience. Witness a figure such as Mary Portas, the television celebrity and self-styled 'Queen of Shops', who states that she is 'waging war on poor service in Great Britain'. Poor service, inattentive sales people and the supposed unfriendly attitude from shop-floor staff are viewed as the major issue to be overcome in the retail industry. There is now a website called www.wellshit.co.uk that lets consumers in the London area 'get angry' about unacceptable customer service.

Customer service marks the crowning end-point of any consumer experience. The item to be bought is selected and carried by the soon-to-be consumer and is processed by the shop worker to whom the amount due for the product is given. The shop worker is placed at the end point in which the very purpose of the consumer experience—the exchange of money from consumer to company—occurs. The pleasant behaviour of the shop assistant, from the friendly smile to the seemingly spontaneous expression of thanks, is enmeshed in the end-point of consumerism; these procedures accompany and in some way make natural the transfer of money. Good customer service is the oil that lends the entire consumer experience the necessary lubricant it requires at the till. One does not just exchange money for goods, one also experiences good customer service. Or, in another formulation, one experiences good customer service in lieu of the exchange of money: the one stands in for (and replaces) the other.

Why the anger with bad customer service? Because bad customer service radically disrupts the seamlessness of the commodity experience: it marks the point at which the

naturalness of consumerism and its apparent inevitability start to come undone. In his essay on the epic theatre of the German Marxist playwright Bertolt Brecht, Benjamin writes that 'the task of epic theatre, according to Brecht, is not so much the development of action as the representation of conditions. This presentation does not mean reproduction as the theoreticians of Naturalism understood it. Rather, the truly important thing is to discover the conditions of life. (One might say just as well: to alienate [*verfremden*] them.) This discovery (alienation) of conditions takes place through the interruption of happenings'.[222] In short, epic theatre, for Benjamin, makes no attempt to be realistic, but rather shows that these are actors acting, that they do not 'mean' what they say and do.

What Benjamin identifies at work in Brecht's epic theatre is at work in experiences of bad customer service. Bad customer service, unlike the imagined good customer service that is supposed to accompany all transactions, disrupts the perfect and natural consumer experience. Instead of the transfer of money being covered by the naturalness implied by good service, bad service (which is the absence of good service) makes unfamiliar or alienates [*verfremdt*] the transaction. Better, it captures the alienation inherent in the structure of the transaction. Bad service reveals the 'representation of conditions' at the heart of consumerism: the mask is dropped, the veil is lifted. The 'happening' of the transaction is radically interrupted, in which the awareness of the consumer is drawn away from the naturalness of the transaction to the actual reality of money ('hard earned wages', in another register) exchanged for a worthless commodity. Bad customer service shows the consumer that there is nothing genuine about their social and personal exchange; it is only the exchange-system at work.

All at once the complete artifice of the shop, the till, the reality of the minimum-wage position of the shop worker, the position of the consumer within the shop and the fetish of the item in the

hands of the consumer, disintegrates. In the same manner that Benjamin argues that Brecht's theatre explodes the conservative theatre of Naturalism at the end of the nineteenth-century, bad service explodes the hermetic seal of the department store: the fiction is at last present for all to see. And the anger directed towards the shop worker is the upsetting realisation of this state of affairs. It is for this reason that we should value bad customer service: it provides us with more than our money's worth.

70. The Scrabble Squabble; or, the Plight of Online Opposition

The group behind the Facebook application version of Scrabble posts a picture of tiles reading: '$M_3O_1M_3E_1N_1T_1S_1$', asking 'how many words can you create?' The comments beneath are unanimous: 'pity the letters C, R, A, P weren't there!', 'you caused upset worldwide the MOMENT you changed all this', 'your new format is rubbish!'; plainly: 'bring back the old Scrabble'. In May, Mattel, the creators of the immensely popular Facebook game Scrabble, briefly announced to all its players to finish up their games as the format was changing, to a new and improved playing experience, provided in conjunction with gaming giants EA.

The reaction has been unanimously uproarious, like the flipping of a board at the end of a losing game, with the tiles going flying; but in this case it's the flipped board that's prompted the upset, in the form of Mattel's deletion of all players' data in one fell overnight swoop: no more stats of longest words, highest scores, and best bingos; no more communication with opponents that users hadn't added as 'friends'. It's a radical erasure, but one rather to be hoped for from the NSA or other secret(-stealing) services than from a programme that details are willingly given over to under the assurance they will remain stored. Petitions have been set up in protest of the revamped game (with its newly built-in capitalistic gimmickry: the insertion of a currency with which you can now buy more board designs, and features of the old version missing from the new, at the 'store'), and even the mainstream news have reported the debacle.[223] Now, months on, anything that is uploaded to the Scrabble fan page, such as 'MOMENTS', is met with instant invective. The squabble, however, is no longer even acknowledged by Mattel.

Although *it's only a game* in the case of Scrabble, in an increasingly virtualised world, we might have to draw some wider consequences concerning the online community space and the strictured and prescribed capacity of the comments box as a means of *voicing* concern or dissent. An aspect of such social media is that it is able to represent to the user an assuring reality of 'everyone being on the same page' when the case may rather be that everyone is only on the same social media page; awareness that such a structure can be put to use to quarantine as well as to collectivise should be kept. As the Scrabble rabble will attest, the comments box can be easily ignored and, although able to bring so many disparate voices so proximally close together, it can also reinforce their very distance (in physicality and non-commutability) if needs be.

The question this leaves for the Scrabblers is how to viably voice their antidisestablishmentarianism (38 points!) in relation to the new game. The question for forthcoming digital generations is: what can be taken to, *virtually*, in the place of streets?

71. Talking Behind the Back

Person A and Person B are working side by side in an office. 'Apparently', remarks A, 'I'm the office Simon Cowell...' B, busy and slightly distracted, is nonetheless intrigued by the remark, feeling that it does obscurely sum something up about A's personality. A repeats the remark, slightly pettishly this time, only for B to remember why the remark seems familiar. Over drinks with Person C several weeks before, B had said exactly that about A! B cannot remember the context, but knows that the joke wouldn't have been meant altogether unkindly. However, at some point in the interim C has told A, and A is now baiting B

into confessing to making what is now being perceived as an outright insult.

In this familiar moment of social awkwardness, we find an everyday example of what Alenka Zupančič has referred to as 'the introduction of the Ego/I into what is called objective reality', whereby suddenly, *'the ego exists'*.[224] We are used to thinking of our inner thoughts and feelings as the irrefutable anchor of our being. What are we to do then, when we come up against evidence our Ego/I is somehow 'out there', an object making a material impact on the world in ways that we can't anticipate. Person B cannot really remember what she meant by the remark, but A and C certainly remember what they think B meant. As such, how can B make any special claim for her version of events, when A and C's version of B is as—or rather even more—vividly recalled? B's being cannot be altogether her own for as long as a version of her is 'out there', her shadowy double, wandering around meddling with things in the representations and reflections of others.

Shakespeare's *Twelfth Night* offers a useful comparison for this situation. When Sebastian arrives in Illyria after surviving a shipwreck, Sir Toby and Sir Andrew mistake him for his sister Viola, who at this stage is dressed as a man and looks just like her brother. When challenged, Sebastian beats the two knights up. Viola is in the position of Person B. She might well know herself that she didn't beat up the two knights, but on the plane of objective reality at least, it happened! Similarly, B must come to terms with the fact that whatever we ourselves 'really meant', our *ego exists*. It is out there in the world, and must be incorporated into any assessment of our being.

Art by Laura Callaghan.

72. Amazon Turk and Inevitable Capitalism

Amazon has been a household name for years and has long been a huge corporation, but in the last 12 months it has become synonymous with global capitalism in new ways. Criticisms of its tax 'scandal' are partly responsible, though these judgements were in fact slightly misplaced; it's quite normal for globally trading companies to declare their profits where corporation tax is lower. John Lewis jumped at the chance to appear ethical by distancing themselves from the practice, but their claim had nothing to do with ethics and simply sought to advantage companies that only trade in the UK, such as themselves.[225] Regardless of people's growing suspicions and reservations, Amazon continues to take over the online world, with its share prices having doubled in the last two years. It's now the eighth most visited website and has more traffic than Twitter. The general public are used to Amazon, so they may be surprised to hear that its biggest move is yet to come. Amazon Turk, currently online in BETA form, has the potential to take Amazon's power to new levels and drastically affect the employment market.

For those who haven't heard of it, Amazon Mechanical Turk is a new part of Amazon's 'marketplace' (note the traditionalist language) except that instead of goods, the product is labour. The site calls itself 'crowdsourcing', which means that businesses or individuals (known as *Requesters*) can post jobs and offer financial rewards for their completion. Workers (known as *Turkers*) can then complete the tasks listed for the reward offered, almost exclusively from their own computer. In only being paid the value of the task they have completed (or less) the individual becomes a resource whose only value is its direct use-value for the greater system (circumventing minimum wage and time-based valuations of labour).[226] The average wage of a mechanical *Turker*, if they work quickly, is about one dollar per hour, with

most tasks paid only a few cents. It follows typical outsourcing trends but seems oddly honest about doing so: *Requesters* have to be in the US, where *Turkers* can be from anywhere. The idea is to get small people doing tasks for big companies as cheaply as possible, with no workers' rights and no ethical responsibility, as long as that benefits the right economy.

There are at least three major effects of this system. Firstly, it turns the individual into a resource or raw material waiting to be harvested for the use of the bigger and more important system and order.[227] If people are only its raw materials, the system appears to run without being under anyone's control. Secondly, it centralizes the power and the appearance of power, reducing the scope for alternative systems to develop by increasing dependency on the central system as the provider of work (in this case quite specifically the dependency of the rest of the world on the US). Thirdly, it moves the Amazon Corporation from the secondary (selling goods) to the tertiary (selling services) sector, potentially meaning that all people in the wage market (not just the buying/selling goods industry of Amazon proper) no longer have to see or speak to each other. This feeds back into the first point; if no one has to see the people involved, the system appears as not run by people; people are only used by a system which proceeds in its own direction.

All these effects are ideological as well as economic, they control the way we perceive the economic market. They contribute to the way media language posits 'the economy' as the root of all other social issues, the way that the economy appears a 'driving force', taking us in a direction that we can do nothing about. Thus, all three effects connect up—we are left with a centralized system that appears to run itself, in which people are taken up and put down by its power but are powerless to change this. This centre is made invisible so that those in control can pretend not to be, making out that they share a powerlessness with those the system abuses. The name Turk comes from the

chess-set trick conducted by Hungarian nobleman Wolfgang von Kempelen, which convinced people that he had built a machine that made decisions using artificial intelligence when in fact it contained a chess master. In other words, Amazon knows exactly what it's doing: tricking people into believing that capitalism runs itself to avoid responsibility for their part in it.

This is how it will justify itself to criticism, as it did more legitimately with the tax scandal, by saying that these things are happening elsewhere anyway, that they are part of modernity and not Amazon's responsibility. What we are left with is an *inevitability* of capitalism and an obscured and invisible system in which it appears that there is nowhere to lay blame.

The language used in our media to discuss capitalism is divided between speaking about impending collapse and inevitable continuation. What goes unnoticed here is the removal of a third language that has been in use, referring to capitalism's own future. Žižek has famously said that 'it's much easier to imagine the end of all life on earth than a much more modest radical change in capitalism.'[228] With Amazon Turk this could really be realized; talk about what we can do to affect capitalism's future will disappear because a trick has been played in which the system appears to be something that happens regardless of human actions. It is this trick, embodied perfectly by Amazon Turk, which allows those implementing these practices to exacerbate class divide and prevent resistance without admitting that they are doing so.

73. What is a Strike?

In 2013 the BBC reported a story on the confusion of children over where their food comes from: 'cheese is from plants', 'pasta's made of meat', 'fish fingers come from chicken', etc.[229] Despite the ambiguity that would have arisen over a kid hesitating an answer of 'horse beef', we should perhaps look to certain of the tropes by which not only teachers, but the media too, explain things (both of whom being educationalists. Indeed, as is John Reith's motto that the BBC was built on: *'educate,* inform, and entertain'). So, whereas it might seem preposterous to a certain generation to have to explain where cheese comes from, so it might to have to explain what a strike is. The rhetorical buzzwords of 'mass disruption' and 'financial cost to the country' that media institutions such as the BBC report such events with, however, display the tendency of presenting a strike as a bizarre aberration of some kind of 'natural order'—which is, to be blunt, *the capitalist order*—recklessly implemented by irresponsible whingers, to purposefully impair *real* people's important lives and business *in the city.* One would perhaps feel just as ridiculous and pedantic in elucidating the concept of a strike as one would that of the origin of fish fingers, but it might just be necessary in reaction to the ways in which strikes (such as the those on the London Underground) are being presented, and going by some of the reactions to them seen of late.

A strike *is meant* to disrupt things and incur unnecessary costs to those to whom the strike is opposed (i.e. employers in a position of power, who exploit that power, or have been in some way oppressive, or unfair); it is not simply the unhappy by-product of events that have taken a wrong-turn through irresponsibility, or just the selfish action of the (imaginary) *'few'* (the workers) which affects the (imaginary) *'many'* (the 'country as a whole')... In this respect—to restrike a balance in its

reportage—a strike should have returned to its presentation the aspect that can demonstrate its utilisation as a plea of workers to be recognised as *integral* to a country as a whole, and to be treated accordingly; for them to unite *as a whole*, as workers; and not simply to be shown as an act of *sabotage*, as it often comes across.

We must be wary—in a time in which workers are becoming *Turkers*—of too quickly surrendering our rights as workers, pandering to the policy-makers who want to ban the right to strike, in the wake of rhetoric that tries to subtly co-opt its audience through presenting *no alternative* to the view that privileges the capitalist (or, rather, *capitalism itself*) over the worker; the bourgeoisie—to brutally reuse the language of Marx for full effect—over the proletariat. Indeed, we must be on guard against the fundamental misrecognition—the symbolic poverty—that can lead to such an occurrence as Warwick University students organising their own student-led classes as their lecturers striked (a cause championed by none other than Katie Hopkins)...[230]

As Félix Guattari put it: 'it is not only species that are becoming extinct but also the words, phrases, and gestures of human solidarity.'[231] Indeed, it appears we might now have to defend against the risk of losing with the word the very concept of solidarity itself.

Notes

1. See our articles, 'Robin Thicke and the Position of Feminism' and 'LONG.LIVE.A$AP: *The Voice as Trill*', in this volume, and the tweet from @L_hod: 'why isn't YOUR focus on the misogynistic pro-rape structures of society? why only target feminism?', https://twitter.com/L_Hod/status/4082856928 30035968.

2. Slavoj Žižek, *Event* (London: Penguin, 2014) pp.130-131.

3. See Slavoj Žižek, 'Buddhism Naturalized', talk held at Ira Allen Chapel, University of Vermont, 16.10.2012.

4. Jacques Lacan, 'The Symbolic, the Imaginary, and the Real', in *On the Names-of-the-Father*, trans. by Bruce Fink (Cambridge: Polity Press, 2013) pp.37-38.

5. Franco Moretti, 'The Soul and the Harpy: Reflections on the Aims and Methods of Literary Historiography', trans. by David Forgacs, in *Signs Taken for Wonders: On the Sociology of Literary Forms* (London: Verso Radical Thinkers, 2005) pp.14-15.

6. Franco Moretti, 'Kindergarten', trans. by David Forgacs, in ibid. p.261, note 22.

7. Ezra Pound, *ABC of Reading* (New York: New Directions, 1960) p.29.

8. Jeffrey Andrew Weinstock, 'Introduction: Taking *South Park* Seriously', in *Taking* South Park *Seriously*, ed. by Jeffrey Andrew Weinstock (Albany: State University of New York Press, 2008) p.2.

9. Sigmund Freud, *The Interpretation of Dreams*, in *The Standard Edition of the Complete Psychological Works of Sigmund Freud, Volume V (1900-1901):* The Interpretation of Dreams *(Second Part) and* On Dreams, ed. by James Strachey, with Anna Freud, assisted by Alix Strachey and Alan Tyson, 24 vols (London: Vintage, 2001) V, p.571.

10. ibid.

11. See Slavoj Žižek, 'Human Rights in a Chocolate Egg', *Cabinet*, 11 (2003) http://www.cabinetmagazine.org/issues/11/kinderEgg.php.

12. ibid. note 1.

13. Roland Barthes, 'Soap-powders and Detergents', in *Mythologies*, trans. by Annette Lavers (London: Vintage Classics, 2009) p.36.

14. See Peter Kramer, 'Ronald Reagan and Star Wars', http://www.historytoday.com/peter-kramer/ronald-reagan-and-star-wars.

15. See http://www.ebaumsworld.com/video/watch/83969544/, for example.

16. See Olivia B. Waxman, 'Snickers Ad Manages to Be Sexist to Both Men and Women', http://time.com/40255/snickers-ad-manages-to-be-sexist-to-both-men-and-women/.

17. Robert Pfaller, 'Interpellation', in *The Žižek Dictionary*, ed. by Rex Butler (Durham: Acumen Press, 2014) p.142.

18. Originally published in the *Guardian* as Everyday Analysis, 'Jonathan the tortoise – slowly yet surely he wins over the human race', http://www.theguardian.com/commentisfree/2014/mar/14/jonathan-tortoise-slowly-surely-human-race-animals.

19. Sally Kettle, 'Meet Jonathan, St Helena's 182-year-old giant tortoise', http://www.bbc.co.uk/news/magazine-26543021.

20. EDA Collective, 'Why are Animals Funny?', in *Why are Animals Funny? Everyday Analysis: Volume 1* (Winchester: Zer0 Books, 2014) pp.65-66.

21. Donna Haraway, Adrian Franklin, Michael Emmison and Max Travers, 'Investigating the therapeutic benefits of companion animals: Problems and challenges', *Qualitative Sociology Review, Special Issue: 'Animals and People'*, 3rd ser., 1 (April 2007) 42-58 (available from: http://www.egs.edu/faculty/donna-haraway/articles/investigating-the-thera-

peutic-benefits-of-companion-animals/).

22. Jacques Derrida, *The Animal That Therefore I Am*, ed. by Marie-Louise Mallet, trans. by David Wills (New York: Fordham University Press, 2008) p.5.

23. Slavoj Žižek, *The Sublime Object of Ideology* (London: Verso, 1989) p.118.

24. Roland Barthes, 'The Death of the Author', in *Image Music Text*, ed. and trans. by Stephen Heath (London: Fontana Press, 1977) p.148.

25. Walter Benjamin, 'The Work of Art in the Age of its Technological Reproducibility, Second Version', trans by Edmund Jephcott and Harry Zohn, in *The Work of Art in the Age of its Technological Reproducibility and Other Writings on Media*, ed. by Michael W. Jennings and others (Cambridge, MA: The Belknap Press of Harvard University Press, 2008) p.42.

26. See Priscilla Frank, 'The World's Most Famous Performance Artist Will Do 'Nothing' For Her Next Project', http://www.huffingtonpost.com/2014/04/08/marina-abramovic_n_5106 347.html.

27. Walter Benjamin, 'The Storyteller: Reflections on the Works of Nikolai Leskov', in *Illuminations: Essays and Reflections*, ed. by Hannah Arendt, trans. by Harry Zohn (New York: Shocken, 1969) p.86.

28. Alan Woods, 'Guernica – Lessons of the Spanish Civil War', talk delivered at Whitechapel Gallery, London, 18.02.2010.

29. Slavoj Žižek, *Violence: Six Sideways Reflections* (London: Profile Books, 2009) p.9. See also Theodor Adorno, 'Commitment', trans. by Francis McDonagh, in Theodor Adorno and others, *Aesthetics and Politics*, ed. by Perry Anderson, Rodney Livingstone, and Francis Mulhern (London: Verso Radical Thinkers, 2007) pp.189-190, for this story.

30. Viktor Shklovsky, 'First Preface', in *Knight's Move*, trans. by

Richard Sheldon (Champaign: Dalkey Archive Press, 2005) p.3.

31. Jacques Lacan, 'The Mirror Stage as Formative of the *I* Function as Revealed in Psychoanalytic Experience', in *Écrits: The First Complete Edition in English*, trans. by Bruce Fink (New York: W. W. Norton, 2006) p.78.

32. Jacques Lacan, *The Seminar of Jacques Lacan, Book XI: The Four Fundamental Concepts of Psychoanalysis*, ed. by Jacques-Alain Miller, trans. by Alan Sheridan (New York: W. W. Norton, 1981) p.98.

33. Kristin Ross, *The Emergence of Social Space: Rimbaud and the Paris Commune* (London: Verso Radical Thinkers, 2008) p.39.

34. Shklovsky, 'Regarding "The Great Metalworker"', in *Knight's Move*, p.55.

35. Terry Eagleton, 'Foreword', in Ross, *The Emergence of Social Space*, p.xii.

36. Michel Foucault, *The Archaeology of Knowledge*, trans. by A. M. Sheridan Smith (Abingdon: Routledge Classics, 2002) p.19.

37. James Joyce, 'A Painful Case', in *Dubliners* (London: Penguin, 1956) pp.108-109.

38. W. K. Wimsatt Jr. and M. C Beardsley, 'The Intentional Fallacy', *The Sewanee Review*, 54th ser., 3 (July-September 1946) 468-488 (p.470).

39. ibid. p.487.

40. James Joyce, quoted in Arthur Power, *Conversations with James Joyce*, ed. by Clive Hart (Chicago: University of Chicago Press, 1974) p.103.

41. Ian McEwan, in 'Ian McEwan on his novels as A-level set texts: 'My son got a very low mark' – video', http://www. theguardian.com/books/video/2012/apr/03/ian-mcewan-a-level-set-text-video.

42. Greg McEwan, quoted in Anonymous, 'Novelist Ian McEwan's son didn't make the grade', http://www.daily

mail.co.uk/tvshowbiz/article-488781/Novelist-Ian-McEwans
-son-didnt-make-grade.html, although here McEwan's son
is referred to as 'Ian junior'.

43. McEwan, in 'in 'Ian McEwan on his novels as A-level set
texts'.

44. See Laura Miller, 'Ian McEwan fools British shrinks',
http://www.salon.com/1999/09/21/mcewan_2/, and the
bogus article itself in Ian McEwan, '*Appendix I*', in *Enduring
Love*, (London: Vintage, 1998) pp.233-243.

45. Wimsatt and Beardsley, 'The Intentional Fallacy', p.474.

46. Neil McCormick, 'Morrissey, *Autobiography*, first review',
http://www.telegraph.co.uk/culture/books/bookre-
views/10385321/Morrissey-Autobiography-first-review.
html.

47. T. S. Eliot, 'Tradition and the Individual Talent', in *The Sacred
Wood* [1920] (London: Faber and Faber, 1997) p.41.

48. Maurice Merleau-Ponty, *The World of Perception*, trans. by
Oliver Davis (Abingdon: Routledge Classics, 2008) p.83.

49. Immanuel Kant, *Critique of Judgement*, trans. by James Creed
Meredith, rev. and ed. by Nicholas Walker (Oxford: Oxford
World's Classics, 2007) p.37, footnote 2.

50. ibid. p.135.

51. See Alenka Zupančič, *Ethics of the Real: Kant and Lacan*
(London: Verso, 2000) pp.156-157.

52. Morrissey, *Autobiography* (London: Penguin Classics, 2013)
p.99.

53. ibid. p.377.

54. Theodor Adorno, 'Letters to Walter Benjamin', trans. by
Harry Zohn, in Adorno and others, *Aesthetics and Politics*,
p.113.

55. Nina Power, *One-Dimensional Woman* (Ropley: Zer0 Books,
2009) p.41.

56. Jean Baudrillard, 'The Implosion of Meaning in the Media',
in *Simulacra and Simulation*, trans. by Sheila Faria Glaser

(Ann Arbor: University of Michigan Press, 1994) p.80.

57. See Anonymous, 'Get a life! Using the social network seems to make people more miserable', http://www.economist .com/news/science-and-technology/21583593-using-social-network-seems-make-people-more-miserable-get-life, and Samantha Murphy Kelly, 'Report: 56% of Social Media Users Suffer From FOMO', http://mashable.com/2013 /07/09/fear-of-missing-out/.

58. On the 'humblebrag', see Harris Wittels, 'Humblebrag Hall of Fame: Oprah, Tila, and a guy named Totes: The best Humblebraggers of all time', http://www.grantland.com /story/_/id/6665462/humblebrag-hall-fame.

59. Erving Goffman, *The Presentation of Self in Everyday Life* (Garden City: Doubleday, 1959) p.229.

60. See Tiqqun, *Preliminary Materials for a Theory of the Young-Girl*, trans. by Ariana Reines (Los Angeles: Semiotext(e), 2012).

61. Ben Jonson, *Epicene*, in *The Alchemist and Other Plays*, ed. by Gordon Campbell (Oxford: Oxford World's Classics, 1998) p.172.

62. Tiqqun, *Preliminary Materials for a Theory of the Young-Girl*, p.15.

63. ibid. p.18

64. See, for example, the argument of Tim Taylor, 'Children learn best when they use their imagination', http://www. theguardian.com/teacher-network/teacher-blog/2013/feb/ 05/imaginative-inquiry-teaching-classroom.

65. See 'How to Use Your Imagination', ed. by Marsinterstella, Jonathan E., Flickety, Somebody, and 21 others, http://www. wikihow.com/Use-Your-Imagination.

66. EDA Collective, 'Angry Birds and Postmodernism', in *Why are Animals Funny?*, pp.90-92.

67. William Shakespeare, *A Midsummer Night's Dream*, in *Complete Works of Shakespeare, Volume I*, Act V, Scene I, 14-16,

p.408.

68. See EDA Collective 'Panopticism Now', http://www.every-dayanalysis.com/post/53592217709/panopticism-now.

69. Martin Heidegger, 'The Question Concerning Technology', in *The Question Concerning Technology and Other Essays*, trans. by William Lovitt (New York: Harper Torchbooks, 1977) p.16.

70. ibid. p.17.

71. ibid.

72. See Lacan, *Seminar VII: The Ethics of Psychoanalysis*.

73. Jacques Lacan, *The Seminar of Jacques Lacan, Book I: Freud's Papers on Technique, 1953-1954*, ed. by Jacques-Alain Miller, trans. by John Forrester (New York: W. W. Norton, 1988) p.131. This is Heine's 'picture of the psychogenesis of [God's] Creation' – as Freud puts it – from the *Neue Gedichte*, 'Schöpfungslieder VII', quoted in Sigmund Freud, 'On Narcissism: An Introduction', in *Complete Psychological Works, Volume XIV (1914-1916)*, p.85.

74. See Christina Warren, '10 People Who Lost Jobs Over Social Media Mistakes', http://mashable.com/2011/06/16/weinerga te-social-media-job-loss/, and James Legge, 'Manchester Metropolitan: 'Bullying' university bans world-renowned professor who spoke out', http://www.independent.co .uk/news/education/education-news/manchester-metro-politan-bullying-university-bans-worldrenowned-prof essor-who-spoke-out-8223782.html.

75. See EDA Collective, 'Does it Really Make a Difference Whether it was James Gandolfini or Tony Soprano who Died?', in *Why are Animals Funny?*, pp.49-51.

76. Dorothy Lepkowska, 'A poor Ofsted report could lead to headteachers being 'disappeared'', http://www.theguard ian.com/education/2014/mar/11/heads-poor-ofsted-report-dismissal-shortages.

77. Sigmund Freud, *Civilization and its Discontents*, in *Complete*

Psychological Works of Sigmund Freud, Volume XXI (1927-1931), p.111.

78. *Guardian* Readers, 'Pisa league tables: are you surprised by the results?', http://www.theguardian.com/education/2013/dec/03/pisa-league-tables-results-performance.

79. Richard Adams, 'Schools will be allowed to test four-year-olds from 2016, government confirms', http://www.theguardian.com/education/2014/mar/27/four-year-olds-compulsory-tests-2016-government-confirms.

80. See the *South Park* episode 'AWESOM-O', season 8, episode 5 (2004).

81. See 'Chaos Reigns at Cannes Film Festival 2009', on the *Antichrist* DVD (Denmark: Zentropa Entertainments, 2010).

82. See Jacques Lacan, *The Seminar of Jacques Lacan, Book XX: Encore: On Feminine Sexuality, the Limits of Love and Knowledge, 1972-1973*, ed. by Jacques-Alain Miller, trans. by Bruce Fink (New York: W. W. Norton, 1998) pp.64-90.

83. See Anonymous, '*SKINT*: Is this how we want Grimsby to be portrayed on national TV?', http://www.grimsbytelegraph.co.uk/want-town-portrayed-national-TV/story-20439251-detail/story.html.

84. See John Plunkett, 'Benefits Street to be investigated by Ofcom following viewers' complaints', http://www.theguardian.com/media/2014/feb/25/benefits-street-investigated-ofcom-channel-4.

85. Charlie Brooker, 'Benefits Street – poverty porn, or just the latest target for pent-up British fury?', http://www.theguardian.com/commentisfree/2014/jan/12/benefits-street-poverty-porn-british-fury.

86. Karl Marx, 'The Eighteenth Brumaire of Louis Bonaparte', in *Selected Writings*, ed. by David McLellan (Oxford: Oxford University Press, 1977) p.318.

87. Gayatri Spivak, 'Can the Subaltern Speak?', in *Marxism and the Interpretation of Culture*, ed. by Cary Nelson and

Lawrence Grossberg (Urbana: University of Illinois Press, 1988) p.276.

88. ibid.

89. Jacques Lacan, *The Seminar of Jacques Lacan, Book VII: The Ethics of Psychoanalysis, 1959-1960*, ed. by Jacques-Alain Miller, trans. by Dennis Porter (New York: W. W. Norton, 1992) p.253.

90. ibid.

91. See, for example, Andrew O'Hagan, 'So Many Handbags, So Little Time', http://www.lrb.co.uk/v35/n12/andrew-ohagan/so-many-handbags-so-little-time: The teenagers – on whom the film is based – like so many celebrities, 'behaved as if shopping (and having things) was the only way not to be a nobody.'

92. Catherine Bray, *'Epic* (U), Review', http://www.time out.com/london/film/epic-2013?page=2&_source=.

93. For these schema, see Jacque Lacan, *The Seminar of Jacques Lacan, Book XVII: The Other Side of Psychoanalysis* [1969-1970], ed. by Jacques-Alain Miller, trans. by Russell Grigg (New York: W. W. Norton, 2007) p.29.

94. Leonard Mlodinow, *The Drunkard's Walk: How Randomness Rules Our Lives* (New York: Vintage, 2009) p.173.

95. ibid. p.175.

96. Steve Jobs, quoted in ibid.

97. ibid. p.178.

98. Slavoj Žižek, 'Hegel with Lacan, or the Subject and Its Cause', in *Reading Seminars I and II: Lacan's Return to Freud*, ed. by Richard Feldstein, Bruce Fink and Maire Jaanus (Albany: State University of New York Press, 1996) p.413.

99. Sigmund Freud, 'Fetishism', in *Complete Psychological Works, Volume XXI (1927-1931)*, pp.152-153.

100. ibid. p.154.

101. See EDA Collective, 'Autocorrect in the History of Literature', in *Why are Animals Funny?*, pp.44-46; and Ben

Zimmer, 'On Language: How Fail Went From Verb to Interjection', http://www.nytimes.com/2009/08/09/magaz ine/09FOB-onlanguage-t.html?_r=5&partner=rssny t&emc=rss&.

102. See, for example, http://failblog.cheezburger.com/.

103. Jonathan Swift, *Gulliver's Travels* (London: Penguin English Library, 2012) p.194.

104. ibid. p.196

105. ibid.

106. Alenka Zupančič, 'Reversals of Nothing: The Case of the Sneezing Corpse', *Filozofski vestnik*, 26th ser., 2 (2005) 173-186 (p.173).

107. Marshall McLuhan, *Understanding Media: The Extensions of Man* (London: Routledge Classics, 2001) p.7, p.9.

108. ibid. p.8.

109. EDA Collective, 'Old Spice and the Structure of Advertising', in *Why are Animals Funny?*, p.18.

110. See Marshall McLuhan, *The Gutenberg Galaxy: The Making of Typographic Man* (Toronto: University of Toronto Press, 1962).

111. See Marshall McLuhan, 'The Medium is the Message: Interview, 1977', http://www.youtube.com/watch?v=Ima H51F4HBw.

112. McLuhan, *Understanding Media*, p.57.

113. Elif Batuman, quoted in Hermione Hoby, 'War and Peace ebook readers find a surprise in its Nooks', http://www. theguardian.com/books/booksblog/2012/jun/07/war-and-peace- ebook-nook.

114. Dan Hancox, 'No Platform for Billy Bragg', http://www.op endemocracy.net/dan-hancox/no-platform-for-billy-bragg.

115. https://twitter.com/Paulflynnmp/status/36033869228973 6705.

116. Louis Althusser, 'Ideology and Ideological State Apparatuses (Notes towards an Investigation)', trans. by

Ben Brewster, in *On Ideology* (London: Verso Radical Thinkers, 2008) p.28.

117. John Berger, *Ways of Seeing* (London: British Broadcasting Corporation and Penguin Books, 1972) p.16.

118. In Japan this issue of non-transparency at corners has caused architects to design such corners as to make it impossible. See Beorpegu, 'Some building sites in Japan have clear perspex corners so you don't bump into people or get mugged when going round them', http://www.reddit.com/r/mildlyinteresting/comments/1n3f3m/some_building_sites_in_japan_have_clear_perspex/.

119. Lacan, *Seminar XI: The Four Fundamental Concepts of Psychoanalysis*, p.80.

120. ibid. p.81.

121. Jacques Lacan, *The Seminar of Jacques Lacan, Book III: The Psychoses, 1955-1956*, ed. by Jacques-Alain Miller, trans. by Russell Grigg (New York: W. W. Norton, 1993) p.322.

122. See Julie Armstrong, 'Chippenham vicar says sorry for Santa gaffe', http://www.gazetteandherald.co.uk/news/towns/chippenhamheadlines/10872312.Chippenham_vicar_says_sorry_for_Santa_gaffe/, and Miranda Prynne, 'Santa Claus is not real, vicar claims to audience of primary school children', http://www.telegraph.co.uk/news/religion/105 13229/Santa-is-not-real-vicar-tells-primary-school-children.html

123. See comments section in story in the first reference in ibid.

124. Slavoj Žižek, *Less Than Nothing: Hegel and the Shadow of Dialectical Materialism* (London: Verso, 2012) p.697.

125. Slavoj Žižek, 'Good Manners in the Age of WikiLeaks', http://www.lrb.co.uk/v33/n02/slavoj-zizek/good-manners-in-the-age-of-wikileaks.

126. Lacan, *Seminar III: The Psychoses*, p.322.

127. Slavoj Žižek, 'Human Rights and its Discontents', talk delivered at Olin Auditorium, Bard College, New York, 15.11.1999, http://www.lacan.com/zizek-human.htm.

128. J. M. Bernstein, 'Introduction', in Theodor W. Adorno, *The Culture Industry: Selected Essays on Mass Culture*, ed. by J. M. Bernstein (London: Routledge Classics, 2001) p.13.

129. ibid. p.14.

130. ibid.

131. See Alenka Zupančič, 'Alenka Zupancic on 'Bio-morality'', http://philosophy.atmhs.com/2012/02/25/alenka-zupancic-on-bio-morality/.

132. Primo Levi, *If This is a Man*, in *If This is a Man/The Truce* (London: Abacus, 1998) p.96.

133. ibid. p.57.

134. ibid. p.80.

135. Alan Farmer, *Anti-Semitism and the Holocaust* (London: Hodder and Stoughton, 1998) p.95.

136. Such as those 'Jewish prominents', who, as Levi suggests, 'form a sad and notable human phenomenon.' He gives the psychological profile of a prominent as such: 'When he is given the command of a group of unfortunates, with the right of life or death over them, he will be cruel and tyrannical, because he will understand that if he is not sufficiently so, someone else, judged more suitable, will take over his post. Moreover, his capacity for hatred, unfulfilled in the direction of the oppressors, will double back, beyond all reason, on the oppressed; and he will only be satisfied when he has unloaded on to his underlings the injury received from above.' – Levi, *If This is a Man*, p.97.

137. Jean Baudrillard, *The Transparency of Evil: Essays on Extreme Phenomena*, trans. by James Benedict (London: Verso, 2009) p.102.

138. ibid. p.105.

139. Primo Levi, 'Afterword', in *If This is a Man/The Truce*, pp.389-390.

140. Baudrillard, *The Transparency of Evil*, p.106.

141. These words are an excerpt from the memorial plaque at

Birkenau, the full text of which reads: 'For ever let this place be a cry of despair and a warning to humanity where the Nazis murdered about one and a half million men, women, and children, mainly Jews from various countries of Europe.'

142. Levi, *If This is a Man*, p.15. Žižek identifies a flipside to this in 'late-capitalist society': 'Today's liberal tolerance of others, the respect of otherness and openness towards it, is counterpointed by an obsessive fear of harassment. In short, the Other is just fine, but only insofar as his presence is not intrusive, insofar as this Other is not really other [...] My duty to be tolerant to the Other effectively means that I should not get too close to him, intrude on his space. In other words, I should respect his *intolerance* of my over-proximity. What increasingly emerges as the central human right in late-capitalist society is the right *not to be harassed*, which is a right to remain at a safe distance from others.' – Žižek, *Violence*, p.35.

143. 'The Germans ordered us to uproot many of the *matzevot*, the gravestones, from the Jewish cemetery of Cracow, to be used for paving roads to the S.S. quarters and the commandant's villa.' – Avital, Moshe, *Not to Forget, Impossible to Forgive: Poignant Reflections on The Holocaust* (Jerusalem: Mazo, 2008) p.127. See also Farmer, *Anti-Semitism and the Holocaust*, p.92

144. For more on these words, see Paul Johnson, *The Holocaust* (London: Phoenix, 1996) p.26. See also the Nazis' 'euthanasia programme [which] was a euphemism to camouflage the killing of mentally and physically handicapped people deemed to be 'unworthy of life'.' – Farmer, *Anti-Semitism and the Holocaust*, p.66.

145. Danuta Czech, 'The Auschwitz Prisoner Administration' in *Anatomy of the Auschwitz Death Camp* ed. Yisrael Gutman and Michael Berenbaum (Bloomington: Indiana University

Press, 1998) p.376.

146. See ibid.

147. Levi, *If This is a Man*, p.127.

148. Jonah Weiner, 'The Music Club, 2011', http://www.slate.com/articles/arts/the_music_club/features/2011/music_club_2011/best_music_2011_the_year_s_best_and_weirdest_protest_songs_.html.

149. Anonymous, 'ASAP Rock – Long.Live.ASAP Album Review', http://www.contactmusic.com/albumreview/asap-rocky-long-live-asap.

150. See Malden Dolar, *A Voice and Nothing More* (Cambridge, MA: MIT Press, 2006).

151. See on the event, for example, Anonymous, 'Robin Thicke on Miley Cyrus MTV VMA performance controversy: 'It's silly', http://www.nme.com/news/robin-thicke-0/73177.

152. See Anonymous, 'Marvin Gaye family sues Robin Thicke over Blurred Lines', http://www.bbc.co.uk/news/entertainment-arts-24696519, and Lily Allen's single 'Hard Out Here', which parodies Thicke's 'Blurred Lines' and highlights aspects of mainstream music culture's sexism.

153. Elizabeth Plank, 'In a Surprising Twist, Robin Thicke Is Now Convinced He's Starting a "Feminist Movement"', http://www.policymic.com/articles/57313/in-a-surprising-twist-robin-thicke-is-now-convinced-he-s-starting-a-feminist-movement.

154. Slavoj Žižek, *Organs Without Bodies: On Deleuze and Consequences* (Abingdon: Routledge Classics, 2012) p.128.

155. Slavoj Žižek, in *The Pervert' Guide to Ideology*, dir. by Sophie Fiennes (2012).

156. Frederic Jameson, 'Postmodernism and Consumer Society', in *The Cultural Turn: Selected Writings on the Postmodern, 1983-1998* (London: Verso, 1998) p.6.

157. Jean-François Lyotard, *The Postmodern Condition: A Report on Knowledge*, trans. by Geoff Bennington and Brian Massumi

(Manchester: Manchester University Press, 1984) p.xxiv.

158. Sigmund Freud, *Inhibitions, Symptoms and Anxiety*, in *Complete Psychological Works, Volume XX (1925-1926)*, p.126.

159. See Dan Hancox, *Stand Up Tall: Dizzee Rascal and the Birth of Grime* (Amazon: Kindle Single, 2013).

160. Anonymous, 'Four Tet Confirms He Is Burial', http://equalizermag.com/news/four-tet-confirms-he-is-burial/.

161. See the interview with Burial in the *Guardian*: Dan Hancox, "Only five people know I make tunes", http://www.theguardian.com/music/2007/oct/26/urban.

162. On '7 Skies h3' see EDA Collective, 'Pushing the Skies' Limit: *A Life in the Day of The Flaming Lips' '7 Skies H3"*, in *Why are Animals Funny?*, pp.81-83.

163. See the film *The Archive*, dir. by Sean Dunne (2009).

164. See Walter Benjamin, 'Paris, the Capital of the Nineteenth Century', trans. by Howard Eiland, in *The Work of Art in the Age of its Technological Reproducibility and Other Writings on Media*, p.104, and Walter Benjamin, 'Unpacking my Library: A Talk About Book Collecting', in *Illuminations*, p.67.

165. See the interview with Mawhinney in *1-2-1 w/jeffstaple feat. Paul Mawhinney of Record-Rama*, dir. by Jeff Staple (2012).

166. David Graeber, *On the Phenomenon of Bullshit Jobs: A Work Rant* (*Strike!*: Little Pocket Pamphlet Series, no. 1, 2013).

167. Félix Guattari, *The Three Ecologies*, trans. by Ian Pindar and Paul Sutton (London: Continuum, 2008) p.23.

168. See, for example, Julie Bindel, 'Sexuality: the nature v nurture debate', http://www.theguardian.com/commentisfree/2013/sep/16/sexuality-nature-nurture-debate; Geoffrey Klempner, 'The Ten Big Questions', http://www.123infinity.com/; and George Dvorsky, '8 Great Philosophical Questions That We'll Never Solve', http://io9.com/5945801/8-philosophical-questions-that-well-never-solve.

169. Edward de Bono, *Lateral Thinking: A Textbook of Creativity*

(Harmondsworth: Penguin Books, 1977) p.82.

170. Gillian Rose, *Hegel Contra Sociology* (London: Verso Radical Thinkers, 2009) p.5.

171. Slavoj Žižek, 'Politics and Responsibility', in *Demanding the Impossible*, ed. by Yong-june Park (Cambridge: Polity Press, 2013) p.2.

172. Ian Parker, *Slavoj Žižek: A Critical Introduction* (London: Pluto Press, 2004) p.3.

173. See Slavoj Žižek, 'Rumsfeld and the bees', http://www.the guardian.com/commentisfree/2008/jun/28/wildlife.conser-vation.

174. ibid.

175. ibid.

176. See Lee Edelman, *No Future: Queer Theory and the Death Drive* (Durham: Duke University Press, 2004).

177. Jacques Derrida, *The Post Card: From Socrates to Freud and Beyond*, trans. by Alan Bass (Chicago: The University of Chicago Press, 1987) p.324.

178. See, for instance, Daniel Martin and Ian Drury, 'Let women fight on the front line: Defence Secretary tells Army to end macho image', http://www.dailymail.co.uk/news/article-2623429/Time-ditch-macho-image-allow-women-fight-frontline-Defence-Secretary-Philip-Hammond-says.html, and Barbara Ellen, 'Women in the British army fighting on the front line? Wrong move, Mr Hammond', http://www. theguardian.com/commentisfree/2014/may/10/women-british-army-fighting-front-line-hammond-combat-sexist.

179. Simone de Beauvoir, *The Second Sex*, trans. and ed. by H. M. Parshley (London: Vintage1953) p.172.

180. ibid. p.209.

181. ibid. p.180.

182. ibid. p.218.

183. Seumas Milne, 'A 'pause' in centuries of British wars is not enough', http://www.google.co.uk/search?client=safari&rls

=en&q=seumas+milne&ie=UTF-8&oe=UTF-8&gfe_rd
=cr&ei=272YU-D_KonR8gf7soH4Cw.

184. Paul Gilroy, 'Introduction: Race is Ordinary', in *There Ain't No Black in the Union Jack: The Cultural Politics of Race and Nation* (Abingdon: Routledge Classics, 2002) p.xxxiii.

185. Althusser, 'Ideology and Ideological State Apparatuses', in *On Ideology*, p.48.

186. ibid.

187. See 'The Scrabble Squabble; or, the Plight of Online Opposition', below.

188. William Shakespeare, *All's Well That Ends Well*, in *Complete Works of Shakespeare, Volume I*, Act IV, Scene V, 20, p.676.

189. Lacan, *Seminar VII: The Ethics of Psychoanalysis*, pp.182-183.

190. Slavoj Žižek, 'A Leftist Plea for 'Eurocentrism'', in *The Universal Exception*, ed. by Rex Butler and Scott Stephens (London: Continuum, 2006) p.201.

191. Lacan, *Seminar VII: The Ethics of Psychoanalysis*, p.183.

192. https://twitter.com/JonathanHaynes/status/3621749638 61553153.

193. William Shakespeare, *All's Well That Ends Well*, Act IV, Scene V, 29, p.676.

194. Ian Pindar and Paul Sutton, 'Notes', in Félix Guattari, *The Three Ecologies*, p.93, note 45. See Gilles Deleuze and Félix Guattari, *A Thousand Plateaus: Capitalism and Schizophrenia II*, trans. by Brian Massumi (London: The Athlone Press, 1988) p.215.

195. Alain Badiou, 'Politics and Philosophy: An Interview with Alain Badiou', in *Ethics: An Essay on the Understanding of Evil*, trans. by Peter Hallward (London: Verso Radical Thinkers, 2012) pp.101-102.

196. For the game, see http://hudsonhongo.com/joyce/.

197. Russell Brand, 'Russell Brand on revolution: "We no longer have the luxury of tradition"', http://www.newstatesman. com/politics/2013/10/russell-brand-on-revolution;

https://www.youtube.com/watch?v=3YR4CseY9pk#t=12.

198. Robin Lustig, 'Russell Brand: Not Only Daft but Dangerous', http://www.huffingtonpost.co.uk/robin-lustig/russell-brand-not-only-dangerous_b_4155341.html.

199. Robert Webb, 'Dear Russell, choosing to vote is the most British kind of revolution there is', http://www.newstatesman.com/2013/10/russell-brand-robert-webb-choosing-vote-most-british-kind-revolution-there.

200. Žižek, *Violence*, p.182.

201. See Simon Keegan, 'UKIP forced to cancel Freepost address after being sent FAECES in the post', http://www.mirror.co.uk/news/uk-news/ukip-forced-cancel-freepost-address-3495376.

202. See the interview with Clement Jones, who researched into whom this constituent might have been and found no support for Powell's claim, in *Windrush*, ep. 2, dir. by David Upshal (BBC: 1998).

203. Julia Kristeva, *Powers of Horror: An Essay on Abjection*, trans. Leon S. Roudiez (New York: Columbia University Press, 1982), pp.2-3.

204. ibid. p.3.

205. ibid. p.4.

206. Jacques Rancière *On the Shores of Politics*, trans. by Liz Heron (London: Verso Radical Thinkers, 2007) p.19.

207. See Jacques Derrida, *Specters of Marx: The State of the Debt, The Work of Mourning, and The New International*, trans. by Peggy Kamuf (Abingdon: Routledge Classics, 2006) p.187.

208. See Slavoj Žižek, 'Fat-free chocolate and absolutely no smoking: why our guilt about consumption is all-consuming', http://www.theguardian.com/artanddesign/2014/may/21/prix-pictet-photography-prize-consumption-slavoj-zizek.

209. Slavoj Žižek, 'A Cup of Decaf Reality', http://www.lacan.com/zizekdecaf.htm.

210. David Conn, *The Beautiful Game: Searching for the Soul of Football* (London: Yellow Jersey Press, 2005) p.21.

211. Roger Callois, *Man, Play and Games*, trans. by Meyer Barash (Urbana and Chicago: University of Illinois Press, 2001) p.12.

212. Jude Wanga, '#Weareallmonkeys: Can a picture of a banana fight racism?', http://www.independent.co.uk/voices/wea reallmonkeys-can-a-picture-of-a-banana-fight-racism-9302344.html.

213. Okwonga tweeted: 'Don't just ban the guy who threw the banana at Dani Alves. Investigate the conditions which made him feel comfortable enough to throw it.', https://twitter.com/Okwonga/status/461485617466327040.

214. Liladhar Ramchandra Pendse, '"Antropofagia Incorporated": A Concept or a Movement?', *LLJournal*, 2nd Ser., 2 (2007). http://ojs.gc.cuny.edu/index.php/lljournal/rt/printer Friendly/279/265.

215. Eve Kosofsky Sedgwick, *Between Men: English Literature and Male Homosocial Desire* (New York: Columbia University Press, 1985) p.89.

216. Alain Badiou, *Being and Event*, trans. by Oliver Feltham (London: Continuum, 2006) p.179.

217. Svetlana Boym, *The Future of Nostalgia* (New York: Basic Books, 2001) p.xiv.

218. See Gordana P. Crnković, 'Non-Nationalist Culture, Under and Above the Ground', in *Croatia since Independence: War, Politics, Society, Foreign Relations*, ed. by Sabrina P. Ramet and others (Munich: R. Oldenbourg Verlag, 2008) pp. 233-250.

219. Jurica Pavičić, quoted in ibid. p.248.

220. See Marcus Christenson, 'Euro 2012: Croatia fined £65,000 for racist abuse of fans', http://www.theguardian.com /football/2012/jun/19/euro-2012-croatia-fined-racism.

221. Jacques Derrida, *The Beast and The Sovereign*, ed. by Michel

Lisse, Marie-Louise Mallet and Ginette Michaud, trans. by Geoffrey Bennignton, 2 vols (Chicago: University of Chicago Press, 2009) I, p.17.

222. Walter Benjamin, 'What is Epic Theatre?', in *Illuminations*, p.150.

223. See the petition by John Lewis, 'Scrabble – If it ain't broke, don't fix it', at http://www.change.org/en-GB/petitions/ scrabble-if-it-ain-t-broke-don-t-fix-it, and Zoe Kleinman, 'Scrabble app changes anger players on Facebook', http:// www.bbc.co.uk/news/technology-22905191.

224. Alenka Zupančič, *The Odd One In: On Comedy* (Cambridge, MA: MIT Press, 2008) p.73.

225 See David Batty, 'John Lewis chief calls on government to tax multinational companies properly', http://www.the guardian.com/business/2012/nov/15/john-lewis-chief-fair-tax-plea.

226. See Hal Hodson, 'Crowdsourcing grows up as online workers unite', http://www.newscientist.com/article/mg2 1729036.200-crowdsourcing-grows-up-as-online-workers-unite.html#.Uyw_fCiXx-R.

227. On this see the above article, 'Big Data, the NSA, and Heidegger's 'Standing Reserve''.

228. Slavoj Žižek, in *Žižek!*, dir. by Astra Taylor (2005).

229. Judith Burns, ''Cheese is from plants' – study reveals child confusion', http://www.bbc.co.uk/news/education-22730 613.

230. See Harriet Bignell, 'Warwick students break university staff strikes by holding self-run lectures', http://www. indepen dent.co.uk/student/news/warwick-students-break-university-staff-strikes-by-holding-selfrun-lectures-9096976.html.

231. Félix Guattari, *The Three Ecologies*, p.30.

zero
books

Contemporary culture has eliminated both the concept of the public and the figure of the intellectual. Former public spaces – both physical and cultural – are now either derelict or colonized by advertising. A cretinous anti-intellectualism presides, cheerled by expensively educated hacks in the pay of multinational corporations who reassure their bored readers that there is no need to rouse themselves from their interpassive stupor. The informal censorship internalized and propagated by the cultural workers of late capitalism generates a banal conformity that the propaganda chiefs of Stalinism could only ever have dreamt of imposing. Zer0 Books knows that another kind of discourse – intellectual without being academic, popular without being populist – is not only possible: it is already flourishing, in the regions beyond the striplit malls of so-called mass media and the neurotically bureaucratic halls of the academy. Zer0 is committed to the idea of publishing as a making public of the intellectual. It is convinced that in the unthinking, blandly consensual culture in which we live, critical and engaged theoretical reflection is more important than ever before.

ZERO BOOKS

Capitalist Realism Is there no alternative?
Mark Fisher
An analysis of the ways in which capitalism has presented itself
as the only realistic political-economic system.
Paperback: November 27, 2009 978-1-84694-317-1 $14.95 £7.99.
eBook: July 1, 2012 978-1-78099-734-6 $9.99 £6.99.

The Wandering Who? A study of Jewish identity politics
Gilad Atzmon
An explosive unique crucial book tackling the issues of Jewish
Identity Politics and ideology and their global influence.
Paperback: September 30, 2011 978-1-84694-875-6 $14.95 £8.99.
eBook: September 30, 2011 978-1-84694-876-3 $9.99 £6.99.

Clampdown Pop-cultural wars on class and gender
Rhian E. Jones
Class and gender in Britpop and after, and why 'chav' is a
feminist issue.
Paperback: March 29, 2013 978-1-78099-708-7 $14.95 £9.99.
eBook: March 29, 2013 978-1-78099-707-0 $7.99 £4.99.

The Quadruple Object
Graham Harman
Uses a pack of playing cards to present Harman's metaphysical
system of fourfold objects, including human access, Heidegger's
indirect causation, panpsychism and ontography.
Paperback: July 29, 2011 978-1-84694-700-1 $16.95 £9.99.

Weird Realism Lovecraft and Philosophy
Graham Harman
As Hölderlin was to Martin Heidegger and Mallarmé to Jacques Derrida, so is H.P. Lovecraft to the Speculative Realist philosophers.
Paperback: September 28, 2012 978-1-78099-252-5 $24.95 £14.99.
eBook: September 28, 2012 978-1-78099-907-4 $9.99 £6.99.

Sweetening the Pill or How We Got Hooked on Hormonal Birth Control
Holly Grigg-Spall
Is it really true? Has contraception liberated or oppressed women?
Paperback: September 27, 2013 978-1-78099-607-3 $22.95 £12.99.
eBook: September 27, 2013 978-1-78099-608-0 $9.99 £6.99.

Why Are We The Good Guys? Reclaiming Your Mind From The Delusions Of Propaganda
David Cromwell
A provocative challenge to the standard ideology that Western power is a benevolent force in the world.
Paperback: September 28, 2012 978-1-78099-365-2 $26.95 £15.99.
eBook: September 28, 2012 978-1-78099-366-9 $9.99 £6.99.

The Truth about Art Reclaiming quality
Patrick Doorly
The book traces the multiple meanings of art to their various sources, and equips the reader to choose between them.
Paperback: August 30, 2013 978-1-78099-841-1 $32.95 £19.99.

Bells and Whistles More Speculative Realism
Graham Harman
In this diverse collection of sixteen essays, lectures, and interviews Graham Harman lucidly explains the principles of Speculative Realism, including his own object-oriented philosophy.

Paperback: November 29, 2013 978-1-78279-038-9 $26.95 £15.99.
eBook: November 29, 2013 978-1-78279-037-2 $9.99 £6.99.

Towards Speculative Realism: Essays and Lectures Essays and
Lectures
Graham Harman
These writings chart Harman's rise from Chicago sportswriter to
co founder of one of Europe's most promising philosophical
movements: Speculative Realism.
Paperback: November 26, 2010 978-1-84694-394-2 $16.95 £9.99.
eBook: January 1, 1970 978-1-84694-603-5 $9.99 £6.99.

Meat Market Female flesh under capitalism
Laurie Penny
A feminist dissection of women's bodies as the fleshy fulcrum of
capitalist cannibalism, whereby women are both consumers and
consumed.
Paperback: April 29, 2011 978-1-84694-521-2 $12.95 £6.99.
eBook: May 21, 2012 978-1-84694-782-7 $9.99 £6.99.

Translating Anarchy The Anarchism of Occupy Wall Street
Mark Bray
An insider's account of the anarchists who ignited Occupy Wall
Street.
Paperback: September 27, 2013 978-1-78279-126-3 $26.95 £15.99.
eBook: September 27, 2013 978-1-78279-125-6 $6.99 £4.99.

One Dimensional Woman
Nina Power
Exposes the dark heart of contemporary cultural life by
examining pornography, consumer capitalism and the ideology of
women's work.
Paperback: November 27, 2009 978-1-84694-241-9 $14.95 £7.99.
eBook: July 1, 2012 978-1-78099-737-7 $9.99 £6.99.

Dead Man Working
Carl Cederstrom, Peter Fleming
An analysis of the dead man working and the way in which
capital is now colonizing life itself.
Paperback: May 25, 2012 978-1-78099-156-6 $14.95 £9.99.
eBook: June 27, 2012 978-1-78099-157-3 $9.99 £6.99.

Unpatriotic History of the Second World War
James Heartfield
The Second World War was not the Good War of legend. James
Heartfield explains that both Allies and Axis powers fought for
the same goals - territory, markets and natural resources.
Paperback: September 28, 2012 978-1-78099-378-2 $42.95 £23.99.
eBook: September 28, 2012 978-1-78099-379-9 $9.99 £6.99.

Find more titles at www.zero-books.net